Painted Wolves

Wild Dogs of the Serengeti–Mara

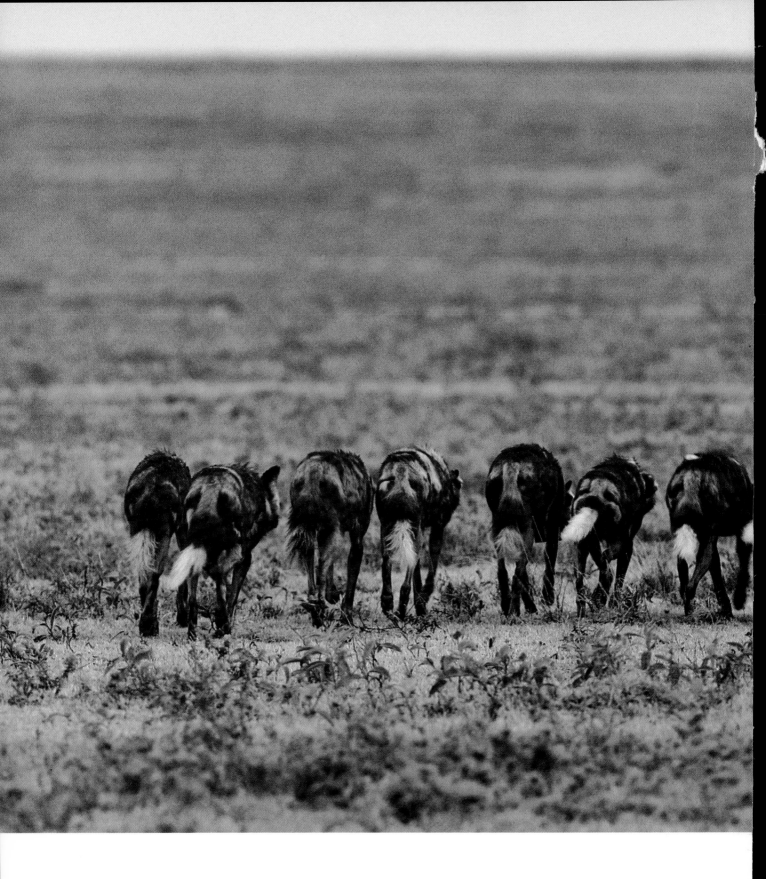

Painted Wolves

WILD DOGS OF THE SERENGETI-MARA

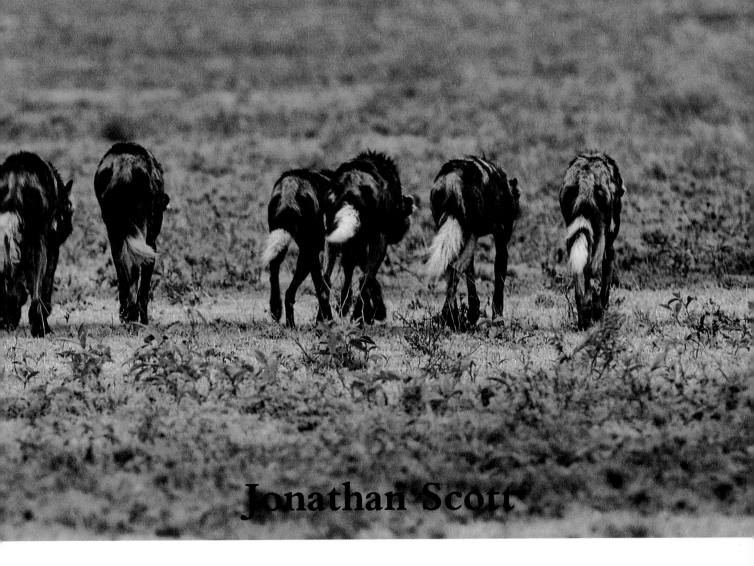

Jonathan Scott

HAMISH HAMILTON · LONDON

*To Colonel T. S. Conner, DSO, KPM, sportsman,
friend and an inspiration to all who know him*

HAMISH HAMILTON LTD

Published by the Penguin Group
27 Wrights Lane, London W8 5TZ, England
Viking Penguin Inc., 375 Hudson Street, New York, New York 10014, USA
Penguin Books Australia Ltd, Ringwood, Victoria, Australia
Penguin Books Canada Ltd, 2801 John Street, Markham, Ontario, Canada L3R 1B4
Penguin Books (NZ) Ltd, 182–190 Wairau Road, Auckland 10, New Zealand

Penguin Books Ltd, Registered Offices: Harmondsworth, Middlesex, England

First published 1991
10 9 8 7 6 5 4 3 2 1

Filmset in 10/13pt Bembo Linotron by Wyvern Typesetting Ltd, Bristol

Printed in Singapore by Toppan Printing Co Ltd

A CIP catalogue record for this book is available from the British Library

Library of Congress Catalog Card Number: 90–84090
ISBN 0-241-12485-9

Contents

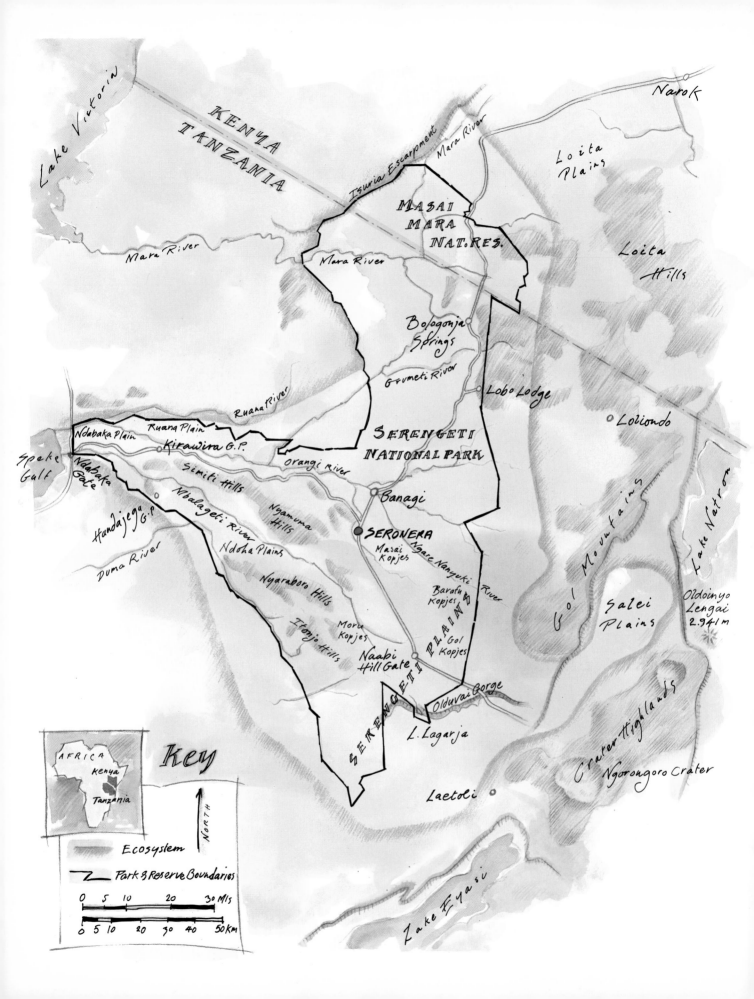

Introduction

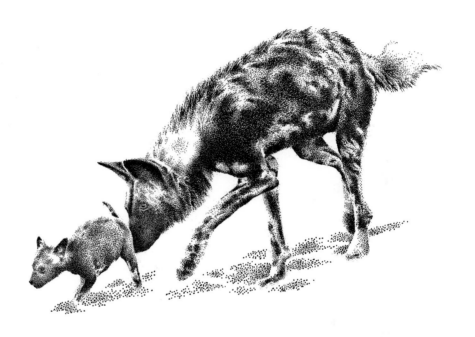

The only thing more abundant in Africa than life is death. It takes a thousand forms, each of infinite variety as opposite as the slashing lunge of a crocodile or the lingering tragedy of the bilharzia snail fluke. It walks, crawls, creeps, flies, swims, and runs in untold disguises, but in no shape is it so brazen, so completely polished, so jaw-snappingly efficient and universally loathed as in the Cape hunting dog or wild dog, Lycaon pictus. Even the great cats are casually respected by their prey, who merely keep a distance just past the danger point. Only the presence of the wild dog in thick bush country creates the mindless horror of death unique among predators.

Death in the Long Grass, PETER HATHAWAY CAPSTICK

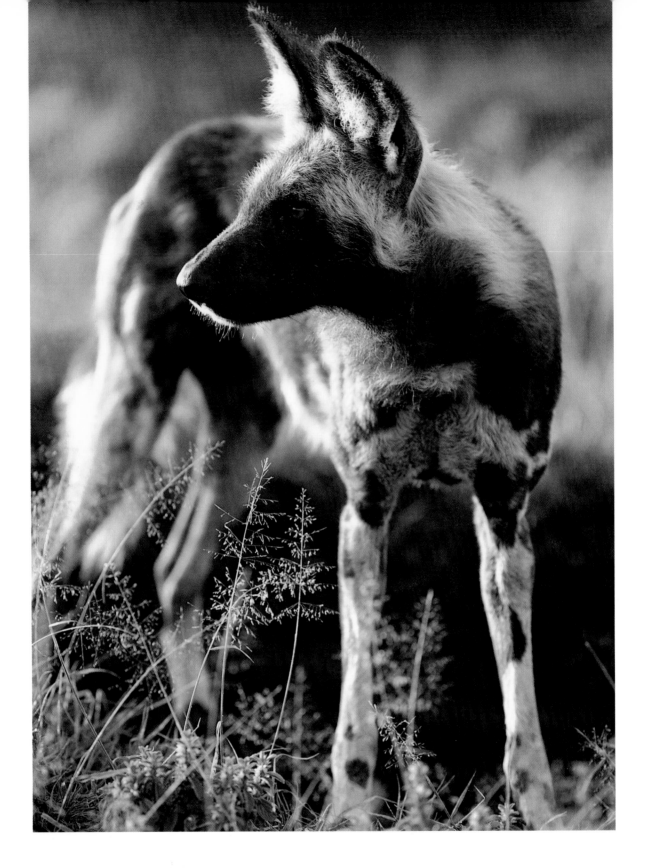

Hoo . . . hoo . . . hoo . . . hoo . . . hoo. Repeated again and again, plaintive yet beautiful. It was unlike any wild sound I had heard before: thin and willowy, like the singing of the wind. It lacked the boldness of a hyaena's whoop or the authority of a lion's roar. A mournful, bell-like call reaching out into the darkness – the eerie cry of an African wild dog separated from other members of her pack.

The wild dog was one of five that had been held captive at a game trapper's ranch in Botswana. They had been dug from their den as puppies and then sold as adults to a zoo in Europe – all except one. The zoo had wanted only males. So the female remained, confined in a small wire enclosure. Each night she called into the darkness, searching for her litter-mates with an unmistakable cry of distress. She would stand with ears cocked, listening for the answer that I knew she would never hear.

African wild dogs, or hunting dogs as they are sometimes known, are remarkable-looking animals with huge bat-ears and a broadly white-tipped tail. They differ from other members of the dog family in having four rather than five toes on their front feet. Their scientific name, *Lycaon pictus*, means painted or ornate wolf, celebrating their motley array of coat markings: a jigsaw of dark brown, blotched with patches of burnished yellow and white. Each dog is uniquely coloured, as if painted by hand: its coat is as individual as the human finger print. Some are scruffy and mangy-looking; others are as beautifully coated as the finest pedigree; and some have virtually no hair at all, revealing a skin of greyish black. In the southern part of

Lycaon pictus *means painted or ornate wolf. Each dog is uniquely coloured*

their range – for example, in the Kruger National Park in South Africa – wild dogs generally have more yellow in their coats, giving them a lighter appearance than those found in East Africa.

Until recently most visitors to Africa's parks and reserves had either never heard of wild dogs or presumed them to be some kind of domestic dog 'gone wild'. Those who did know something about them were quite likely to recoil at the mere mention of their name: their reputation has always been their greatest enemy. Wild dogs used to be indiscriminately destroyed for no other reason than that they had been depicted as 'cruel, vicious killers'. Ranchers in many parts of Africa considered them vermin, incompatible with animal husbandry. Yet it was only when man appropriated virgin land for farming or depleted the dogs' natural prey that they turned to killing livestock.

It would not be an exaggeration to say that there has been a spectacular decline in wild dog numbers throughout Africa since the arrival of the white man. Today it is the most endangered large carnivore in Africa. Though still widely distributed south of the Sahara, probably less than 5,000 survive in the wild – possibly only 3,000 – and the species is listed by the International Union for the Conservation of Nature (IUCN) as threatened by extinction. The recently completed pan-African survey of the status and distribution of the wild dog reports that: 'The outlook for *Lycaon* is bleak.' The authors, Frame and Fanshawe, strongly recommend that its conservation status be raised from 'vulnerable' to 'endangered'.

Undoubtedly it is the frenzied manner in which a pack of wild dogs tears into its living prey that disturbs human sensibilities, conjuring up stark images of a street gang attacking a helpless victim. The dogs are coursers, hunting as a pack. Only by doing so can predators the size of wild dogs attempt to overpower prey considerably larger than themselves, though they usually select smaller animals, which can be dealt with more efficiently. Unlike members of the cat family, who usually hunt alone, hyaenas and wild dogs do not have much need for a single killing bite. Instead they run their prey to the point of exhaustion, and then disembowel it. Their victim dies as a result of being eaten alive; killing and dismembering are one process. Once they have secured their prey, the dogs compete amicably with one another for their share of the meat by bolting their food as quickly as possible. A small animal, such as a Thomson's gazelle, is usually

dead within seconds, but when the dogs attack an animal the size of an adult wildebeest, it may be many minutes before it dies, particularly if the pack is small. This is what has caused people to judge the dogs so harshly.

Even park wardens and conservationists were guilty of vilifying wild dogs, encouraging game rangers and trophy hunters to shoot them on sight, under the misapprehension that unless rigorously controlled, the dogs would endanger prey populations. A number of parks in southern Africa adopted an official policy of predator control – a euphemism for killing – in the misguided belief that by greatly reducing the numbers of lions, leopards, cheetahs, hyaenas and wild dogs they would help conserve the species on which they preyed. As recently as the early 1970s, ill-informed park rangers destroyed entire packs of wild dogs on two separate occasions in or around the Serengeti. As far as they were concerned, the fewer wild dogs that survived the better.

Not long ago I was approached by a visitor to the Masai Mara National Reserve in Kenya who was deploring the fact that he had just witnessed a pack of wild dogs killing a heavily pregnant Thomson's gazelle. The man was beside himself with rage. 'What kind of creatures are these wild dogs, that they can do such a thing? If there had been a gun to hand I would have killed them all.' He left me in no doubt that he meant it. And yet on the same day, other visitors had been enraptured at the sight of the dogs rushing back to their den to feed their puppies. The dogs, it seems, continue to inspire admiration and hatred in equal measure.

The more negative sentiments are all too familiar, reminiscent of attitudes expressed by J. A. Hunter nearly thirty years ago in *Wild Life*, the magazine of the East African Wildlife Society. Hunter was a well-known professional hunter living in Kenya, and a person of some prominence in East African conservation circles.

> The rapacious appetite of these foul creatures is stagger-
> ing . . . I maintain these pests should be outlawed
> wherever found. They are gifted with extraordinary
> staying powers and once on the track of an animal its
> living hours are few. Their method is cruel in the
> extreme; they feed on the flesh of a beast before it is dead
> . . . Impala, those debonair sleek-coated antelopes,
> suffer badly from wild dogs . . . A lone impala ram used

to hang around quite close to my encampment [on the lower Mara]; one evening bleats of pain reached me and shortly I was surprised to see my friend the impala rushing towards me evidently for protection. Behind it followed three open-mouthed wild dogs: the ram stopped beside me shivering and bleeding freely from having been emasculated. The last dog of the trio held its head high evidently to facilitate swallowing. I shot it dead through the neck with a .22 Winchester and the other dogs shared the same fate.

In response to Hunter's article, the editor published a letter of reply from George Schaller, then an American Research Associate Professor studying gorillas in the Belgian Congo (now Zaïre). Schaller was one of the first of a new generation of biologists who were interested in making field studies of wild animals in their natural habitats rather than in the artificial environments of laboratories and zoos. Many of the myths and prejudices surrounding animal behaviour were about to be challenged by the findings of these studies.

Schaller objected to a number of points raised by Hunter.

Because of their habits, scavengers and some predators have roused the ire of man and they are usually described with some derogatory adjective, no matter how ill-fitting. Thus hyenas and wolverines are 'cowardly' and 'foul,' vultures are 'disgusting,' wild dogs, weasels, and wolves are 'blood-thirsty' and 'ferocious.' The fact that predators such as wolves and wild dogs kill only to eat and rarely kill more than they need is seldom discussed.

Instead of considering wild dogs 'a great curse to game at large,' it may well be that, as has been found with predators in other areas, the presence of this hunter may be of distinct benefit to the local fauna . . . The practice of eliminating predators . . . can have various consequences. In a few instances it may be justified. However, if the existing game population is large it may have serious effects. In one area of Alaska, wolves, for some reason, were nearly eliminated by predator control. Within a few years the caribou multiplied so rapidly that it was feared that forage would not be sufficient. Now

the area is closed to all wolf hunting with the hope that these predators will re-occupy the range.

Some years later, having watched wild dogs as part of a three-year study on predators and their prey in the Serengeti National Park in Tanzania, Schaller eloquently articulated the contentious issue of the manner in which the dogs kill, refuting the tendency on the part of man to burden other species with virtues or faults we value or despise in ourselves: 'Nature has neither cruelty nor compassion. The ethics of man are irrelevant to the world of other animals. Dogs kill out of necessity, in innocence not in anger, hardly a situation to engender revulsion on the part of man.'

I was determined to try and learn more about these enigmatic creatures. I longed to see them running wild. Whenever people mentioned wild dogs, I invariably thought of the Serengeti's treeless plains where Schaller had studied the dogs: kilometre after kilometre of open grasslands brought to life by the appearance of a pack of the brindled hunters. If I closed my eyes I could already see them streaming along the dusty horizon in remorseless pursuit of a gazelle or wildebeest.

The Serengeti is a vast oasis of wildlife bordering the Masai Mara National Reserve in Kenya, where I had been based since 1977. Together, the land of Serengeti–Mara forms the last great stronghold of Africa's predators and prey, though it encompasses barely half the 30,000-square-kilometre ecosystem described by the travels of the migratory wildebeest and zebra, for which the area is famous.

I paid a fleeting visit to the Serengeti in 1975 but there was no sign of wild dogs, which had always been scarce in comparison to lions and hyaenas. In fact Myles Turner, who was a game warden in the Serengeti when Schaller was working there, told him that the dogs had maintained their low numbers since he arrived in the area in 1956. During the 1970s the population dwindled even further. Pup survival rates were greatly reduced during this period, which undoubtedly added to the decline in the adult population. The number of packs living on the plains almost halved, dropping from twelve to seven, and the number of individuals of more than one year of age fell from 110 to just twenty-six – a decrease in density from one dog per thirty-five square kilometres to one per 200 square kilometres.

It has long been suspected that disease may account for sudden and

The land of Serengeti–Mara is the last great stronghold of Africa's wildlife – page 9

7

dramatic reductions in wild dog numbers. Between 1967 and 1973 at least five packs are thought to have lost more than half their adults due to distemper. The large hyaena population has also been implicated in the dogs' demise: hyaenas compete for possession of the dogs' food and possibly even kill their puppies. But undoubtedly the greatest threat to the survival of the wild dog is still man: last year a South African farmer shot twenty wild dogs which trespassed on his land, bordering the Kruger National Park. Even with the advent of more enlightened attitudes, loss of habitat and depletion of suitable prey populations could eventually see the end of these far-ranging predators outside all but the very largest protected areas – *if* they manage to survive the ravages of epidemic diseases, some of which are introduced by the domestic dog population.

Much of what is known about the Serengeti's wild dog population stems from the early work of the wildlife photographer Hugo van Lawick. It was he who initiated a photographic identification file in 1967 to record information on individual wild dogs living in the Serengeti, and his book *Innocent Killers*, written with Jane Goodall, was one of the first attempts to portray the behaviour of wild dogs and hyaenas in a more accurate and sympathetic light. Over the next ten years wildlife biologists maintained the continuity of records, charting the life histories of pack members. But when Lory Frame concluded her work in 1978, the Serengeti wild dog project ground to a halt.

By this time I had taken up residence in the Masai Mara National Reserve in Kenya. While there I was fortunate enough to be able to make intermittent observations of a pack of wild dogs known as the Aitong pack. They traditionally denned in the area surrounding Aitong Hill, just to the north-east of the reserve, but within a few years they had died out, ravaged by disease and by competition from too many lions and hyaenas – and too few dogs. It seemed that the wild dogs were in decline throughout the Serengeti–Mara eco-system.

It was not until 1985 that word began to filter out from the Serengeti that wild dogs were being seen again. There was even talk of a large pack of forty dogs roaming between Naabi Hill and the adjoining Maswa Game Reserve, to the south of the park. This welcome news was provided by John Fanshawe and Clare FitzGibbon, working at the Serengeti Wildlife Research Centre. John and Clare had been trying to piece together the missing chapters in the

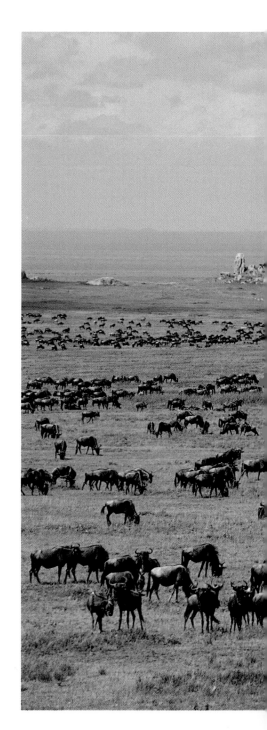

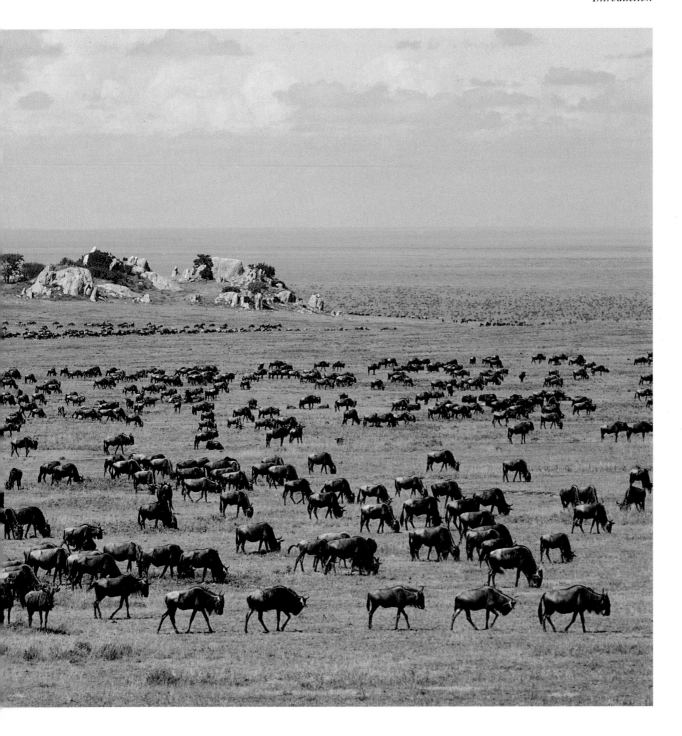

history of the Serengeti's wild dog population. No one knew for sure how many dogs still survived in the woodlands to the north and west of the plains, but it was thought that there might be as few as eighty dogs in the entire park – an area of 12,500 square kilometres.

I desperately wanted to visit the Serengeti and see wild dogs again. But with the reopening of the border between Tanzania and Kenya in 1983, the Tanzanians had revised their park entrance fees. A one-man safari to Serengeti would be prohibitively expensive.

By chance, towards the end of 1985, I met Joyce and Neil Silverman, a young American couple staying at Kichwa Tembo tented camp in the Masai Mara, where I was based. They were visiting Kenya after completing a safari through the spectacular game-viewing areas of northern Tanzania. At the time I was working on a book documenting the story of the great wildebeest migration through the Serengeti–Mara. Neil is a keen photographer and was as anxious as I was to witness the mass calving of the wildebeest during February and March on the Serengeti's short grass plains, and to photograph the attendant predators, particularly the elusive wild dogs. Despite previous safaris to Kenya, Tanzania, Zambia and Zimbabwe, Neil had yet to see or photograph a wild dog. We agreed to pool our resources and undertake a six-week safari to the Serengeti and Ngorongoro Crater, during which time I would seek permission to complete my book. Without Neil's help I could never have afforded those fees. Finding and photographing the wild dogs promised to be the highlight of our safari to the Serengeti.

The Search for the Dogs

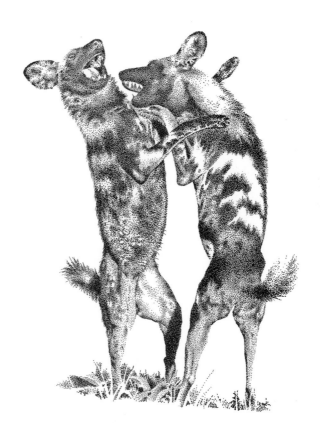

It is a curious paradox that the wolf in its domestic form – the dog – arouses almost maniacal affection, but in the wild engenders feelings of deep loathing and fear. It is this kind of confused prejudice that for centuries has dogged scientific study and overshadowed any understanding of this creature.

BBC Wildlife, MICHAEL BRIGHT

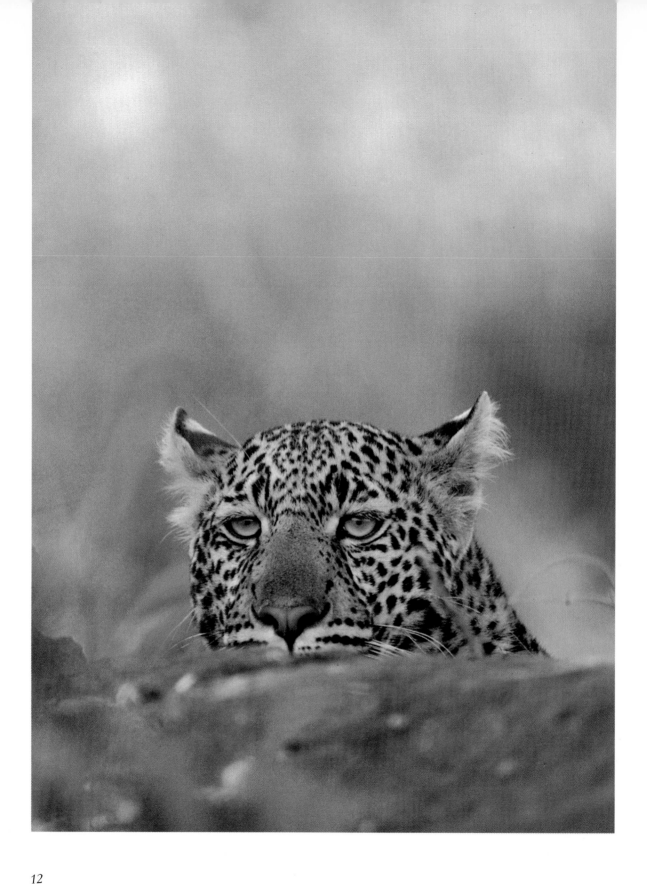

N eil and I drove to Serengeti in mid-January 1986. We had already decided to base ourselves at Ndutu Safari Lodge, just beyond the southern border of the park. Ndutu overlooks Lake Lagarja and is the ideal place to stay for anyone hoping to see the wildebeest massed on the short grass plains during the rainy season.

On arrival we were greeted by the news that a pack of wild dogs known as the Naabi pack had recently been seen. Every scientist and park ranger, and the occupants of each and every tour bus, were questioned as to the dogs' whereabouts. But it was always yesterday, far away, over there; never here, now, just down the road. Throughout the safari, the dogs remained a tantalizing presence – phantoms of the plains, haunting us by their absence. Maybe tomorrow.

To add to our woes, many of the predators we had hoped to photograph proved painfully shy in comparison to those we had seen in the Mara. The number of tourists visiting Tanzania's parks had slumped in the wake of the border closure and for a while the sight of a vehicle had become a rare and sometimes frightening experience for the animals. Though there was an abundance of cheetahs on the eastern plains and around Ndutu, they invariably fled if we tried to approach. And a number of the Serengeti's famous leopards had paid the ultimate price for flaunting their beauty around Seronera and Lobo Lodges. Like spotted cats elsewhere they had been poached during the 1970s to meet the demands of the skin trade. Only now were a new generation of leopards beginning to

Many of the predators we had hoped to photograph were painfully shy

Wild dogs often seek the coolness of a muddy water-hole – page 15

13

emerge from the tangled thorn bushes bordering the Seronera river, to loll unconcerned along the broad limbs of a yellow fever tree. Even some of the lions appeared unusually wary.

Unlike the cautious leopard and the timid cheetah, wild dogs often fail to raise even a hint of a large bat-ear at the sound of an engine or the chatter of people's voices. It is not uncommon for them to lie up right next to the road. But this relaxed and fearless response to vehicles has cost them dearly. A number of wild dogs have been killed in recent years by drivers speeding through the park and these are losses the dwindling population can ill afford.

I should have known better than to hold out hopes of finding the dogs. They remained as elusive as ever, defying our clumsy attempts to track them down. Like the wildebeest, with whom they share the grasslands for part of the year, the dogs of the Serengeti plains are nomadic wanderers, eking out an existence in a loosely demarcated home range of approximately 1,500 square kilometres. They spend much of the day resting, often huddled together in the shade of an erosion terrace or seeking the coolness of a muddy water-hole. With their lean bodies pressed flat against the ground, or curled head to belly in tight, blotched knots in the wispy grass, they are virtually impossible to detect when resting on the plains. Each morning and evening the dogs rouse themselves to hunt, chasing across the grasslands after Thomson's gazelles or wildebeest. Except when they have puppies, they sleep rough, bedding down wherever suits them best. And at times they move and hunt during the night. Today they could be just over the rise; tomorrow some forty kilometres away.

Then one day, less than a week before the end of our safari, we left Ndutu Safari Lodge and headed north to spend the night at Seronera, in the centre of the park. We had not long passed Naabi Hill when Neil mentioned something about 'strange-looking, small, black, hyaena creatures'. I had not seen what he was referring to, and the moment passed. Probably young hyaenas, I thought to myself, and kept driving, anxious to arrive early at Seronera, as I had promised to give a talk to a group of American visitors staying at the lodge. It was only later, when the Americans happened to mention that they had seen nine wild dogs lying up among hyaena burrows, within metres of the main road, that I realized what we had missed. Neil and I just looked at each other.

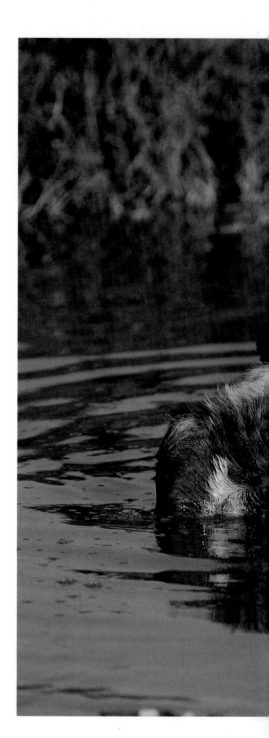

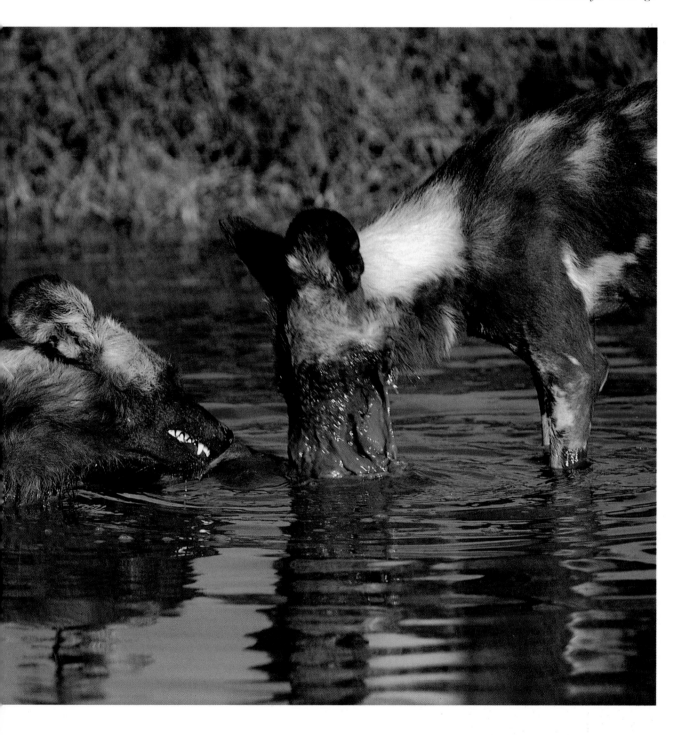

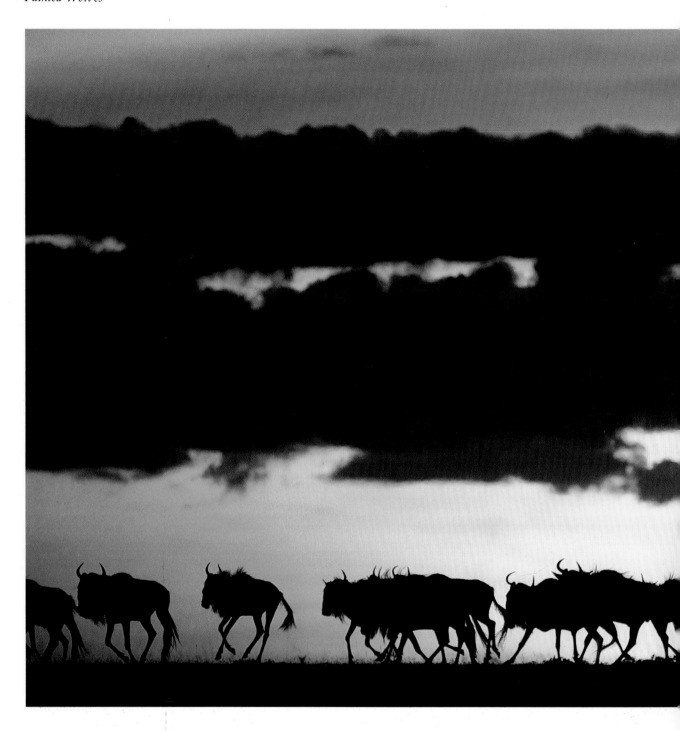

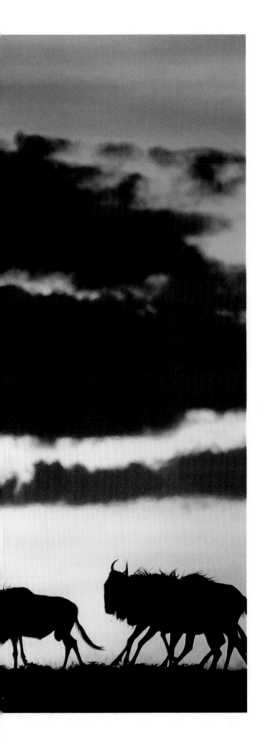

Neither of us slept much that night. I lay staring into the darkness, waiting for the first sign of dawn. After all those days and weeks of searching, of hoping, I had thrown it away. Where were they now? Sometimes the dogs stayed in an area for a few days before moving on, but more often than not they simply vanished, carried effortlessly across the plains on their slim, muscular legs. It might be weeks before they were seen again.

By first light we were already back on the plains. Our hopes soared briefly at the sight of wildebeest streaming across the grasslands – black shapes with long, bearded faces, churning up the dust, edged gold by the rising sun. Surely it must be the dogs that had disturbed them. But no. Three spotted hyaenas, winded by a long chase in pursuit of a week-old calf, were all the chill Serengeti dawn could offer us. Up and down the road we drove, scouring the area for signs of the dogs, checking and rechecking. Nothing; just a warren of empty burrows. Imagine, then, our frustration on hearing that the dogs were then seen on two out of the next three days.

Having hunted, the Naabi pack had returned to exactly the same cluster of old hyaena dens that we had driven past on our way to Seronera. This was not as surprising as it might sound. Certain resting places find particular favour with the dogs and this knowledge is passed from one generation to the next. By following one another, individual pack members eventually become familiar with every detail of their home range; some will live in the same area for most of their lives. Consequently, a wild dog pack is a storehouse of knowledge, a fund of information on the location of suitable den sites and seasonal water holes, of burrows excavated in erosion terraces and culverts set alongside roads.

Finally, our persistence was rewarded. A second group of thirteen wild dogs had been located to the east of Ndutu, in an area known as the Triangle, a place where Hugo van Lawick had often seen dogs in the 1970s. This second group was thought to have originated from the large pack of some forty dogs that had been seen in the Naabi area the previous year. They were known as the Pedallers.

We were able to follow the Pedallers for three days. During our brief encounter with the pack we struggled to distinguish one dog from another, according to age and social status. A typical wild dog pack consists of an unrelated breeding pair, who are the dominant animals, one or more generations of their offspring and some male relatives of the dominant male – usually his brothers. Often, sisters

of the dominant female are also present when a new pack is formed. These females do not usually manage to raise puppies in the presence of their dominant sister, and so they must emigrate again if they are to find breeding opportunities for themselves with unrelated males.

Before the Pedallers could vanish without trace, scientists from the Serengeti Wildlife Research Centre anaesthetized one of the males and fitted a radio-collar around his neck. With limited time and resources it would be impossible to keep track of the wild dogs on a regular basis without using radio telemetry.

We watched as the scientists debated which animal to collar. Besides the dominant female, there were a number of other adult females (either her sisters or her daughters) which would almost

A wildebeest herd fleeing from predators – in this case spotted hyaenas – page 16

The radio-collared male from the Pedallers pack searching for his relatives

certainly emigrate from the pack at some future date. This ruled them out. And even though the risks from immobilization were considered minimal, the dominant male and female excluded themselves on account of their central role in the social cohesion of the pack and as the breeding pair. All except one of the other dogs were yearlings, which meant that they were still growing and so would not be chosen. That left the sandy-coloured male. It had to be him.

The male did not even look up as the vehicle approached to within twenty metres of where he lay. He had no reason to be suspicious: cars held no fear for him. Slowly the researcher raised the long metal blow-pipe to his lips. Steadying himself, he sucked in a lungful of air, then blew hard into the mouthpiece. Thwack! The drug-filled dart curved through the air and slapped against the dog's rump, embedding itself into the muscle and discharging its contents. The dog jumped to his feet and spun around as if he had sat on a thorn or been bitten by a tsetse fly. Other pack members looked up in surprise at their relative's sudden activity. Surely it was still too early to greet or hunt?

Once the male had settled down again and appeared to be getting drowsy, we repositioned our vehicles so that the dogs would not see people moving around outside of the cars. While the radio-collar was being fitted, the dog was weighed and measured, and blood and faecal samples were taken for analysis — data that might provide clues to the reasons for the decline in wild dog numbers.

We stayed on to keep watch over the dog while it recovered, feeling its strong heart beating within that deceptively frail-looking body, helping to chase off the hyaenas which soon gathered to snoop about. Later, we listened in silence as the male called across the plains to his relatives with his mournful contact call. I thought back to that time in Botswana, all those years ago, when I had listened to the female wild dog calling from her wire enclosure, and rejoiced in the knowledge that this particular dog would soon be reunited with his pack.

Our safari to the Serengeti was over, yet we felt elated. All the long hours of searching had finally been rewarded. Before leaving we had watched the dogs hunt, though they failed to catch either the Thomson's or the Grant's gazelle they had pursued. The male Grant had run the pack to a standstill, possessing both the speed and the stamina to outdistance the dogs over a chase of nearly four kilometres. But much more exciting than any of this, we happened to be present when two of the dogs mated. A young female had led

19

the chase after the Thomson's gazelle, racing like the wind across the plains before abandoning the hunt. She turned and looked back at the rest of the pack strung out in single file behind her. As she stood there panting in the face of the breeze, the dominant male ran up and sniffed around her, then mounted. After copulating briefly, the pair remained 'tied' together, end to end, for more than two minutes. The 'tie' is a strange quirk of canine behaviour that is thought to be a mechanism to prevent another male from mating the same female before fertilization has taken place, perhaps also helping to reinforce the pair bond.

This was my first opportunity to witness the competition that invariably arises when a female other than the dominant bitch comes into oestrus. We had already identified the dominant pair in the pack – or so we thought – by watching to see which two dogs performed the 'pee ceremony'. This ritual is the prerogative of the breeding pair and involves the male dog cocking his leg to add his scent to the spot where the dominant female has peed or defecated. All the other dogs in the pack – males and females – squat when they urinate and do not attempt to overlay their scent on that of another dog.

It was sheer opportunism on the part of the dominant male that had enabled him to mate with the young female. If she had not been so swift in the chase of the gazelle, the dominant female may well have prevented them mating. As it was, the dominant female had lagged behind and was unable to do anything to influence the situation. But later she did everything within her power to stop the other female from mating again. She pushed and shoved, forcing herself between the consorting pair, even burrowing underneath them when the male tried to mount, unseating him. It was all thoroughly confusing, with dogs of both sexes interacting with each other in rapid succession. Perhaps the two females were sisters engaged in a battle for exclusive breeding rights within the pack, in which case who was the older, ragged-looking female? Surely, if she were their mother, this would never have happened. I had a lot to learn.

It was late February. I now knew that my only chance of watching and photographing wild dogs for any length of time was when a pack had small puppies and was forced to confine its activities to the vicinity of a den. With a gestation period of seventy days the Pedallers should den in mid–May. Shortly afterwards the wildebeest would depart the short grass plains to endure the dry season among

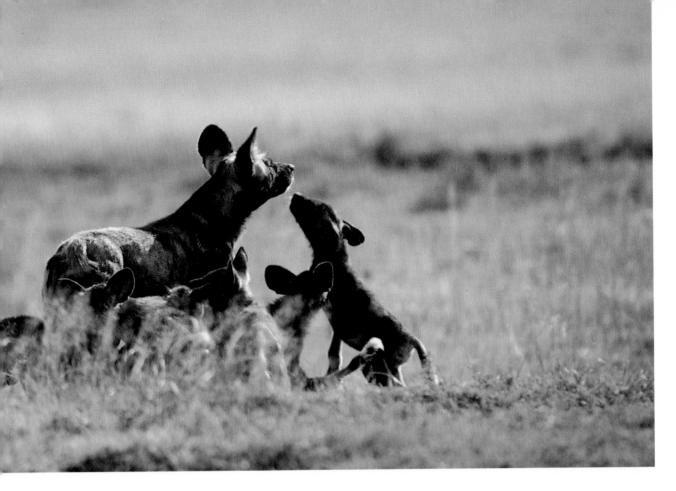

Mama Mzee, the dominant female of the Naabi pack, with a litter of puppies

the wooded grasslands in the west and north, engulfing the Western Corridor (a funnel-shaped extension of the park reaching to within a few kilometres of Lake Victoria) and Kenya's Masai Mara in a tidal wave of migratory animals: some 1·4 million wildebeest, 250,000 zebra, 14,000 eland and more than 450,000 gazelles. Nurturing wild dog puppies on the desolate dry-season plains would not be easy. It was going to be a testing time for the Pedallers.

Besides the Pedallers, the only other wild dogs known to be living on the Serengeti plains in 1986 were the Naabi pack, the same dogs that Neil and I had searched for around Naabi Hill and the Gol Kopjes. The ancestry of this pack remains a mystery as they wandered over large parts of the former home ranges of a number of packs living on the plains during the 1970s. In those days, when there were a dozen groups hunting the plains country, packs remained fairly constant to a given area from one generation to the next, though home ranges overlapped by as much as 35 per cent. Some people think that the Naabi pack are descended from the Plains pack, but with the dramatic decline in the plains population, it is quite likely that new dogs moved in from the woodlands or other outlying

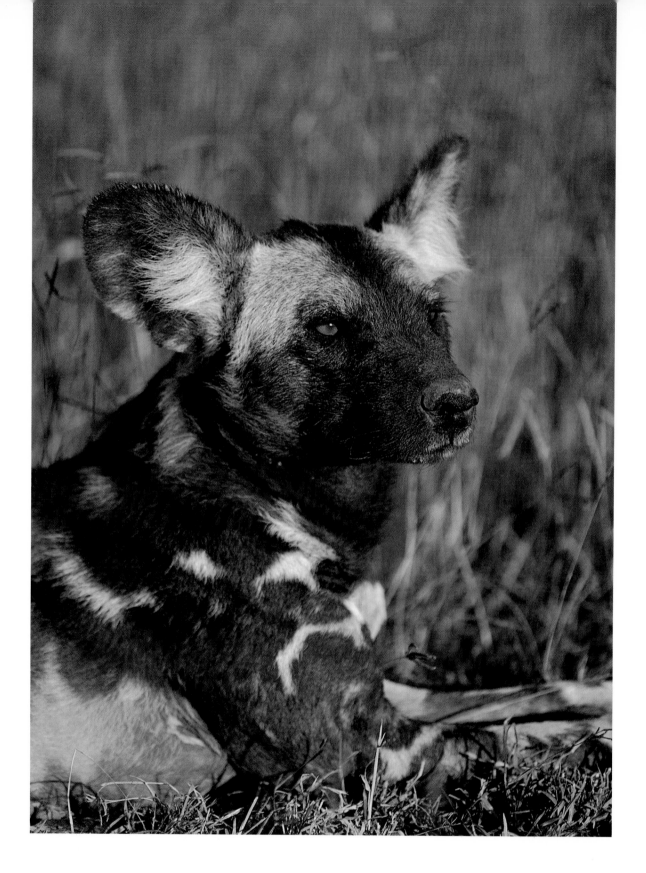

areas in the ecosystem to fill the vacuum. When Clare FitzGibbon first sighted the pack in 1985, it seemed that they had emerged from nowhere. There were three adult males, who may have been brothers, and four females, two of whom were yearlings. The two older females were probably sisters.

Usually only the dominant female in a pack breeds each year, with all the other pack members helping to feed and protect the puppies. But this is not invariable. Sometimes more than one female gives birth at the same time, particularly when a new breeding pack is being forged between a group of sisters and unrelated males. When this happens the dominant sister often tries to control or kill her relatives' puppies. Even if the puppies initially survive, the dominant female may continue to harass their mother and prevent them from obtaining sufficient food.

The Naabi pack denned in mid-March 1985 near Naabi Hill and were located again two weeks later by members of the Serengeti Ecological Monitoring Programme during the monthly radio-tracking flight. Both the adult females had produced litters of puppies. The next report of the pack was on 19 April 1985, by which time the puppies were six weeks old. Three were males and five were females. The two mothers had denned twenty metres apart. Quite what happened to the subordinate female's puppies remains a mystery, though it seems likely they were killed; they never emerged from their den. The dominant female – known as Mama Mzee ('Old Mother' in Swahili) – was seen carrying a dead pup in her mouth; another lay dead on the ground nearby.

In January of the following year the female whose puppies had been killed, together with the two younger females, emigrated from the pack. By this time three of the eight surviving puppies had also disappeared. They were still too young to fend for themselves and must have died of disease or been killed. Tourists reported seeing two dogs – probably large puppies – lying dead on the road. All the signs indicated that they had been run over by vehicles.

In April 1986 Mama Mzee produced a new litter of puppies on the plains between Naabi Hill and Gol Kopjes. Only three puppies were ever seen: a female and two males. These all survived and I stayed with them for a number of weeks in May and June that year. But my mind was on other dogs. Anxiously I awaited word of the Pedallers in the hope that they would produce a sizeable litter of their own. I already knew that the young female I had seen mating in February

Mama Mzee was distinguished by a necklace of white markings on her throat and chest

had failed to conceive. But just before I left for Nairobi to resupply with film, fuel and other essentials, John Fanshawe told me that an aerial search for the Pedallers had been successful. The dogs had been found to the north of Lemuta Hill. John felt sure that they had denned.

Things could not have been better. The den was situated close to a pool of water in an area of great scenic beauty just inside the Ngorongoro Conservation Area, bordering the eastern edge of Serengeti – the kind of place where I had always hoped to find wild dogs at a den. In the distance loomed a huge fig tree, colourfully known as 'the tree where man was born', a spectacular shady retreat out on the sun-burnt plains, used by all manner of creatures. Birds of prey, fruit bats and swarms of bees at times shared its leafy sanctuary. It was thought that the puppies were still too small to appear above ground but would undoubtedly be visible by the time I returned. Was this to be the moment I had waited for? Would there be a large litter of puppies to watch and photograph?

Two weeks later I was back in Serengeti. 'They are all dead,' said John, in response to my excited inquiry as to the dogs' well-being. My heart sank. All dead. The sense of anticipation that I had harboured for the last two and a half months evaporated with his words. I knew that the adults would immediately resume their nomadic wanderings now that they were free of dependent puppies. There would be no hope of following them for more than a day or two at a time, if that.

But the full implication of what John had said to me had still not sunk in. It was not just the puppies. The adults were dead too. They were *all* dead. At one stroke the wild dog population of the Serengeti plains had been halved. What, I wondered, could possibly have precipitated such a disaster at a time when the dogs seemed to be enjoying a minor revival on the plains?

Neil and Joyce Silverman happened to be visiting the Serengeti at the time of the dogs' death. They had generously donated funds to assist in the monitoring of the dwindling wild dog population after Neil's visit in 1986. On hearing that the Naabi pack was accompanied by puppies, and that the Pedallers were denning, the Silvermans had decided to return. As nobody had yet been out to see the Pedallers, Dr Markus Borner, coordinator of the monitoring programme in Serengeti, took the Silvermans on a flight to make sure the dogs were still near Lemuta. They were.

When they landed back at Seronera, the Silvermans rushed off to tell John and Clare the good news. Together, they drove to the den site. Clare was delighted to find the area surrounding Lemuta alive with Thomson's gazelles. Now she would be able to collect plenty of data for her study on gazelle anti-predator behaviour, the subject of her doctoral thesis. John too was excited. One of his main reasons for coming to Serengeti had been to observe wild dogs. He was compiling a report on the dogs in the Serengeti for IUCN's Canid Specialist Group, an appraisal of species threatened with extinction.

On first arriving at the den site, nothing seemed to be amiss, though only four of the thirteen adult dogs could be seen. Not until one of the dogs tried to get to its feet did they realize something was terribly wrong. Some of the dogs were already dead, their remains scattered around the den and a nearby waterhole. Vultures, hyaenas and the dogs themselves had picked the carcasses clean. Two of the four survivors could barely rise from the ground. When they tried to walk, they floundered about on wobbly hind legs before keeling over, thin, emaciated wrecks. It was as if some awful plague had struck the entire pack. It sounded all too familiar, a re-enactment of the scene I had witnessed ten years earlier with the dying Aitong pack in Masai Mara. Both the Pedallers and the Aitong pack shared their range with nomadic pastoralists. Perhaps they had contracted a contagious disease from Masai dogs or even been poisoned.

The healthiest of the four seemed to be the radio-collared male, though he too was painfully thin. At one point, he went over and greeted one of the other dogs, apparently trying to rouse it from its lethargy. But it was too weak to respond. As if to add a macabre touch to the depressing scene, one of the dogs walked past with the front leg of a dead companion clasped in its mouth. A few metres away three small puppies lay huddled together just inside the entrance to a shallow burrow. They were all dead.

The following day, the Silvermans returned with a veterinary surgeon from Arusha who happened to be visiting Seronera Lodge. Another of the dogs had died during the night, so an autopsy was hurriedly performed. Samples of tissue and blood were taken from the corpse and antibiotics administered to the three remaining dogs. The vet felt sure that they had survived whatever disease had wiped out the rest of the pack and were now simply starving to death.

It was June and the long dry season was with us once again. The

The dry season begins towards the end of May, forcing the wildebeest to desert the short grass plains –
page 26

25

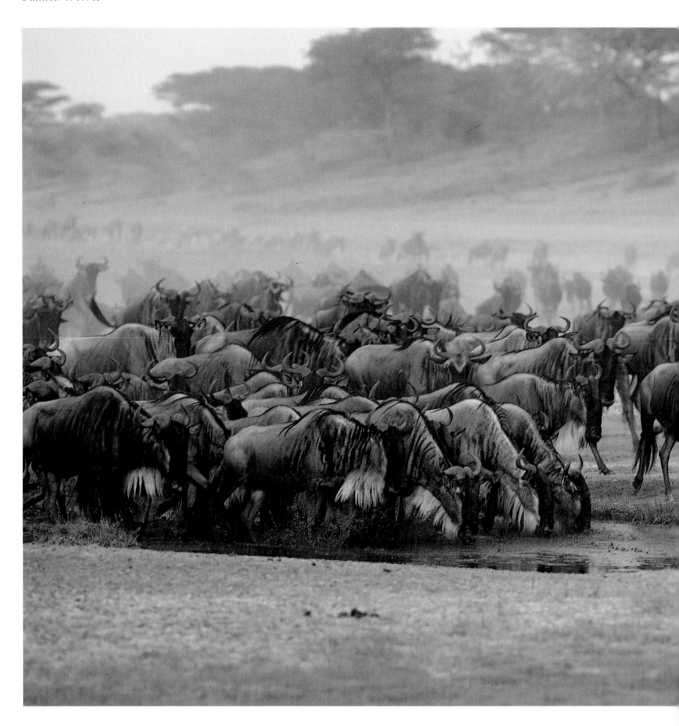

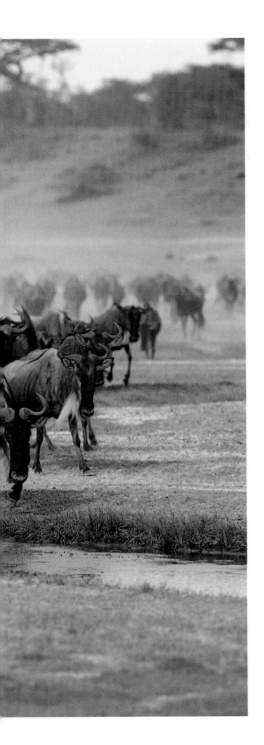

migratory wildebeest had already deserted the eastern plains for greener pastures. There was still an abundance of gazelles in the area, but to hunt them takes all the speed and stamina that even a healthy wild dog can muster. Wild dogs do not possess the powerful forelimbs and sharp, retractile claws that allow the solitary leopard to catch hold of its prey before killing it with a single bite to the throat. The dogs generally rely on the cooperation of other pack members to secure and kill their prey; their hunting efficiency is a reflection of their highly social way of life.

On a number of occasions after a long chase, with predator and prey having run themselves to the point of exhaustion, I had witnessed a single wild dog forced to abandon its efforts due simply to lack of numbers. Just as the dog closed to within catching range, the gazelle would execute a series of space-gaining zigzags – sharp, life-saving turns performed with precision timing. Without other dogs to help corner the gazelle the solitary hunter might be forced to go hungry. Similarly, a lone dog often failed to capture a wildebeest calf when faced with the belligerent defence of its mother. And even if it was successful, a dog sometimes found it difficult to open a carcass quickly and was unable, on its own, to defend its kill from any hyaenas attracted to the scene. The last of the Pedallers were surely doomed.

In the light of the vet's comments, it was debated whether permission should be sought to feed the remaining dogs. This is a controversial issue that always raises more questions than answers. Should one interfere with natural events within the sanctity of a National Park: was it fair to sacrifice gazelles to try and save the dogs when nature had already cast its vote? But what if the Pedallers were dying from a disease introduced by domestic dogs? Would it not then be appropriate to exercise a degree of management and do whatever possible to redress the balance? In the end it was impractical even to try.

And the females, where were they? At the time of the disaster, three young females – one of which Neil and I had seen mating earlier in the year – had been in the process of emigrating from the Pedallers. But it seemed that they too may not have escaped infection. A friend from Kenya reported seeing three female wild dogs barely a few kilometres from the den site. He said they looked in a terrible state. With the Serengeti's wild dog population already depleted, it could only be hoped that they had died, or were no

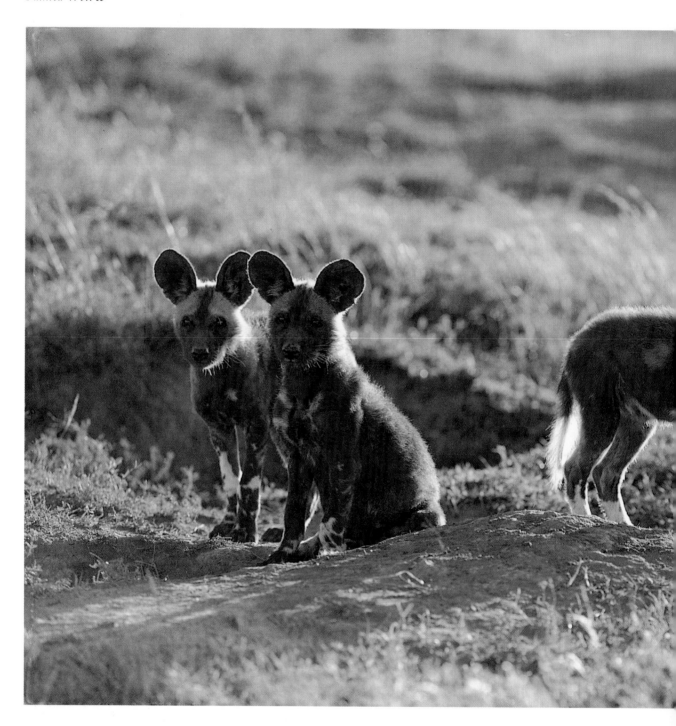

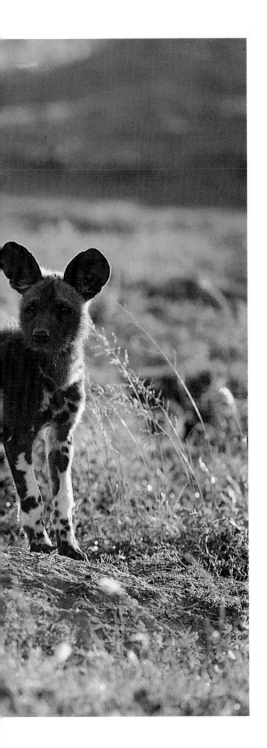

longer infectious, before making contact with healthy males from another pack.

Tests for canine distemper and rabies proved negative, though both diseases are often difficult to confirm in the laboratory. Poisoning by Masai pastoralists was also ruled out. Some weeks later, a scientist from the Research Centre found the hyaena-chewed radio-collar worn by the male. It was the only remaining evidence that the Pedallers had ever existed.

Watching the scientists attach the radio-collar to one of the Pedallers back in February, I had shared their joy at the knowledge that they now had a means of maintaining permanent contact with a second pack of wild dogs. Yet I remember feeling acutely conscious of the intrusion into another animal's life – the risk of death, however small, in the name of science. But now I knew that radio telemetry was the only feasible method presently available for obtaining regular and reliable information on such far-ranging species as wild dogs. Without a radio-collar we would never have known of the Pedallers' ultimate fate; we would not have discovered that they had denned or that they had been wiped out. It is essential to find out as much as possible about the wild dogs, particularly with regard to the role of epidemic diseases in regulating their numbers. We need to know how far they range, and what happens to them when they move beyond the protection of the park and come in to contact with man. Only then might we be able to help in their struggle for survival and atone in some small way for our past prejudices.

Everything seemed to be against the wild dogs. Public opinion still branded them as outcasts, disease continued to hold their population well below optimum levels and densities of competing predators helped prevent their recovery. I despaired of ever seeing a really large pack of wild dogs forty or fifty strong – the kind people said was commonplace during the first half of the century. What hope was there if the dogs could not survive here in some of the finest game country in Africa? It seemed that the wild dogs had reached crisis point. The years of persecution had taken their toll. Having been reduced to a fraction of their population by the early years of this century, the dogs were succumbing to the same relentless pressures that have doomed the last tribes of nomadic Indians in North America and the Amazon basin – loss of habitat, introduction of

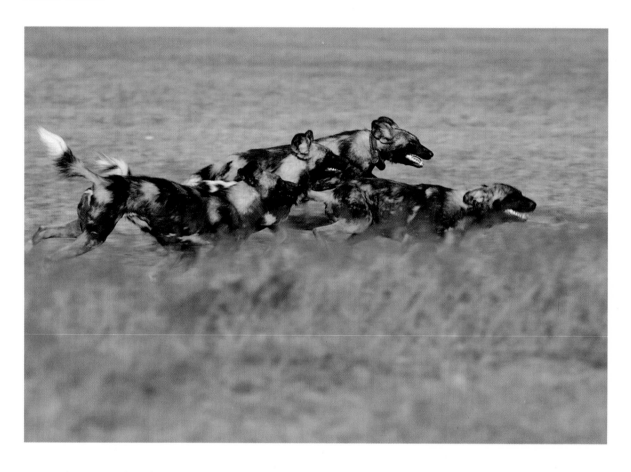

exotic diseases and competition from more powerful competitors.

The eclipse of the Pedallers meant that the Naabi pack was alone on the plains. Mama Mzee's small litter of three puppies had all survived. Even though they were now of an age at which they no longer needed the security of a fixed abode, the pack chose to remain in the vicinity of the den for the next few months. Here at least they could shelter from the heat, and there were still enough gazelles on the surrounding plains to sustain a pack with so few puppies. But once the Naabi dogs resumed their nomadic existence, it would be pointless for me to try to follow them. I could only hope that Mama Mzee would produce a new litter of puppies early next year during the rainy season. Until then I would follow the vast herds of wildebeest on their year-round migration.

The yearling females who emigrated from the Naabi pack in early 1987

The average wild dog litter in the Serengeti is ten puppies. But in 1986 Mama Mzee had only three, two males and a female, pictured here at ten weeks of age – page 28

The Departure of the Females

JANUARY–FEBRUARY 1987

The English philosopher Alfred North Whitehead, writing about human inquiry into the nature of the universe, said that in simply discussing the issues, the merest hint of dogmatic certainty is an exhibition of folly. This tolerance for mystery invigorates the imagination; and it is the imagination that gives shape to the universe.

The appreciation of the separate realities enjoyed by other organisms is not only no threat to our own reality, but the root of a fundamental joy. I learned from River that I was a human being and that he was a wolf and that we were different. I valued him as a creature, but he did not have to be what I imagined he was. It is with this freedom from dogma, I think, that the meaning of the words 'the celebration of life' becomes clear.

Of Wolves and Men, BARRY HOLSTUN LOPEZ

31

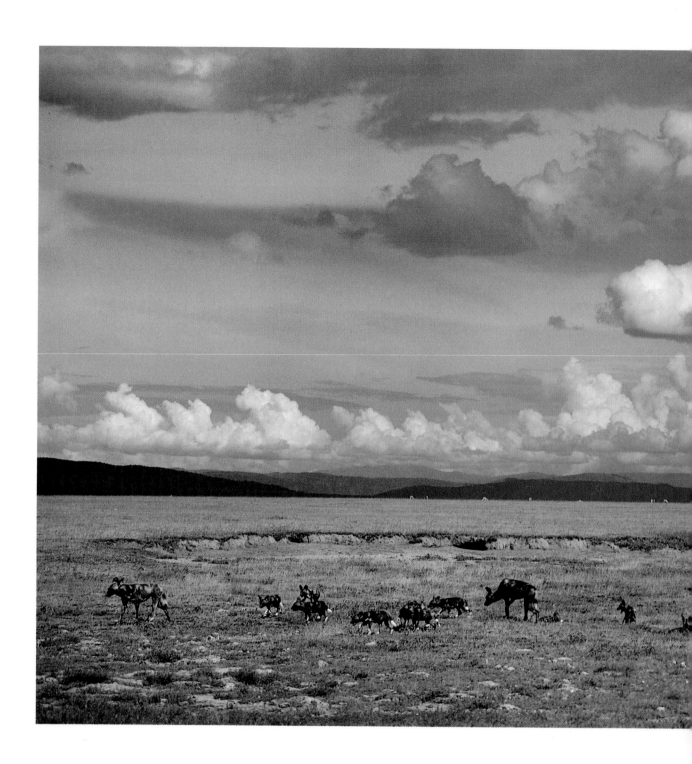

32

There are certain places in the Serengeti that have always been considered good wild dog country. Places where the dogs can compete most effectively against hyaenas and lions for food, and where they can successfully rear small puppies. The animal-covered plains of the rainy season surrounding Barafu Kopjes and the Lemuta valley are one such place: a beautiful stretch of country at the eastern edge of the park. It was here, in January 1987, that Mama Mzee gave birth to another litter of puppies.

The pack had been located from the air during the monthly radio-tracking flight. John Fanshawe then drove to the spot where the dogs had been seen to confirm that they had denned. He watched as Mama Mzee entered the den, describing in his letter to me the excitement he had felt on hearing the sounds of young puppies below ground. Unfortunately, John was unable to wait long enough to see the puppies emerge, as he was due to depart on a visit to England, but before leaving he drew me a map pin-pointing the den site.

The den was situated on the open plains, four kilometres south of Barafu Kopjes, barely half an hour's drive from where the Pedallers had died. Until now Barafu – meaning 'ice' in Swahili – had been just another name on the map to me, a cluster of seven rocky outcrops lying some forty-eight kilometres east of Seronera. But later, when I reached the place, I realized that I had chanced upon it while searching for wild dogs in 1986. Barafu provided a welcome barrier to the icy north-east wind which sweeps down across the plains day and night from the Loliondo Hills.

Painted Wolves

The site chosen by Mama Mzee was perfect – a shallow burrow set in the span of an erosion gully within metres of a green-fringed pool of water. The rains had been generous these past few weeks. Often the dogs would chase madly through the shallow pool after returning from a hunt, or lie and absorb the soothing coolness of the muddy water during the noonday hours. They were surrounded by prey: gazelles in their thousands, parties of zebra and vast herds of wildebeest, all drawn to the easterly plains by the lush carpet of fresh green shoots.

For their first three weeks, Mama Mzee's puppies remained safely below ground. At birth wild dog puppies are tiny, almost naked, creatures, weighing 400 grams, with eyes tightly closed. Their most frequent contacts with the outside world are regular visits from their mother, providing them with essential warmth and succour. In fact Mama Mzee spent 80 per cent of her time inside the den. The dominant male was in no doubt as to whose corner of the Serengeti this was, cocking his leg to pee around the den entrance. On occasion, both the adults and yearlings – to the accompaniment of excited whimpers – crowded around the entrance of the burrow, vying for the chance to poke their head and shoulders into the darkened environs inhabited by the puppies.

Mama Mzee kept a watchful eye on the other dogs, particularly the yearlings, jealously guarding her brood from the risk of injury during these early days and helping to create a strong bond between herself and the new litter. When scolded, the yearlings acted in a solicitous, appeasing manner, licking their mother's face and nuzzling her milk-laden breasts.

Mama Mzee looked very different from the other adults in the Naabi pack. Wild dog litter-mates show a greater similarity of coat markings than non-litter-mates, but the old female's only sister had emigrated again once Mama Mzee had fully asserted her dominance in 1985. She was a small dog, with the litheness of whippet, dwarfed in comparison to Shaba, the dominant male, and his brother Scruffy, who were of course unrelated to her. Mama Mzee's face was rather short and narrow and her throat and chest were distinguished by a necklace of white markings. But more than anything it was her self-assured bearing that set her apart from the others. As the dominant female she was the focus of attention, controlling much of what happened around her, exuding confidence. You could feel her presence, and so could the other members of the pack. When Mama

The 1987 den site at Barafu. In the background are Lemuta Hill and the Gol Mountains – page 32

34

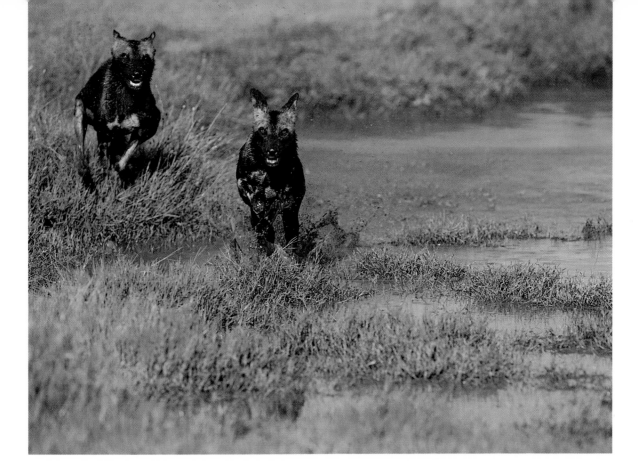

Wild dogs love nothing better than to play in pools of water. In the foreground is Mama Mzee

A den is rarely left unguarded while puppies are vulnerable to predation. Mama Mzee is lying down, together with the three yearlings and her puppies – page 36

Mzee decided to do something, the other dogs invariably followed her lead.

By the end of the second week, perhaps even earlier, the puppies' eyes opened, and a week later, with some gentle coaxing from their mother, they were ready to appear above ground for the first time. I sat listening to the squeaky whines of the puppies as they milled about in the mouth of the den, but I dared not move closer for fear of disturbing the pack. I could hardly contain my excitement as I waited for them to emerge.

It has long been thought that hyaenas are one of the major factors in depressing the wild dog population in the Serengeti by stealing their kills and killing puppies. A recent ground survey of predators yielded a staggering figure of 4,000 spotted hyaenas. An adult hyaena in the Serengeti weighs approximately 45 to 55 kilograms, according to sex, and – unusually among mammalian species – the females are larger and heavier than males, outweighing them by 5 to 10 kilograms. A hyaena is therefore twice the weight of a wild dog and looks bulky and ungainly in comparison to the svelte athleticism of their smaller rivals. It is certainly true that hyaenas are the most numerous and successful of all the Serengeti's larger predators, yet

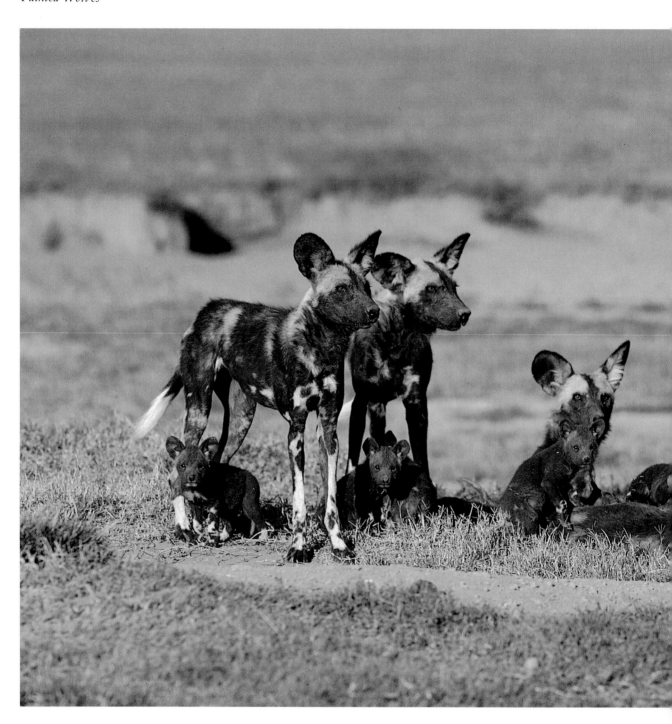

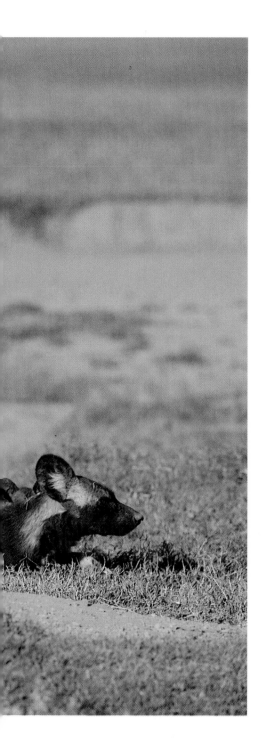

watching the Naabi pack interacting with hyaenas made it quite clear that as a group the dogs were formidable opponents. Nobody, to my knowledge, has ever documented seeing hyaenas killing wild dog puppies, yet it is mentioned as a cause of mortality in nearly every scientific paper published on the dogs. The hyaenas' influence appears to be exercised more through competition over food than direct predation on puppies. But by denning during the rainy season, when there is an abundance of food for all the predators, the dogs ensure that competition with hyaenas is at a minimum.

Allen Reich, who studied wild dogs in the Kruger National Park in South Africa, reported that hyaenas constantly harass resting dogs, especially at night, and may even attempt to catch young puppies. But adult wild dogs are very protective towards their young and under normal circumstances a den is rarely left unguarded while puppies are small enough to be vulnerable to predation by hyaenas. As parents of the litter, Mama Mzee and Shaba were particularly vigilant, but all the dogs in the Naabi pack were related to the puppies and therefore invested time and effort in warding off potential danger. Any hyaena – or even lion – rash enough to wander in the direction of the den site while there were adults present was liable to receive an unpleasant reception.

Whenever a hyaena trespassed beyond an invisible threshold approximately 200 metres in radius from the den, the dogs – invariably led by Mama Mzee – would advance like a war party. Off she would trot, with the rest of the pack responding to her lead. Heads held low and thrust menacingly forward, ears pressed flat against their necks, backs slightly hunched, tails horizontal, the dogs would move towards their adversary.

At first the bulky, bear-like creature might stand its ground, seemingly perplexed by the sight of the tightly bunched phalanx of dogs bearing down on it, uncertain what to do next. But any indecision was soon banished as the dogs surged towards the hyaena at a furious gallop. Effortlessly Mama Mzee or Shaba closed in behind the fleeing hyaena, accelerating to within biting distance, nipping at its heels, slowing it down. As the rest of the pack caught up, the confrontation degenerated into a scene of controlled violence and intimidation, heightened and accelerated by the frenzied 'yipping' of the pack. Daily, the plains reverberated with the sounds of battle.

The dogs were like picadors, taunting and terrorizing their heavier

rival with well-aimed ripping bites to rump and neck. The hyaena would spin like a top, lunging from one side to another, from a sitting position, as it vainly tried to protect its vulnerable backside. But, as always, the dogs worked as a team, orchestrating their assault to maximum effect, exhausting their victim with its own futile attempts to defend itself. As the hyaena turned to face one attacker, other dogs would close in behind it to deliver a tearing bite.

Throughout these encounters the hyaena would bellow a coarse, grating roar of defiance, exposing a row of teeth capable of snapping a dog's thighbone with a single, crunching bite. But this never happened. The victim was too intimidated to retaliate effectively and fearful of precipitating an even more brutal response from the pack. Within minutes the hyaena's thick fur oozed red. Its only chance of escape was to reach the relative safety of an underground retreat. To be seen running from the dogs did not appease them; rather, it goaded them into action. Sometimes a hyaena might try to escape by seeking refuge against, or even under, my car. Standing there, cowed but defiant, face taut in an ugly grimace, it would snarl, first at the car then at the dogs, waiting until they lost interest.

The dogs reserved the most brutal treatment for adult hyaenas. Younger animals were usually, though not always, spared, having appeased the dogs with an array of cringing, submissive, gestures similar to those used by the dogs themselves to inhibit aggression between pack members. Adolescent hyaenas were probably tolerated by the dogs in these circumstances only because they acted rather like puppies.

Some evenings an old female hyaena visited the water-hole near the wild dog den to drink and wallow. The hyaena was a member of a thriving clan that had established a communal den at an erosion terrace two kilometres away. She was a particularly large animal with tattered ears and a wall eye which stared wildly from her battered face. I had seen Mama Mzee chase this particular hyaena before. On that occasion the rest of the pack were almost on her before she had time to turn and flee. The old hyaena seemed confused, and for a moment I wondered if she was almost blind. Slowed by her size and age, she had no chance of escape.

A few days later I watched the dominant pair approach the water-hole together to drink. As they walked through the long grass on the far side of the pool, up popped the distinctive shaggy head of a large hyaena. It was the old female again. She acted submissively, not

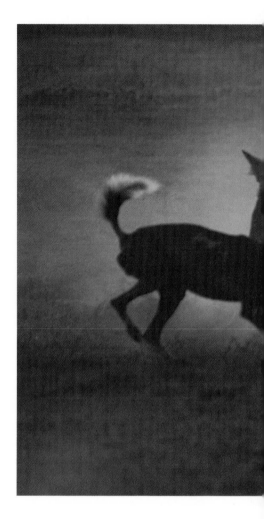

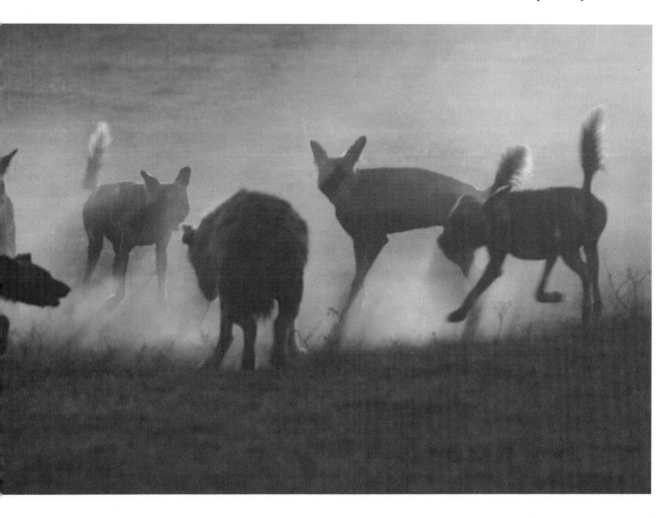

By working as a team, wild dogs are able to prevail against larger rivals, in this case a spotted hyaena

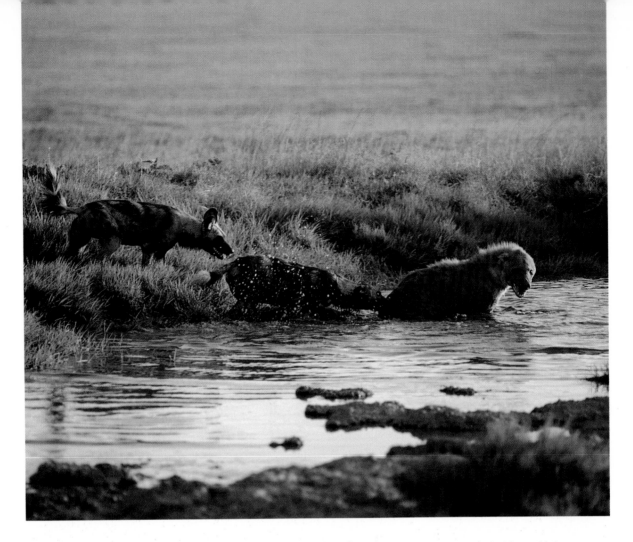

daring to flee, and surprisingly the dogs chose to ignore her, busying themselves drinking. They were barely two metres apart. After the dogs had returned to the den the hyaena got to her feet and ambled off. I watched her depart through my binoculars, thinking that perhaps the dogs sensed that she was not a threat to the puppies. But such sentimental thoughts soon vanished. Her backside was torn and bleeding and it was obvious that she had received a severe beating earlier that morning, perhaps eventually seeking refuge in the water. To the dogs, any hyaena which dared to venture within the vicinity of the den was considered a potential threat. There is little room for compassion between the predators, only vigilance.

There were occasions when other hyaenas responded to a clan member's howls of distress, emerging whooping from the shadows of their resting-places with tails cocked. But this seemed only to arouse the dogs to greater efforts, and they attacked first one then another of the new arrivals. Having clearly asserted their dominance over their heavier rivals, they trotted back to the puppies. Before

When attacked by wild dogs, hyaenas sometimes seek refuge in water-holes

long every hyaena in the area knew the consequences of wandering too close to the wild dog den.

Not even lions were allowed to breach the sanctity of the den area. When a band of nomadic males strolled across the plains towards the dogs, the dogs leapt to their feet, gruff-barking in alarm. The lions stopped and stared with the implacable gaze of predators conditioned to dominating smaller rivals at a kill. But protecting puppies was far more important to the pack than defending a carcass. Shaba and Scruffy led the way, trotting out to where the lions stood watching, leaving Mama Mzee hunched over the entrance to the den. Before long the lions were hurrying on their way, trailed by a line of dogs until they disappeared beyond the kopjes.

A yearling male dog harassing a nomadic male lion that ventured too close to the den

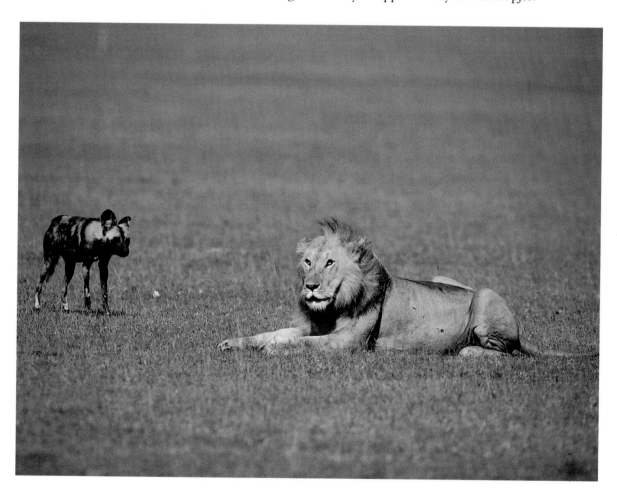

Besides Mama Mzee there were five other females in the Naabi pack, all of whom were her daughters. Four had been born in March 1985, the other in April 1986. Wild dogs are almost fully grown at one year of age and sexually mature by eighteen months. To breed, normally a dog must first achieve dominant status, as it is the dominant pair in each pack which monopolizes breeding, with all the other pack members helping to raise the litter. Female wild dogs do not breed in their natal pack, except perhaps if their mother has died. Suppression of breeding activity in other pack members by the dominant animals is achieved by a combination of behavioural and physiological mechanisms. Subordinate females often fail to come into oestrus due to the subtle day-to-day stresses imposed by the dominant female. This ascendancy over female relatives by the dominant female is most easily and completely accomplished between a mother and her daughters. But prohibiting a sister from breeding often requires the ultimate deterrent of infanticide. When another female in the pack tries to raise a litter, the dominant female is liable to attack her and kill the puppies. Non-breeding females therefore emigrate to search for unrelated males from another pack. In the process, they help to prevent inbreeding.

Among mammals generally, it is the males that disperse, but wild dogs are an exception. The male puppies remain for longer in their natal pack as adults, helping to feed and protect their younger relatives. The loss of opportunity to reproduce for themselves is offset by the fact that they are increasing the puppies' chances of survival. This is known as kin selection, a means of 'benefiting copies of the helper genes in his relatives' bodies'. Theoretically, the more closely related you are, the more willing you should be to help one another. In a pack of wild dogs, brothers of the dominant male sometimes manage to mate with the dominant female. Therefore the possibility of mixed paternity cannot be ruled out, providing an even greater incentive for these brothers to stay and help. Even if they do not manage to sire a litter, they still share a quarter of their genes with the offspring of their dominant brother. The younger generations of dogs in the pack are in all probability full siblings of the puppies and therefore share one half of their genes – that is, they are as closely related to the puppies as they would be to their own offspring. Cousins share an eighth of their genetic heritage with each other, and so on. It was this that led the geneticist J. B. S. Haldane to make his famous pronouncement that he would

lay down his life for two of his brothers or eight of his cousins.

In certain circumstances, male wild dogs do emigrate to form new breeding packs – availability of food would be one factor influencing such a decision. With a single female capable of producing large numbers of young each year, eventually the number of adults in a pack begins to strain resources. In a pack with a well-established breeding pair, the brothers of the dominant male often stay, perhaps because as the next most senior males they already sometimes manage to mate with the dominant female, to whom they are unrelated. As time passes the original brotherhood of males is weakened through the inevitable injuries and diseases that may lead to their death. These older dogs are soon outnumbered by successive generations of closely bonded younger males, who can afford to leave as a group and search for females of their own or may even one day challenge for dominance.

The best time for wild dogs living on the plains to emigrate is during the rainy season, which usually begins in November and ends in late May or early June. The rains herald the season of plenty for all the animals in the Serengeti. It is the optimum moment to breed, with an abundance of food for both predators and prey. This is when the wildebeest migration reaches out across the southern plains in a tidal wave of 1·4 million animals. Within the space of a few weeks during February and March, approximately 400,000 buff-coloured calves are born into the herds. Not surprisingly, it is during the rainy season that the plain's packs have most success in raising puppies, and the majority of litters are born at this time. It is also the season that provides most support to small groups of females wandering in search of mates. When they leave – usually during their second or third year – females depart as a group, capable of hunting for themselves.

Not long before Mama Mzee gave birth at Barafu, the four female litter-mates began to show signs of mounting independence. Each evening after the pack had hunted and the night had closed in around them, the dogs lay down to rest. It did not have to be a special place, such as a familiar erosion terrace or dense clump of *Indigofera* – anywhere on the open plains was home to the Naabi pack. But it was evident that the four females were restless. Life was no longer simply a question of finding enough food. Their bodies were telling them to move on, to venture beyond the familiar landmarks of Barafu, Gol and Naabi. It was time to breed for themselves, to sever the ties that

Gol Kopjes. Kopjes, or inselbergs, are granite outcrops, hundreds of millions of years old – page 44

43

had, until now, kept them as part of the pack. There was no chance that they would be able to raise puppies in the presence of their mother.

Leaving the security of the pack which has helped nurture it to search for a mate is the beginning of the most stressful chapter in the life of a wild dog, with a subsequent increase in disease and mortality. Yet to reproduce, to pass on one's lineage, is a priority for any adult. The decision of when to leave is probably the result of a combination of factors: the inhibiting influence of the mother, pack size, food availability, density of wild dogs in the surrounding areas and sudden appearance of unattached males might all play their part. So might the arrival of a new litter of puppies. I had seen for myself how both Mama Mzee and Shaba jealously controlled access to the puppies during the first few weeks of their lives. It is a period of considerable tension within the pack, and the puppies soon started to demand regurgitated food from all of the adults, regardless of sex or status. If there was a good time for the females to leave, then surely it must be now.

At first when the Naabi females wanted to go off at night, the rest of the pack followed – albeit reluctantly. Why keep moving when your belly was full, at a time when you just wanted to huddle together for warmth against the chill Serengeti night? The pack was losing some of its cohesion. Bonds that had been forged since birth, binding adults and young into a close-knit social unit, were about to be ruptured. Knowing that the four females were likely to emigrate, John and Clare radio-collared one of them so that they could continue to monitor her movements. By the time I arrived at Barafu the females were on the verge of departing.

That evening I followed the pack as they set off to hunt, watching as they chased and killed a male Thomson's gazelle. Having finished eating, the dogs returned to the den, leaving the four females and their brother Spot – the five survivors of Mama Mzee's 1985 litter – chewing on scraps from the kill. When they had finished eating they trotted off towards Lemuta, in the opposite direction to the den. By next morning Spot was back with the older dogs, but his sisters were nowhere to be seen. Five days later I awoke to find one of the young females, known as Liz, returning with the pack from their morning hunt. Liz was the easiest of all the dogs to identify because of the saddle of pure white hair astride her back. She was obviously

distressed at being separated from her sisters and gave the 'hoo' call repeatedly. Unlike Spot and the three younger dogs, for the moment Liz showed no interest in the puppies. Instead she just kept trotting around, sniffing the ground and staring off into the distance, searching for clues to the whereabouts of her sisters. Perhaps she had become separated from the others while hunting and had returned to the den only in the hope of finding them here. It was certainly preferable to hunting alone. Finally, she settled down and I departed for the shade of one of the Barafu kopjes to await the evening hunt.

From out of the stillness a dog stirred, moved by an inner sense of time. It was almost 5.30 p.m. Spot opened his eyes and sniffed the coolness of the late afternoon air. Glancing to his left he recognized the familiar presence of his sister Liz lying in the long grass a few metres away. On the other side, one of his two yearling brothers had also chosen this moment to look up. With forepaws flopped on to his chest and black lips pulled back in a grimace of pleasure, Spot began to squirm and wriggle, pumping his hind legs in a bicycling movement which enabled him to scratch his back and shoulders against the bone-hard ground. After a few seconds of this he stood up and shook himself, causing his large, rounded ears to slap noisily against his face and neck, releasing a cloud of powdery earth into the dry air.

At two years of age Spot was already fully grown, weighing eighteen kilograms. He was slightly larger than his younger brothers but not as thick-set as Shaba and Scruffy, the two oldest males in the pack, who weighed between twenty and twenty-five kilograms. Spot looked around at the other dogs – his father and mother, brothers and sisters, his uncle Scruffy – all scattered about him at the edge of the pool. Each of the dogs looked different, and each responded to him differently according to their age, temperament, mood and status in the pack.

Spot stretched, lowering his forequarters and arching his bottom. He yawned, displaying a fearsome array of forty-two sharp white teeth, starkly profiled by his black gums. When he opened his eyes again he saw his younger brothers – the two yearlings – running towards him, ears pressed flat against their heads.

To say that the two males were running towards Spot does not adequately describe the way they approached their older brother. Their bodies seemed to writhe as they trotted shoulder to shoulder towards him. Suddenly the grass was alive with sound and

Liz was the easiest of the dogs to identify because of her saddle of white hair

Scruffy, the dominant male's brother, being greeted by one of the yearling males – page 48

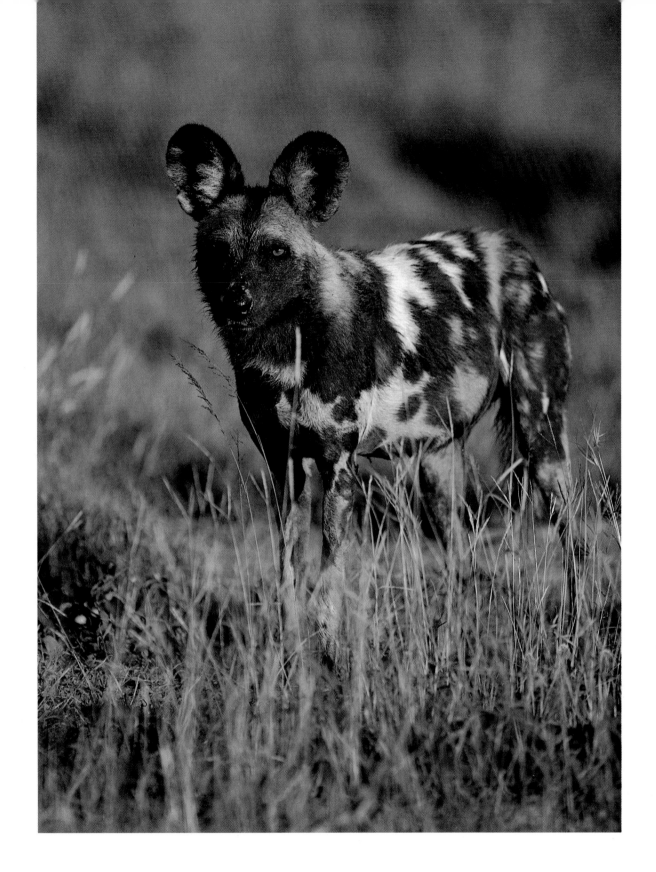

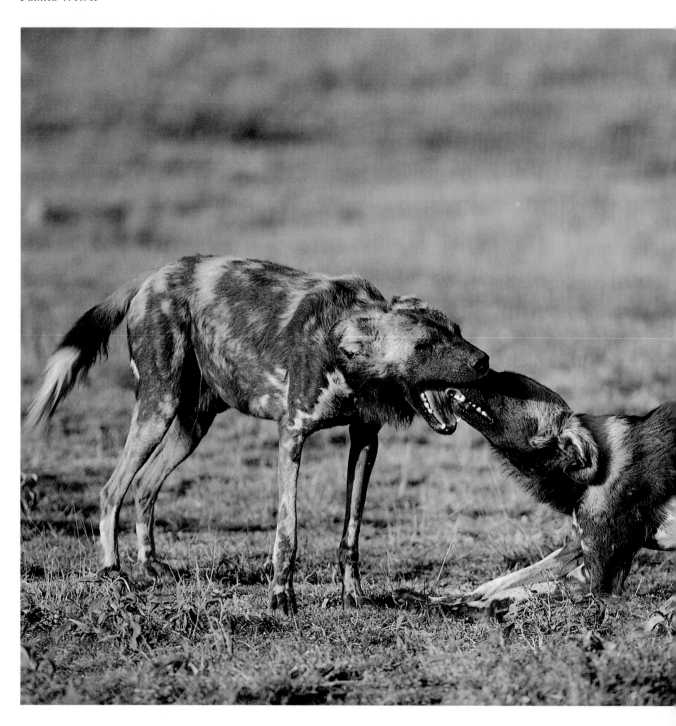

movement. Dogs were running everywhere, peeing and defecating, joining together in twos and threes, then separating, thrusting their noses into another's open muzzle, lapping into mouths and licking at each other's faces, milling around like the swirling of the wind – all yittering in a frenzy of excitement. No one was ignored as the members of the pack greeted one another. Sometimes a dog would pause and look around, searching for a particular individual. It was obvious that the dogs knew when one of their number had escaped their attention.

The 'greeting ceremony' of a pack of wild dogs is a sight worth waiting for. They perform this ritual each morning and evening prior to hunting. Their behaviour is like that of puppies: a ritualized form of food begging and appeasement. The ceremony is explicitly friendly in nature, an unambiguous and exuberant reaffirmation of the strong social bonds forged between pack members. It has been likened to a 'pep rally', helping to focus the individual's attention on the cooperative task of procuring food. It also serves as a 'head count', acknowledging to the pack any dogs which might be missing or are sick. And it clearly marks their presence in an area with a highly odoriferous 'scent site' where they have peed and defecated. Sometimes a bout of greeting erupts which does not seem to be tied to any particular activity, as if the dogs are just saying, 'Hello, it's good to see you.'

Shortly after the pack had greeted, Liz trotted off in the direction of Barafu Kopjes, drawing the others in her wake. But when the skies opened and it started to rain the whole pack retreated once more to the shelter of the erosion terrace surrounding the den. Later, after the rain had ceased, they set off to hunt. First they tried to catch a zebra foal, though without success. Harassing the zebra herds had become a daily ritual for the pack since the wildebeest had drifted away to greener pastures.

A cursory glance suggested that the zebra foal was part of one enormous herd comprising hundreds of individuals, but a closer looked revealed that it was possible to distinguish individual family units among the confusing array of black and white stripes. Each family consisted of a number of females and their young, accompanied by a mature stallion who vigorously guarded his charges against the wild dogs and hyaenas of the Serengeti plains.

Despite the belligerent presence of the stallions the Naabi pack seemed drawn towards the zebra herds, partly due to the exuberant

and highly amateurish efforts of the three yearlings. At one year old the younger dogs were still only learning what to hunt, ready to pursue virtually any animal that appeared over the horizon, regardless of size or suitability. But the three older males showed little interest in getting involved with the zebra. The behaviour of a pack of wild dogs is a reflection of its hunting environment, adapted to the species of prey most readily available within its particular home range. Each new generation of adults learns from the more experienced pack members how best to tackle different kinds of prey. The Naabi pack had no previous history of hunting zebra and was patently at a loss to know how best to deal with them.

Trying to isolate one of the foals meant braving the flailing feet and lethal bite of the stallions. Packs that regularly hunt zebra usually contain a number of adult males which have perfected the highly dangerous art of leaping up and grabbing a zebra by the upper lip – without getting bitten. Only then is it possible for the rest of the pack to anchor the prey and kill it. The packs that Hugo van Lawick watched hunting zebra generally killed foals or mares, which tended to tire more quickly than the stallions. On one occasion Scruffy did briefly manage to penetrate the tightly packed ranks of adult zebra and latch onto the leg of a very young foal, pulling it to the ground. But the stallion immediately came charging to its offspring's rescue, dropping to his knees and slashing at Scruffy with razor-sharp incisors, forcing him to release the foal and flee.

The use of a lip-hold is by no means confined to wild dogs. Wolves in North America use this hold when attacking moose; farmers control bulls by putting a ring through their noses; and horse trainers sometimes fasten a 'twitch' on the upper lip of a difficult animal to steady it. David Mech, in his book on the Arctic wolf, reported that 'laboratory rats that are grabbed by the nose have increased levels of morphine-like brain hormone that may calm the animal and serve to minimize pain during traumatic times – an advantage for both the predator and the prey'. Certainly any extremity, such as tail, ear or nose, is safer than trying to grab a running animal by the hide, and helps the dogs avoid the hooves of their prey.

Male wild dogs are generally 10 per cent heavier than females, with larger heads and necks, thicker throat ruffs and broader shoulders. Invariably, it is the males which secure prey with the lip-hold and reach up and grab an animal by the throat to strangle it.

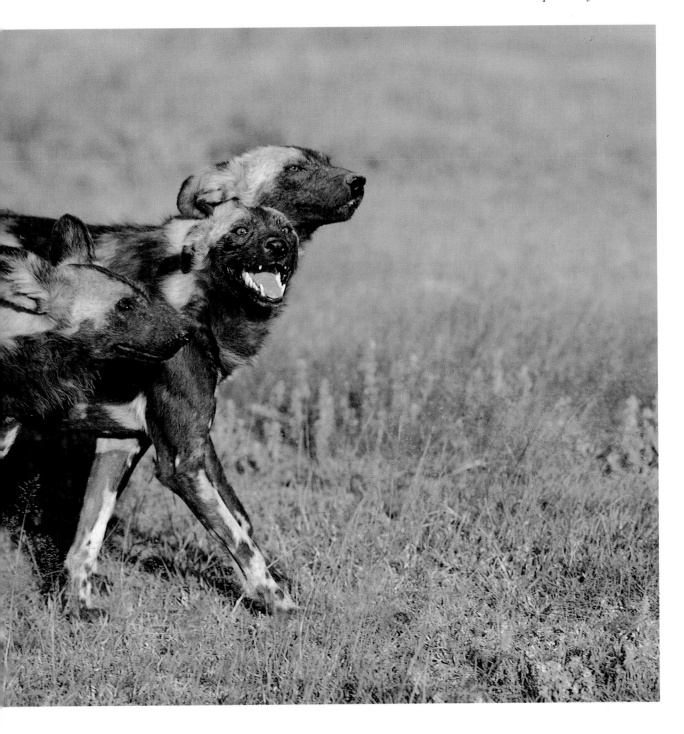

Physically, they are better suited for this strenuous role, which enables other pack members to disembowel the prey more easily and begin feeding quickly. But females are quite capable of applying these holds for themselves when hunting in groups without males. The lack of marked sexual dimorphism between male and female wild dogs is in stark contrast to lions, where the much larger males have to fight to defend a territory, and the lionesses do most of the hunting. In wild dog society serious fights among adult males are rare and both sexes are required to play their part in all group activities, whether hunting, sharing food or helping to rear puppies.

On this particular evening – as was often the case – the Naabi pack soon abandoned the zebra herds in favour of the Thomson's gazelles. The 'Tommies' produce the majority of their young during the rainy season. The fawns' only real protection on the short grass plains is the colour of their coat and their stillness, as they try to avoid detection by resting with their chins to the ground in a posture of concealment.

The Naabi pack sometimes spread out as they trotted along, keeping a sharp lookout for fawns as they passed through. Once flushed, the youngest of these fawns were invariably killed by the dogs, making an important addition to their diet. Very occasionally the dogs surprised an African hare, squatting, ears flat, among the clumps of vegetation. Recovering from the explosive departure of their quarry, some of the dogs would give chase as the hare streaked for the safety of the nearest burrow. But the returns from such quarry are small: hares weigh less than two kilograms and usually manage to avoid capture. It was generally only the yearlings that bothered to invest much energy in racing after one of these slippery customers, though the chase did allow them to sharpen their skills for the more serious business of hunting adult gazelles and wildebeest.

During the pursuit of a territorial male Thomson's gazelle, Liz and one of the yearling males became separated from the rest of the pack. Under the circumstances I thought it likely that she would continue alone to wander in search of her sisters. But by dawn Liz was back at the den. Every ten minutes or so during the next three hours she 'hoo' called, and that evening, after the pack had hunted, she started to call again.

I lay in bed and listened as Liz called into the still night air. It is said that a human being can hear the call of a wild dog from a distance of

The greeting ceremony is performed prior to hunting. On the left is Scruffy, on the right is Spot, and in the middle of the yearling female – page 51

three or four kilometres, so perhaps her sisters would hear her. I strained my ears, listening for a reply, but there was none. The moon rose full and ripe, casting a ghostly light across the plains. Then, far away, I felt sure I heard them answer. Or was it just a gentle sighing of the wind? Liz never moved. I could see her standing there, clearly silhouetted in the moonlight, lowering her head to the ground and calling, over and over again.

I awoke next morning to find the pack lying in a huddle, trying to shield themselves against the brisk dawn air. Mama Mzee had only just emerged from the den when I noticed her stiffen, her keen eyes fixed on three dark shapes approaching from Barafu. At first I felt sure they must be hyaenas. What else would make the old female stand and stare with such obvious vigilance? She advanced a few paces, then froze mid-stride, muzzle pushed forward. Back went her large, rounded ears and up came her white-tipped tail until it pointed directly backwards. A ripple of alarm passed from one dog to another. It was like a whisper, barely audible, unseen. The whole pack looked up, directed by Mama Mzee's unflinching gaze.

I watched through binoculars as the three female wild dogs drew closer. They looked apprehensive, as if unsure of how their relatives would receive them. For the moment they were outsiders. Now they were trotting, pressed so closely together that it was difficult to single them out. Suddenly they were galloping, their strides perfectly matched, eating up the ground like hunters returning from a kill. You could feel the energy. Closer and closer they came, sweeping past their mother amid a frenzy of excited yittering. It was a madhouse, a riot of activity that quickly dissipated the tension created by their dramatic reappearance and dissolved memories of their absence.

Liz and Spot – siblings and age-mates of the three wanderers – were particularly excited by the reunion, for theirs was a relationship of a special kind. The bonding of litter-mates, so essential for their survival, is clearly evident in every pack of wild dogs.

Even though fully integrated into the pack as adults, litter-mates spend more time interacting with each other than with younger or older dogs; they huddle together when resting and play together when active. There is added strength in being part of a group within a group, of forging an alliance between age-mates – particularly those of the same sex – with whom you may later emigrate.

Long after the puppies and adults had settled down to rest, the four

sisters and their brother continued to erupt into renewed activity. They gambolled and frolicked about, careering between the pool of water and the den, revelling in one another's company.

Questions sprang into my mind. Why had the females returned to their natal pack? Had they found life too difficult on their own? Were three females too few? Perhaps they had returned to reclaim Liz, not just as a fourth sister to bolster their number but as one of the swiftest hunters in the pack. Or had they simply left without first ascertaining the existence of other wild dogs and then found that there were none? Without hope of creating a new pack, was it in the females' own interest to remain as members of a larger pack and help to rear their younger relatives?

Previously, groups of emigrant females in Serengeti had separated from their natal pack never to return. But that was at a time when there were more dogs with which to form breeding packs. In trying to make sense of the lives of other animals there is always a tendency to categorize and generalize, to simplify everything into 'norms'. But there is invariably greater flexibility in the behaviour of animals than is at first apparent and than is suggested by generalizations. Lions and hyaenas, cheetahs and leopards, jackals and wild dogs – all are capable of adapting to changed circumstances, of behaving differently, according to their environment. There are no absolutes.

That evening a herd of wildebeest appeared from the south, the first I had seen in the area for two weeks. But there were no calves or yearlings to prey on, so after stirring up the dust in the wake of the fleeing herd the dogs lost interest and continued on their way. As they crested the rise they saw ahead of them the familiar bear-like shape of a large hyaena.

Quite how the hyaena came upon the male Thomson's gazelle was a mystery; the gazelle was still fresh and looked in good health. There were no visible signs of injury and nothing to suggest that it had been killed by the hyaena. With 35,000 vultures and numerous predators willing to act as scavengers, it was something of a rarity to find a gazelle that had died of disease or natural causes in the Serengeti and was still untouched. Hyaenas do chase and kill adult Tommies, though their greatest success in preying on this species is in finding gazelle fawns 'lying out' on the open plains.

Hyaenas are endowed with large muscular necks, enabling them to carry off sizeable portions of food. On seeing the dogs rushing towards it, the hyaena grabbed the gazelle in its powerful jaws and

ran. But the hyaena was no match for the dogs in a high-speed race across the plains – even without its burden. The moment it felt the first bite on its hind leg the hyaena dropped the carcass and fled.

Within a few minutes the pack had torn the gazelle apart. The dogs were obviously very hungry, because having stripped the carcass of meat they headed south again. Mama Mzee and the puppies would have to wait before they received their share of the food. It did not take long for the dogs to find more wildebeest. Four of the dogs – the females – quickly singled out a yearling from the herd and, after a long chase, finally succeeded in pulling it to a halt. Meanwhile, just over the rise, the rest of the pack was struggling to subdue a cow wildebeest. She was fiercely defending herself, hooking at any dog bold enough to try and face her.

It was unusual for the Naabi pack to attempt to kill an adult wildebeest. A cow weighs about 150 kilograms – roughly seven times the weight of the average wild dog. At this time of year, when so many of the cows were giving birth, the pack could invariably find a calf or yearling, rather than risk being tossed or skewered on the sharp points of an adult wildebeest's horns. But the cow was heavily pregnant, that was the difference. A few more days and her calf would be born. When the herd had turned and fled, the cow had been a pace or two slower than the others. The dogs recognized that this particular animal was vulnerable. As one, they sliced across the plains towards the pregnant cow, ignoring all the other animals. Within half a kilometre she was left stranded in the dust of the fleeing herd.

Normally the cow could have deterred the pack from pressing home their attack, lashing out with her sharp hooves whenever a dog tried to grab her leg or tail, forcing them to abandon the chase and try for easier prey. Instead her stamina deserted her; she was exhausted, her strength gone. Only a stubborn will to survive kept her going.

The dogs kept a sharp eye on each other as they raced after their prey. They worked together as a team, adjusting their stride to match the cow's, sapping her energy, running the pace from her legs. Each time she veered to the left or right, one of the dogs would spurt forward and head her off. As she ran, the cow swung her head from side to side so as to keep watch on her pursuers. She could see Shaba and Scruffy closing on her flanks; she could hear the dog's high-pitched yips of excitement; she could feel the other members of the pack snapping at her heels. One last time the cow tried to force

Scruffy using the lip-hold to immobilize a wildebeest cow, allowing the rest of the pack to begin feeding immediately – see page 57

herself forward, to break free, but the race was over. This was the moment the dogs had been waiting for; the cow had run herself to a standstill.

Scruffy leapt forward and grabbed the wildebeest by the upper lip. Bracing himself, he pulled backwards as hard as he could, sucking in air through clenched teeth. The cow stood, gasping for breath, staring into the dark eyes of the wild dog as the rest of the pack quickly closed in around her and began feeding.

This is the kind of kill that has turned people against the wild dogs. The six dogs were enough to anchor the cow but not to kill her quickly. There was no malice, no aggression on the part of the dogs. The fact that what they were eating was still moving, still alive, had no meaning to them. It simply made their task more difficult. To the wild dogs it was food, that was all – sufficient to feed each and every pack member and the puppies.

On this occasion the dogs had an audience besides myself. They had dragged the wildebeest to a halt within 100 metres of a large hyaena den. The bellows of the dying wildebeest, interspersed with the excited yipping of the dogs, soon alerted the hyaenas to the prospect of a free meal. Seven large heads popped up from a dozen burrows set in the side of the erosion terrace. Younger hyaenas raced for cover, alarmed by the sudden commotion around them.

For the moment the dogs ignored the hyaenas. They were far too busy trying to eat now that they had finally dragged the cow to her knees. This was quite different from the way lions feed. Lions, the only truly social members of the cat family, snarl and growl, aggressively defending their position around a carcass, lashing out at other members of the pride who dare to trespass at their feeding site. Once the prey is dead it is every lion for itself. The dogs, however, show little sign of aggression when feeding. There is neither growling nor biting. The dogs gulp down whatever they can tear most easily from the carcass. They bolt their food rather than fight over it.

As the light drained from the sky the hyaenas began to circle. '*Whoo-oop . . . whoo-oop . . . whoo-oop.*' The dogs looked increasingly nervous, glancing over their shoulders as their adversaries pressed still closer. Now there were nineteen of them, bolder and louder by the second. The noise was incredible: a cacophony of drawn-out moans and staccato grunts. Up went the hyaenas' tails as they charged forward aggressively, cackling and howling, a fierce

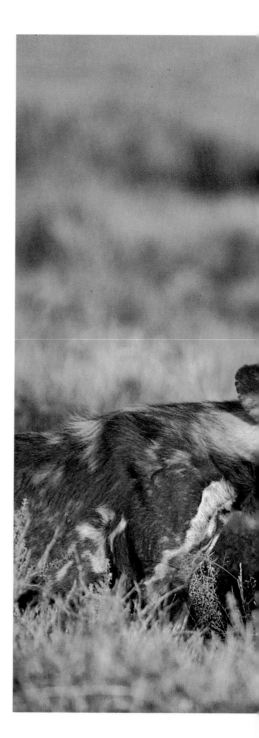

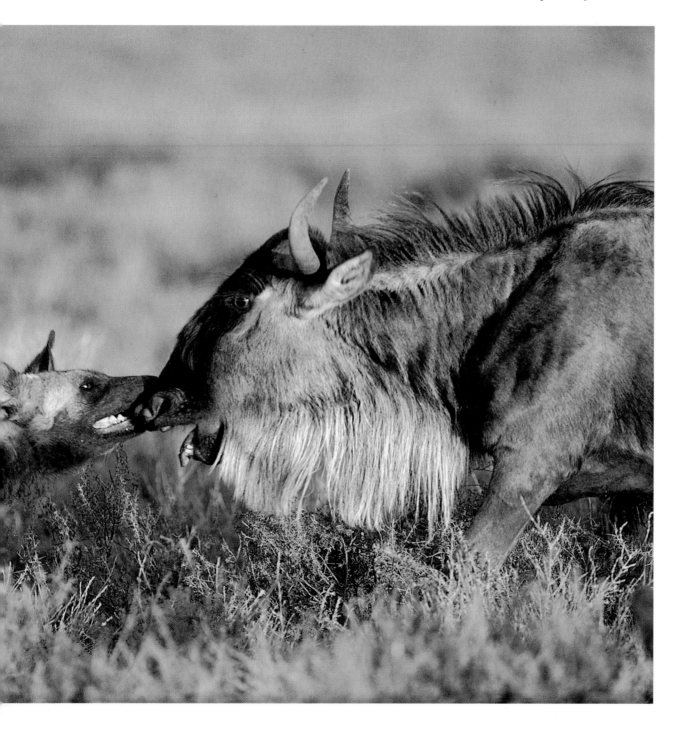

press of blood-drenched bodies thrusting and wrenching, tearing apart the carcass with their powerful, bone-crushing jaws.

The dogs slipped soundlessly away. They knew when to fight and when to run. By the time I found my way back to the den the hunters had long since regurgitated food for Mama Mzee and the eleven hungry puppies. I marvelled at the efficiency of the dogs' methods. By carrying food in their stomachs they were able to deliver large quantities of meat directly to the puppies without the risk of losing it to lions or hyaenas, or attracting them to the den.

The dogs lay resting around the entrance, at peace in their world. But when I counted the adults, I could find only seven. Liz and her three sisters had failed to return. Once again they had chosen to strike out on their own.

By chance I met the four Naabi females late the next evening, not far from where the cow wildebeest had died. They were being chased by a gang of hyaenas, though I could see no sign of a kill. The hyaenas looked particularly belligerent and the dogs were decidedly nervous. Relationships between different predators are complex affairs, based on past encounters, numbers of each species present and how hungry they are. Quite why the hyaenas should take the initiative to chase and mob the wild dogs when there was no food to contest was a mystery, though the dogs had passed quite close to the hyaenas' den. Perhaps they sensed that the four females were vulnerable and decided to emphasize their dominance while the opportunity presented itself. The females certainly showed none of the boldness that I had come to expect from watching the Naabi pack.

Despite their speed in the chase, life for Liz and her sisters was going to be very different now that they were on their own. Out on the open plains you can see for ever: there is no cover to conceal the hunter from the gaze of its competitors. The sight of gazelles stotting or wildebeest churning up the dust is guaranteed to arouse the interest of every predator for kilometres around. With only four dogs to defend a kill, the Naabi females would always have trouble keeping the more numerous hyaenas at bay.

It seems unlikely that the females ever again intentionally tried to make contact with Mama Mzee and the Naabi pack. There must have been occasions when the two groups of dogs saw one another, or found signs of the others in passing, but there was no reason now for them to take any further interest in each other, for their needs

were different. Soon the Naabi females started to venture beyond their natal range, striking out into new country, moving south to the wooded grasslands of the Maswa Game Reserve and west to the rugged Moru Kopjes. Each month their position was pin-pointed from the air, and on each occasion hopes were raised that they might have forged a successful union with unrelated males. But as the months passed our worst fears were confirmed. With the loss of the Pedallers there were no other wild dogs available to create a new breeding pack on the plains. For the moment the Naabi females must continue their search.

Barafu Kopjes

FEBRUARY–APRIL 1987

The Serengeti plains . . . are endless and they are empty, but they are as warm with life as the waters of a tropic sea. They are webbed with the paths of eland and wildebeest and Thomson's gazelle and their hollows and valleys are trampled by thousands of zebra. I have seen a herd of buffalo invade the pastures under the occasional thorn tree grove and, now and then, the whimsically fashioned figure of a plodding rhino has moved along the horizon like a grey boulder come to life and adventure bound. There is nothing, as far as you can see, or walk, or ride, except grass and rocks and a few trees and the animals that live there.

West with the Night, BERYL MARKHAM

60

I stayed with the Naabi pack at Barafu throughout February and March of 1987. I already knew and could easily recognize each of the seven adults from watching them the previous year. The three puppies born then, a female and two males, were now one year old and almost fully grown, though still exhibiting the boisterousness of young animals. All of the dogs were different, not just in terms of coat colour but also of character. Each day I found new fascination in their social activities.

Trying to make head or tail of the eleven tiny puppies was quite a different matter. I had never seen puppies so small. When they first appeared at the mouth of the den they were about three weeks old and had just begun to cut their teeth. They were tiny, pug-faced individuals with floppy ears, the largest weighing about one kilogram. Their coats were a rich chocolate-brown colour with white spots and blotches, most noticeably on their legs. And just emerging in the dark parts of the fur were the first hints of patches of pale brown.

The puppies were still rather unsteady on their feet and looked dwarfed in the presence of the adults. Mama Mzee presided over their world with all the fussiness of a broody old hen, confining them to within a metre of the entrance to the den. The slightest noise or sudden movement sent them tumbling over each other in their hurry to regain the safety of the familiar darkened burrow. When suckling her young, Mama Mzee often stood in the ramp-like mouth of the den, legs spread wide to accommodate the eleven puppies clamouring to reach her twelve teats. By standing like this Mama Mzee could keep a watchful eye on the surrounding plains, and the puppies could

Painted Wolves

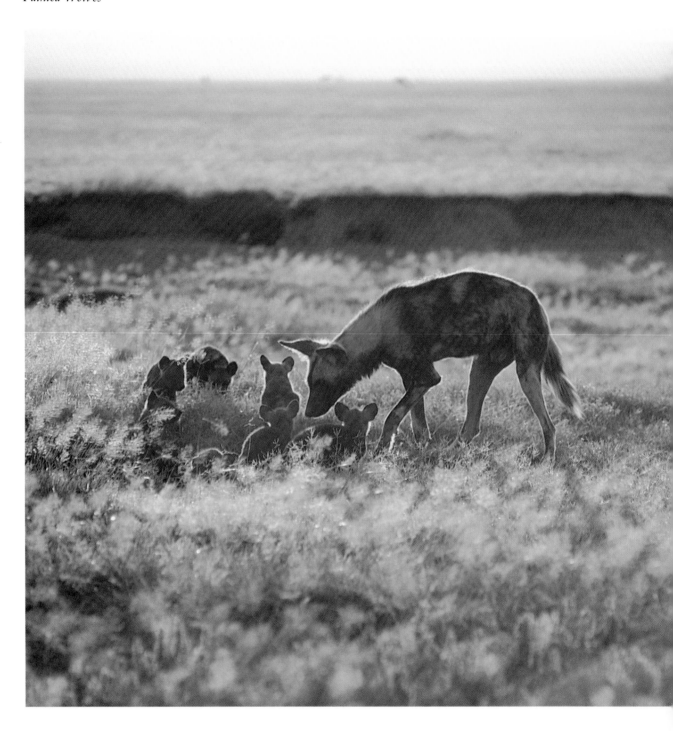

62

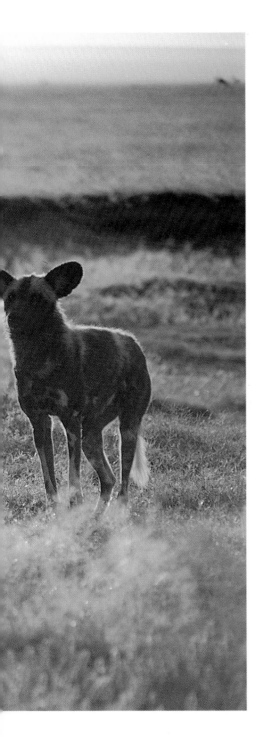

suckle for two or three minutes at a time without actually leaving the safety of the den. At the first hint of danger, one or other of the adults would gruff-bark, causing the whole pack to leap to their feet. In the twinkling of an eye the puppies would vanish.

Initially the puppies were too young for me to distinguish them on the basis of an individual's character; their behaviour seemed to be identical. And facially they looked the same: there were no unique patterns of markings on their faces, such as help to distinguish individual cheetahs or leopards; no rows of the whisker spots which can positively identify one lion from another. So I switched ends, as I also wanted to know the sex ratio of the litter: how many were males, how many females. Each puppy had a different pattern of markings on its bottom. Some had patches of white, others were unmarked. All had white tips to their tails, though some had more white than others. And some of the tails were distinguished by one or more dark spots in the white areas, or showed variations in the proportions of the black and brown bars in their tails. After a few days of frustration and numerous sketches, I could tell them apart. Six were females and five were males.

It is impossible to know the true sex ratio of a litter of puppies in the wild, as they do not emerge from the den during their first two or three weeks of life. Those that perish during this period disappear unrecorded. Even accepting this limitation, reports that there is a bias at birth in favour of males are not supported by figures from the Serengeti and Mara in recent years. Totals from sixteen litters born to seven packs were sixty-six males and seventy-three females, an approximate sex ratio of 1:1.

People have speculated that female wild dogs give birth to more male puppies because breeding packs generally contain many more adult males than females. We now know that the reason for this imbalance in numbers is that young males generally remain longer in their natal pack, while females always emigrate. The mortality of females emigrating is higher than that of males staying, and the ratio of males to females in the adult population is approximately 2:1.

One's senses become numbed by the vastness of these treeless Serengeti plains. They seem to run on for ever. No wonder the Masai called this land '*siringet*', meaning an extended place. I can think of nowhere else on earth that captures more truly this sense of limitless space than the plains beyond Barafu Kopjes. You drive and

drive, setting your sights to the east, yet it feels as if you will never reach the far-off shores of the Gol Mountains. Tall and rugged, they stand out like a mirage on the plains, ever retreating, creating a distant backcloth to the country surrounding Barafu. Beyond the Gols – a rough-shod two-hour drive away by road – are the remote, dark-blue shapes of the Crater Highlands. But it is the plains that linger in one's memory.

So it was as if I had awoken from a dream the first time I saw the wooded valley of Soit Le Guresoi, a southerly offshoot of the Ngare Nanyuki lugga (lugga means an intermittent watercourse), as refreshing to the eye as discovering a pool of clear water in a desert, or feeling the first hint of a gentle breeze on a burning hot day. Soit Le Guresoi is an oasis of umbrella-topped trees, thornbush and water, a secret place concealed within a deep fold of the rutted skin of the southern plains. Only in places such as this, on steep and rapidly leached slopes, can trees prosper. Elsewhere on the plains, the alkaline soils are underlain by a concrete-hard layer of calcium carbonate that prohibits all but the shallowest-rooted grasses from flourishing. The grasses found here are adapted to heavy grazing, yielding a higher ratio of leaf to stem than the taller grasses which sustain the wildebeest during the dry season in the wooded grasslands to the north and west. It is these more nutritious grasses, rich in calcium and protein, that have lured the great herds back to the Serengeti plains each rainy season for more than a million years.

The weathered floor of Soit Le Guresoi is pockmarked with a chain of shallow pools. The waters sparkle in the sun, reflecting the colours of clear blue skies and golden evenings, inviting the wandering herds of wildebeest and zebra to pause and drink as they trek across the thirsty plains. Far from deterring the animals, the highly alkaline waters may benefit the great herds, helping to provide an additional source of calcium for cow wildebeest during the stressful months before and during lactation.

It was here that I would sometimes find lions waiting to ambush the migratory herds or would pause to watch as a cheetah mother cautiously led her newly emerged cubs from one of the thickets. The wrinkled bark of some of the trees bore the deep imprint of claw marks, where a leopard had struggled to drag its kill to safety, out of the reach of lions and hyaenas. A wealth of smaller creatures inhabited the sparse cover of the thorn bushes: caracals and dik-diks, banded mongooses and puff adders – all surrounded by a sea of grass.

These puppies are about five or six weeks old. Puppies first appear above ground at three weeks of age – page 62

A four-week-old puppy begging for food from one of the yearling males – page 65

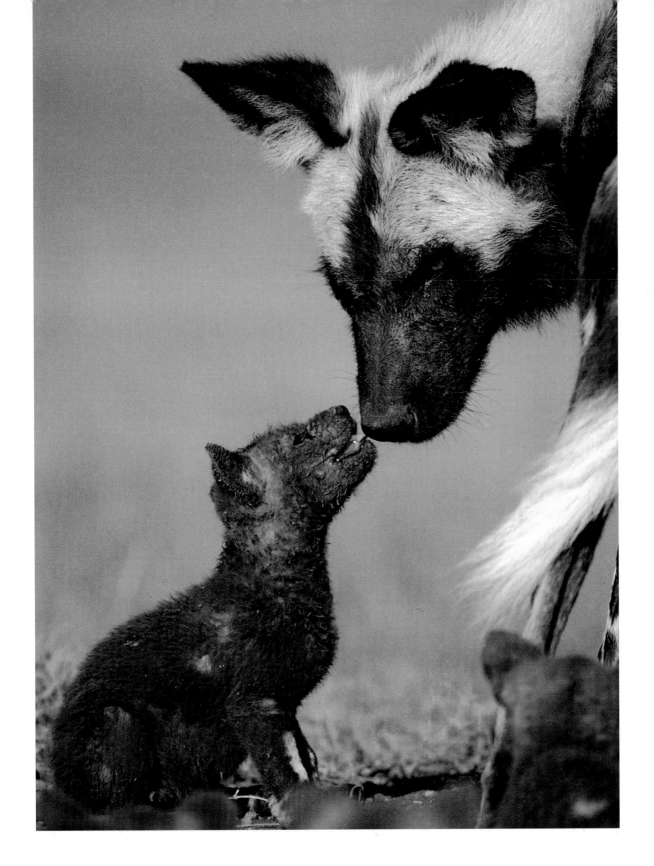

By early February the bulk of the migration had departed for the Gol Kopjes, where rain had fallen a few days earlier. Soon the plains around Barafu looked empty. As the wildebeest disappeared over the western horizon, I remained with the wild dogs. I had smashed the front spring of my vehicle, causing it to gouge a hole in the chassis. This would be a minor misadventure under normal circumstances, but when friends arrived with the spare spring I had stored at Ndutu Safari Lodge, it proved to be the wrong size, designed to fit a petrol Landcruiser while mine was a diesel. Fortunately, I was able to call on the help of an experienced bush mechanic and he made light work of improvising a means of fitting the oversized spring.

I gritted my teeth as the vehicle laboured uncomfortably over the scarred landscape, conscious of the strain our makeshift arrangement was putting on the damaged chassis. I drove to the largest of the seven kopjes and climbed to the top. Looking out at an angle to the sun I could see dozens of tracks carved deeply into the ancient grasslands. In places the ruts threaded across one another, creating a maze of pathways. But the majority of tracks followed a similar direction, highlighting the general trend of the migration as it passed from west to east and back again each year, pausing only where the herds stopped to slake their thirst at Soit Le Guresoi and at the seepage line at the base of the kopjes.

For the moment not a single wildebeest was to be seen within kilometres of Barafu. The great herds of wildebeest and zebra rotated around these pastures each year, never staying too long in any one part, always on the move, following the rains. At least I had the dogs to watch while waiting for a new spring leaf to arrive from Nairobi. There was no way I was leaving, even for a day, while I had the opportunity to fulfil my ambition of observing the Naabi pack and its puppies.

The dogs had already departed by the time I awoke next morning. The sun burst briefly above the horizon then vanished among a wall of cloud. There was no sign of the puppies, but I decided to stay at the den and wait for the adults to return. It was pointless searching for them at this hour. They would undoubtedly have hunted and were probably already on their way home.

The surroundings of the den looked glorious in the wake of the rains, covered with a variety of flowers: buttercups and coral-pink

inflorescences. Insects flourished, attracting red-capped larks and Caspian plovers. And ever since the dogs had denned, there were always one or two representatives – sometimes more – of the two smaller species of vulture found in Serengeti: the hooded and Egyptian vultures. The birds were attracted to the den in the same way that they are attracted to human settlements, scavenging for whatever edible tit-bits they could find – in this case, the abandoned scraps of skin and flesh left scattered around by the puppies. They probed and pecked with their slender bills, picking up this, examining that, searching also for insects and the droppings deposited by the puppies. Here, the smaller species could avoid competition with the larger vultures, whose greater numbers and stronger bills helped them to dominate at a kill.

The wild dog puppies were intrigued by the vultures once they had overcome their apprehension of the miraculous way the birds disappeared over their heads. At first they had been at a loss to know where the birds had gone, but now there was nothing the puppies liked better than to try and stalk them. The older dogs, particularly Mama Mzee, saw things differently, trying to chase the birds away with futile rushes and lunges. Vultures were a nuisance to the pack. Not only did they try to steal the dogs' kills but they also alerted other predators to the place where the pack was feeding. It was in the dogs' interest to be particularly vigilant at the den. A bird the size of a vulture might turn out to be a predatory eagle looking for a pup-sized meal. But it made little difference to the vultures. When confronted by Mama Mzee they simply escaped into the sky, then waddled back again as soon as she lay down or turned her back.

Shortly after 9.00 a.m. the first puppy emerged from the den and sat quietly grooming itself. Others soon followed, a sleepy procession of young animals, gummy-eyed and full of huge yawns. They had spent most of the night huddled together for warmth below ground, occasionally responding to the noisy urging of one or other of the adults to make an appearance above ground. The puppies looked around them for signs of the adults; they had learned by now that it was 'out there' that they might find the adults galloping back across the horizon. But all they could see were the Thomson's and Grant's gazelles returning their stare; even tiny wild dogs receive questioning looks from the prey species. Gradually the puppies shed their lethargic demeanour and began exploring the possibilities for play with their brothers and sisters. Twenty minutes

Ten-week-old puppies awaiting the return of the adults from hunting
– page 68

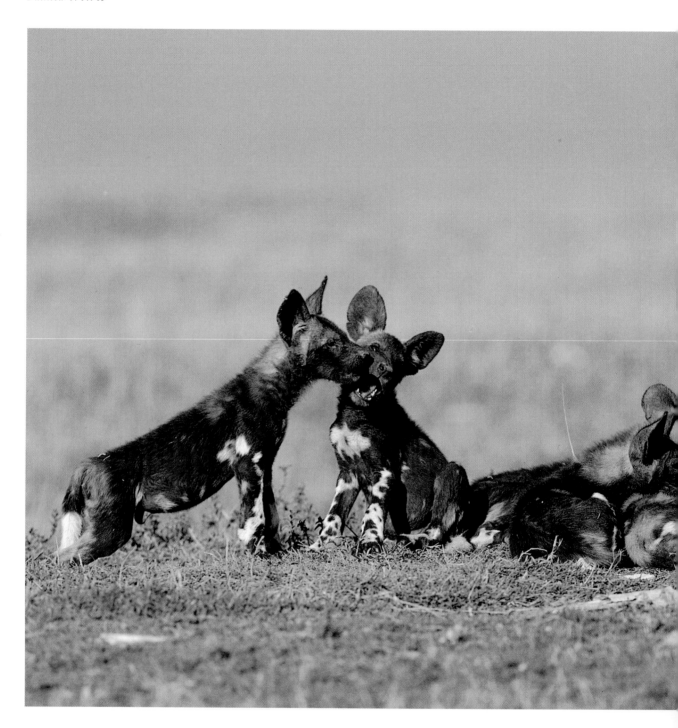

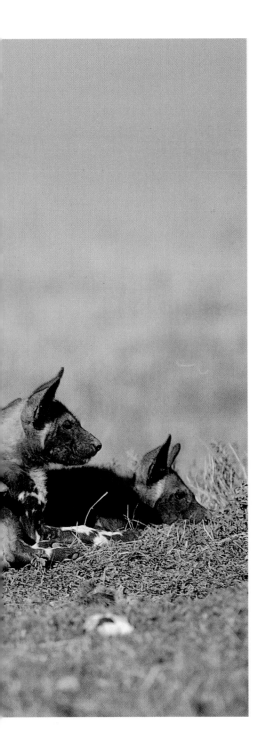

later they had exhausted their daily repertoire of hide and seek, bite a brother, chew on a bone, rip up a rough-stemmed clump of Sodom apple, and had retreated to the cool interior of the den.

The wariness exhibited by the puppies when they had first emerged from the den five weeks earlier had long since vanished. Now, at nearly eight weeks, they had a better understanding of what did or did not constitute a threat. They no longer dived for cover at the sound of an approaching vehicle, the passage of a bird overhead or an unusual noise. Instead they made judgements based on what they had learned was of real danger. It was unnecessary now for Mama Mzee or one of the other adults to stay and guard the den. The puppies knew to retreat to the safety of their burrow if a lion or hyaena approached too close.

Unknown to the puppies, the pack was resting in the shade of an erosion terrace barely two kilometres away. Twice they had chased into the midst of herds of wildebeest, but had failed to locate a calf or yearling. Scruffy had even initiated a half-hearted attack on a herd of bachelors, charging towards them and lunging at their ankles. It was a test of nerves for both predator and prey: approach too close and the dog risked being injured by a sweep of those curved horns; run and the wildebeest might provoke an all-out attack by the whole pack. But the bulls were not easily intimidated into fleeing from the dogs. They stood their ground, snorting and grunting, shaking their massive horned heads, forming a black wall that barred the free passage of the pack. The bulls edged forward, bolder by the second, driving Scruffy in front of them, forcing him to turn and lope away. After running a few paces, the old male stopped and faced the herd again, lowering his head and chasing them back. Perhaps it was all just a game, a sign of frustration on the part of the hungry dog. But for the wildebeest it ensured that this particular herd would not provide an easy meal for the wild dogs.

Watching the Naabi pack hunting made me wonder about the need for their elaborate coat markings: the pattern of spots and blotches does not help camouflage them on the open plains. However, the dogs' method of hunting is not like that of the lions or leopards, who need to stalk unseen towards their prey to have any hope of success; they do not have to hide to capture their prey. There again, these treeless plains are by no means typical wild dog country. Though much of the research into wild dog behaviour has been done on the short grass plains of the Serengeti, it is not their optimum

habitat; it just happens to be a particularly good place to watch and follow them. When seen in areas of thicker bush the wild dogs' coat markings seem more appropriate, helping to break up their outline and merging them with their surroundings. This may be of assistance when they are forced to rely more on surprising and confusing their prey during brief chases in denser cover, and may help in avoiding the attention of their competitors.

The short grass plains, which receive very little rainfall during the dry season, cannot support a large variety or density of resident herbivores. In this part of the Serengeti, the wild dogs' primary prey are the Thomson's gazelles and wildebeest, both of which are to a greater or lesser degree migratory, responding to the scattered and unpredictable occurrence of the short green grass they prefer to feed on. Here it is a feast-or-famine regime for the dogs and their prey, forcing them to roam far and wide simply to survive. This is in stark contrast to the lifestyles of predators such as lions and leopards living in the woodlands, who mark out a territory incorporating a variety of resident prey species that can sustain them all year round. Wild dogs living in areas of mixed habitat derive similar benefits. In the Kruger National Park in South Africa (where the primary prey is impala), and the Masai Mara in Kenya, packs require much smaller home ranges – in most cases 600 to 800 square kilometres, half that used by dogs living on the short grass plains of the Serengeti.

Now that their puppies were older, the Naabi pack seemed quite content to lie up beyond reach of their energy-sapping attentions. The puppies were almost weaned from their mother's milk, though they still worried Mama Mzee to let them suckle. Their appetite for meat made a considerable demand on the food intake of their older relatives. When the pack failed to make a kill the puppies pestered them for food, begging and jostling the adults, pushing their muzzles right into their mouths, as they tried to force them to regurgitate. This behaviour ensured that the adults increased their killing rate to accommodate the needs of the puppies. But rather than endure the constant begging for meat they had not consumed, there were occasions, such as today, when the adults rested away from the puppies. Instead of making a fruitless journey back to the den, they conserved their energy for the evening hunt.

The puppies spent most of that afternoon below ground, emerging for a few minutes every two hours or so to pee or look

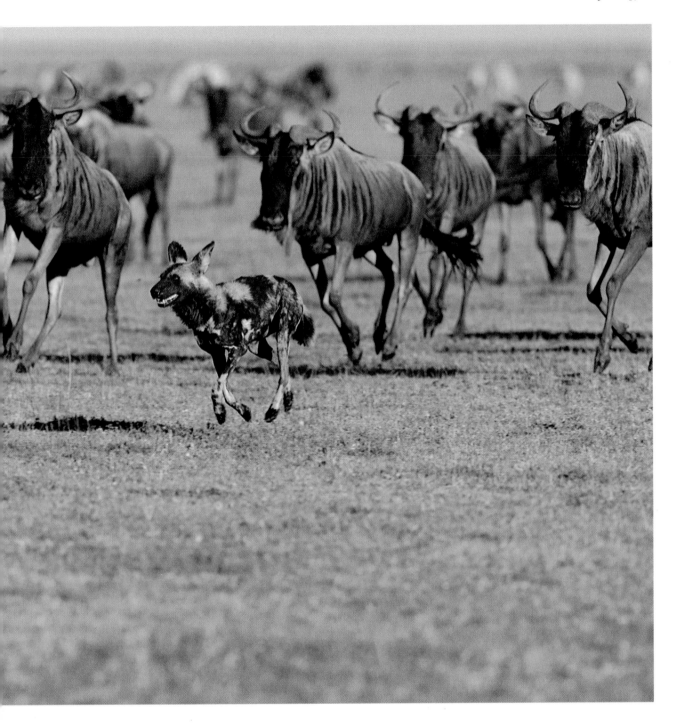

around. By 6.00 p.m. the sun had lost its power to exhaust them and they lay sprawled in an untidy heap around the entrance to the den, a confusing jumble of black, brown and white coat markings. Gradually they began to stir. There was nothing dramatic or violent about the transition from resting to playing. A leg was stretched against another's ear. An ear was chewed. A paw was deliberately flopped on to a brother's head. A tail was flicked, and in return was bitten, at first only gently. Imperceptibly the pace quickened, disrupted by moments of boredom and feelings of hunger, of sitting and staring towards the horizon. And then at last a wave of gazelles stampeded across the short grass, clean white bellies flashing, dazzling, reflecting the sunlight like a shoal of fish. The puppies jumped to their feet, large ears pricked inquiringly. They hesitated for a moment, uncertain. Perhaps it was some other predator causing panic among the herds. But when they saw Shaba racing towards them the puppies rushed to meet him.

Shaba's head and shoulders were covered in fresh blood, his thick throat-ruff matted with gore. It was obvious that the pack had killed something larger than a Thomson's gazelle – in all probability a wildebeest calf. As the puppies reached their father he slowed to a halt. They crowded around him, jostling one another in their efforts to reach up and nip at the corners of his mouth, licking his face, uttering high-pitched whines and yips. With flanks heaving the dog lowered his head to the ground and deposited a mound of meat and offal at their feet. It was gone within seconds.

Less than a minute later Scruffy, Mama Mzee and the yearling female came galloping over the rise, accelerating in a headlong dash to reach the puppies first. Scruffy was absolutely bloated with meat. The old male seemed a particular favourite of the puppies, probably because he provided them with plenty of food. Three times he responded to the insistent begging of the puppies by regurgitating for them. They did not snap or growl over these half-kilogram-sized parcels of food. It was a good-natured free-for-all, with each puppy desperately trying to gulp down a share of the offerings. One of the male puppies ran off with a mouthful of meat far too big to be swallowed whole, hoping to distance himself from his siblings long enough to chew it into more manageable portions. Three of the other puppies raced after their brother, and eventually managed to secure a hold on the meat. They yanked and pulled in a teeth-jarring tug-of-war, bracing themselves, creating a resistance to pull against.

Bull wildebeest are normally too large for a pack of wild dogs to kill. Here Scruffy is chased away by a herd of bachelors – page 71

This is the same method employed by the adult dogs to tear up a carcass. Each dog establishes an identical rhythm, first bracing itself and then pulling at the same time as the others. By doing this a dog uses every ounce of its strength efficiently, creating the maximum force for tearing apart a carcass quickly and thereby gaining access to food more rapidly than when trying to feed alone.

Beyond the rise Spot and the yearling males chewed on the remains of the month-old wildebeest calf killed by the pack three quarters of an hour earlier. Scattered about them were shards of bone picked clean of flesh. Vultures edged nervously forward to peck at the calf's skull, which each dog in turn had chewed before abandoning it. Even on days such as this, when the pack had time to feed at length on a carcass, 40 per cent of the kill remained inedible. Between them the seven dogs had consumed twelve to fifteen kilograms of meat, a third of which would be regurgitated for the puppies during the next few hours.

A lone hyaena circled, freezing momentarily whenever a dog looked up and fixed it with a stare of unmistakable aggression that, for the moment, deterred any thoughts the hyaena might have had of trying to appropriate the kill. But there was nothing left for the dogs here. The yearlings jousted, leaping up on their hind legs and playfully biting and tugging at each other's ears and throats, pushing and wrestling, measuring their strength. When Spot turned and headed for the den the yearlings quickly fell into step behind the older dog, then raced him over the horizon.

The vultures needed no further invitation than the sight of the dogs hurrying into the distance. Those closest to the scraps of ribcage and vertebral column flapped and hopped forward, hissing. Others dropped from the sky, until the bloodied grass disappeared beneath a seething maul of feathers. Their frantic attempts to strip every last morsel of flesh from the remains of the wildebeest calf were hastened by the sight of the hyaena galloping towards them. Those vultures buried deepest beneath the press of feathered bodies suddenly felt the burden released, heard the frantic beating of giant wings above them. The hyaena lunged open-mouthed at the mob, wisely keeping its eyes tightly shut to protect itself from the birds' slashing feet and flailing wings, forcing them away with snapping jaws. But they were too many and the rewards too little. With a final charge at the infuriating birds, the hyaena departed for a quieter spot.

A yearling male, Limp, surrounded by puppies, approximately three months old – page 75

73

By the time Spot and his brothers arrived at the den the puppies had already eaten their fill and were waddling around the entrance, looking uncomfortably fat. They hardly bothered to acknowledge the return of the three males. Gradually their play diminished until all were still and only the grass moved, creating a sound not unlike the crashing and gusting of coastal breakers. Stunned by the heat and the wind, the adults sought whatever shade they could find. Some preferred the coolness of the long grass at the edge of the water-hole. Others took their places among the hive of burrows surrounding the den, hugging the shadows cast by the overhanging walls of the erosion terrace, relishing the dampness of the night-chilled soil.

Every so often a dog got up and pawed at the ground, kicking up spurts of powdery earth, digging feverishly until it reached cooler ground on which to lie. Certain individuals were restless and fidgety, forever seeking the company of another, whining at the mouth of each burrow in turn, mostly deterred from trying to enter by a low growl of occupancy. But despite such protestations a dog sometimes managed to worm its way in on top of another, creating an uncomfortable huddle. Seeing the pack secluded like this made me realize how lucky Neil and I had been in finding the dogs the previous year. A flick of a wispy white tail-tip was all that might alert you to their presence at this time of day.

Once in a while an adult rose out of the bowels of the plain, shaking the dry soil from its coat. It would stand staring into the heat haze, lifting its nose to the breeze, before trotting over to the den. The yearlings seemed particularly inclined to visit the puppies while they were still small. A few sharp whines were usually sufficient to encourage the pups to emerge. They would stand, ears cocked, noses raised, drawing in the strong scent of their older relatives, questioning the reason for being awakened. Sometimes the yearlings regurgitated food for the puppies, but often they appeared to want simply to make contact, or to play, forcing some activity into long sleepy days. It all helped to integrate the new litter into the social environment of the pack. Despite their adult size, in many ways the yearlings acted like puppies themselves – restless, curious, reckless and often naïve.

The puppies were growing rapidly, looking gangly with their long legs and huge ears. From about eight to ten weeks of age they started to initiate their own greeting ceremony as a well-defined group. As the sun began to wane, two or three of the puppies might

74

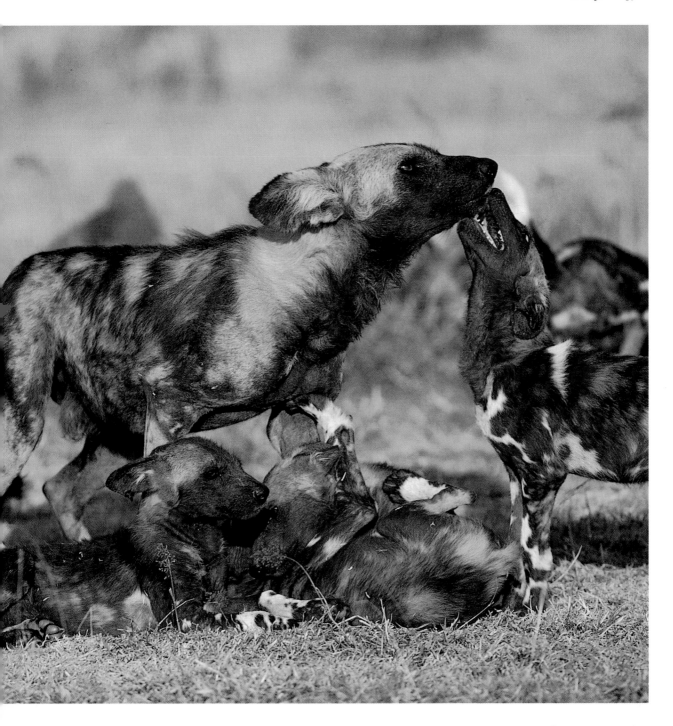

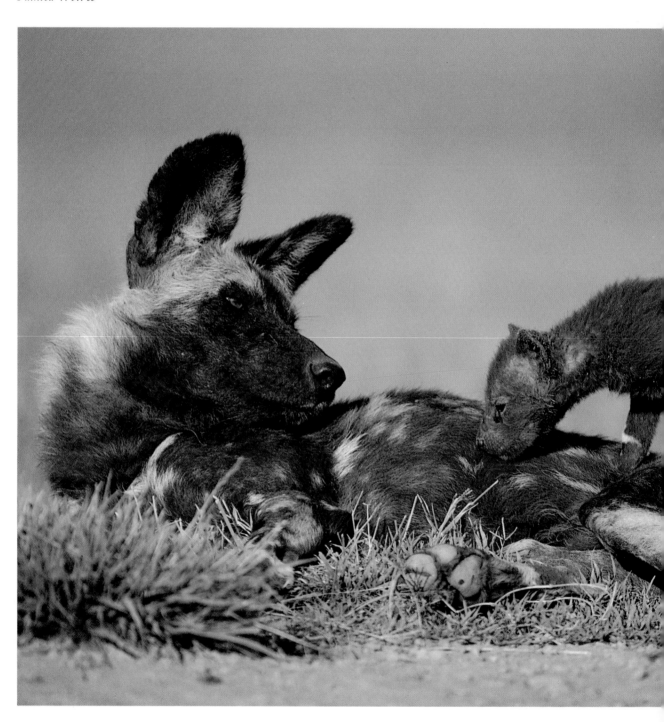

suddenly rear up on their hind legs and whimper, resting their oversized paws on each other's shoulders, or hurdle across the back of a brother or sister, pausing a moment to press their chins down over another's throat, peeing as they went. This invariably brought the yearlings racing to the den – sometimes their arrival prompted it – and they in turn would then look for Mama Mzee and Shaba, who might already be running towards them. On other occasions it was Scruffy who was the first to stir, in which case he would trot submissively to where Shaba and Mama Mzee were resting, and then all three would run to the puppies and greet them.

The relationship between the puppies and the adults was gradually changing. To begin with the puppies had been fun to have around, something new to play with. Now they were big enough and mobile enough to be a thorough nuisance. It was no longer possible for a dog simply to walk away when it had indulged its own need for contact with the puppies. Interactions were no longer so one-sided; they did not simply involve a puppy being shunted around the den on the tip of an adult's nose, or squirming on its back, or being licked clean. Mama Mzee was the first to start to discipline the puppies when she wanted to be left alone; as their mother it was her prerogative to do so and a necessary part of the weaning process. But soon all the adults had reason to reprimand the puppies, to curb their excesses.

When the puppies were hungry they demanded food from all the dogs, and even when they were not, they still sometimes sought their attention. With each passing day the older dogs seemed less and less inclined to tolerate undue pestering from the puppies or to play with them. They responded with highly effective signals – short, sharp rebukes serving notice that they wished to be left in peace. They lunged at the puppies, ears back, heads held low, white teeth flashing, biting down over their necks or on top of their noses. At first the puppies seemed surprised and shocked by this treatment, squealing in alarm and throwing themselves on their backs in submission. But it looked far worse than it was. Though the puppies were unhurt, this discipline served its purpose and brought a sense of order to their lives within the pack.

Throughout the night the wind howled, rocking my vehicle. Suddenly I was awake, startled by a violent crashing on the roof. To my amazement I saw a huge vulture flapping and flailing its wings

against the window, curved talons clawing at the side of the car as it struggled in vain to gain a foothold. Then it was gone, ghostly black wings lofting it into the moonlight. Sleep beckoned and then deserted me. How much longer, I wondered, would the Naabi pack remain with their ten-week-old puppies at the den? And where would they move to when they left? I waited for the first hint of daylight, longing for the night to end, watching the dogs through my binoculars as sunlight gradually seeped into the morning sky.

The adults lay scattered around the den, heads tucked into midriffs, hind legs pulled up tight against bellies, making themselves as small as possible in an attempt to shut out the biting wind. Mama Mzee and Shaba huddled together, close to the den. I could see Scruffy and Spot, nearby, lying ten paces apart, and beyond them the three yearlings. When the first of the puppies appeared above ground, the yearlings trotted over to greet them, forcing some warmth into their cold bodies. Soon the whole pack was on its feet, tearing about the entrance to the den in a merry-go-round of greeting. Then they were off, striding effortlessly across the plains, leaving the puppies staring after them. For a moment I thought that they might try and follow the adults, but after a few hesitant steps the puppies lost interest, absorbed in play.

It was quite apparent that the Naabi pack's morning and evening forays over the plains involved far more than simply procuring sufficient food. The journeys kept them attuned to what was happening around them. These were exploratory travels as well as hunting trips, enabling them to know something of what the other animals had been doing during their absence. Like everything in nature, the wild dogs were caught up in a complex web of interrelationships; they were part of a larger order. The pack spent considerable time investigating their surroundings, forever curious and inquiring, deciphering the rich world of scent messages that I could only guess at. One or other of the dogs would suddenly pause and circle around, nose pointed to the ground, drawing the attention of the other dogs to the place. Sometimes it was nothing in particular, simply an opportunity for the pack to 'do something together'. It may have been the freshly deposited bone-white scat of a hyaena that attracted the dog's attention, or the blood-spattered feathers of a yellow-throated sandgrouse killed earlier in the morning by a female Montagu's harrier. Perhaps they had discovered the spot where a band of nomadic male lions – territory seekers

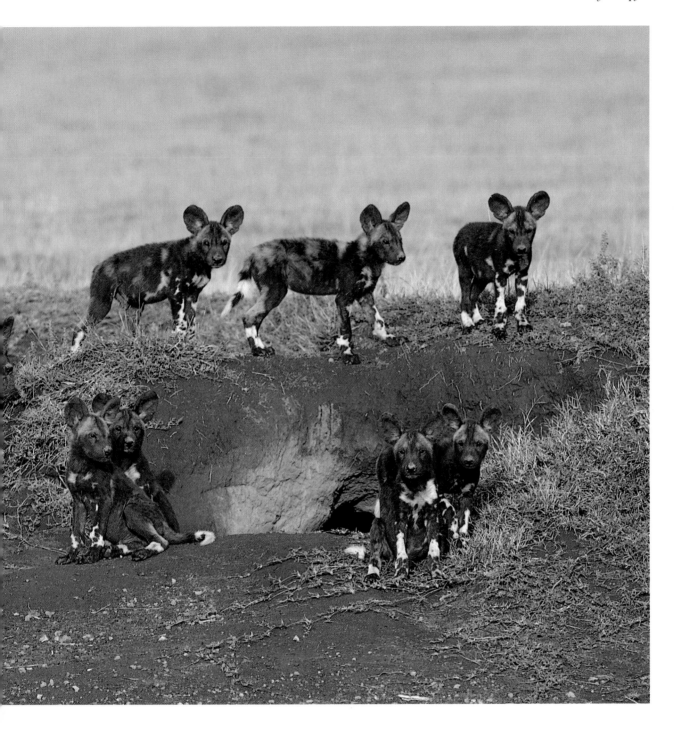

– had sprayed their scent on the coarse tufts of *Indigofera*. Or was it the powerful and distinctive wild dog odour that on this particular morning caused the whole pack to gather in a tight huddle, each one eager to investigate the scent for itself?

Gazelles stood like sentries, taut with anticipation yet seemingly aware that the hunters were uninterested in pursuing them. The dogs never faltered, never paused to examine the dainty brown and white antelopes, and continued south in search of the wildebeest. When I cut the engine of my vehicle I could hear the distant murmur of the migratory herds as they swarmed across the plains, clipping the fresh green grass that had been hastened by the arrival of the rains. I wondered how much the dogs used their acute sense of smell in tracking their prey, particularly the wildebeest. It is certainly not *just* their eyes that guide wild dogs to the prey of their choice. It was wildebeest they were searching for today and though they could not yet see them, they seemed to know where to look. If I could hear the wildebeest, so could they.

The pack trotted over the horizon. There they were. One by one the dogs slowed to a walk, brushing alongside each other as they bunched closer around Mama Mzee and Shaba. Pressed together in this fashion, noses thrust forward and ears laid flat against their heads, it was difficult to distinguish individuals, difficult to identify them as wild dogs. Moving in this manner they were able to get closer to the herd than if they had advanced on a broad front with each dog clearly outlined as a predator. The wildebeest stood motionless, a dark wedge of animals. Hunters and hunted were separated by 100 metres. A few of the bulls began to turn away, then paused, wary, reluctant to make a break from the security of the herd and identify themselves as a possible target. Calves pressed closer to their mothers, sensing danger yet unsure of its nature. The tension was electric as the dogs pressed forward. Fifty metres. By now the cows with calves had turned and were trying to slip away to the west, partially concealed by the massed ranks of the wildebeest hordes. But it was too late. The dogs had seen them. A ripple of movement spread through the entire herd, galvanizing the wild dogs into pursuit.

Shaba led the charge. Within a hundred metres he was travelling at nearly sixty kilometres an hour, an effortless gallop that quickly closed the gap between him and the wildebeest. Scruffy was there too, veering sharply to the left, drawn like a magnet towards a

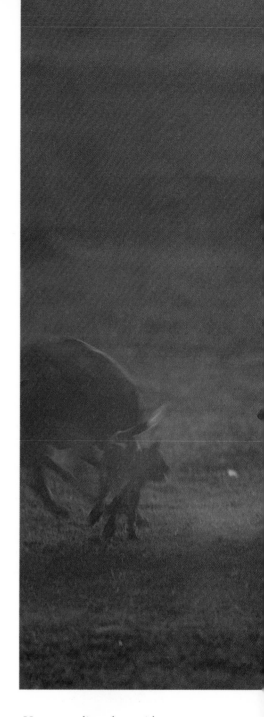

Here a yearling plays with a young puppy. But all adults in the pack socialize with the litter – page 76

The eleven puppies at the Barafu den, about ten weeks old – page 79

80

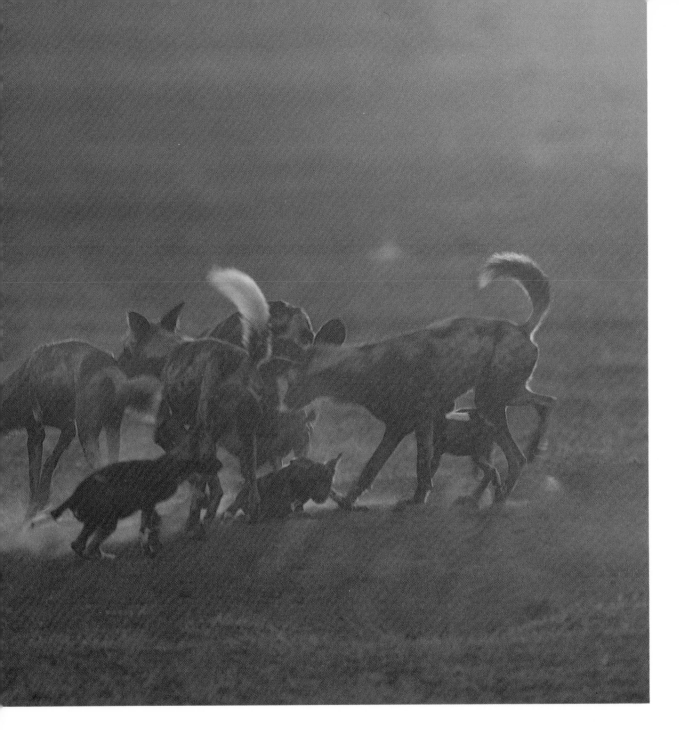

Adults calling the puppies up from the den in the early morning

By bunching together, the pack is able to get closer to its prey – page 82

second group of cows and calves that was desperately trying to keep in contact with the herd. The yearling males followed the old dog as he sped over the horizon.

It looked so easy, with Shaba pacing alongside the cow and calf, biding his time until the other dogs moved closer. Now was the moment. He lunged forward and grabbed the calf by the thigh. The

Painted Wolves

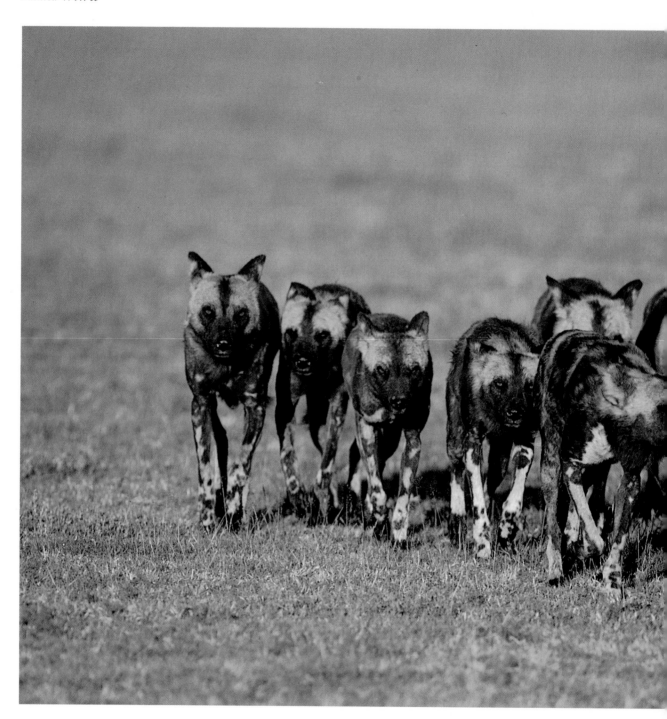

cow wheeled round, attempting to hook at Shaba with her horns. But even as she did so she felt Spot's teeth sink into her leg. By this time Mama Mzee and the yearling female were there too, forcing the mother wildebeest to abandon her calf or risk being killed herself.

The four dogs quickly tore the calf open, ripping through the thin belly-skin close to the groin and gulping down the most accessible portions first. Within two or three minutes they had eaten the contents of the body cavity: heart, lungs, liver and intestines. By the time Scruffy and the yearling males returned from their own abortive hunt, only the dominant pair and the yearling female were still feeding on the carcass. The other members of the pack had to content themselves with chewing the calf's slender leg bones and scraps of skin, neither of which provided much sustenance for the late arrivals.

Scruffy stared into the distance. He was still hungry. The sight of another herd of wildebeest trailing across the horizon seemed to hold more promise of food than the sparse remains of the calf. The yearling males followed his gaze, then trotted after him. As they did so Mama Mzee and Shaba departed for the den, prompting the three males to abandon any thoughts of hunting again and sending them hurrying back to the carcass.

Shaba was first to arrive at the den and immediately regurgitated food for the puppies. During the next ten minutes Mama Mzee regurgitated three times, as the pups continued to beg for food. Half an hour later Scruffy and the yearling female arrived, followed by Spot and lastly the yearling males, all of whom eventually regurgitated.

So powerful was the urge to regurgitate that sometimes a dog tried to retrieve some of the meat, frantically gobbling a portion of it down again before it disappeared into the throats of the puppies. One yearling managed to snap up its own offering before it touched the ground, much to the amazement of the puppies that had gathered expectantly. But there was not much that escaped Mama Mzee's attention. She was everywhere, darting this way and that, helping herself to some of the food destined for the stomachs of others.

In early April I had to leave the Naabi pack and return to Nairobi to resupply with provisions. The eleven puppies had already begun to make their first tentative attempts to abandon the immediate surrounds of the den and follow the pack when it went hunting. One

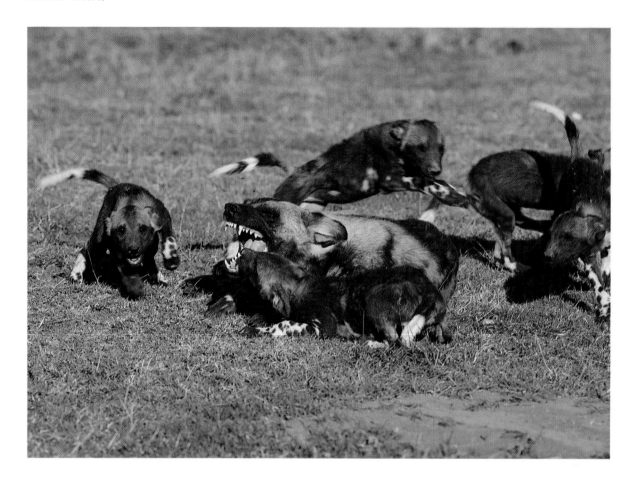

or more of the adults would lag behind and stay with the puppies when they did this, sometimes leading them back to the den and waiting with them until the hunters returned. I knew that my time with the dogs at Barafu was over. Within the next week or so the puppies would be confident enough to follow the adults wherever they chose to wander.

As the puppies grow older, the adults become less tolerant and serve notice when they wish to be left in peace

The Ndoha Pack

JUNE 1987–MARCH 1988

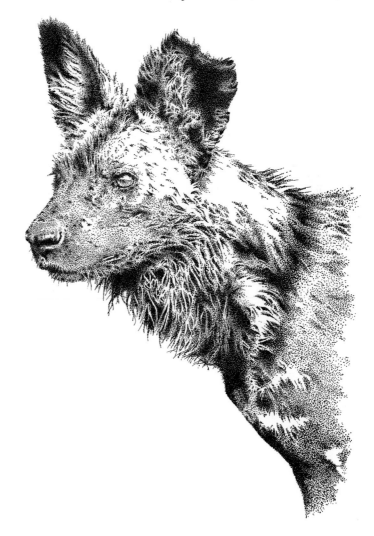

Only the mountain has lived long enough to listen objectively to the howl of a wolf.

A Sand County Almanac, ALDO LEOPOLD

Towards the end of 1987 John Fanshawe wrote to tell me that the Serengeti monitoring unit had at last managed to radio-collar another pack of wild dogs. They were known as the Ndoha pack and they roamed the length and breadth of the Western Corridor. The existence of the pack had been rumoured for some while and was substantiated by sightings of wild dogs by rangers stationed at Kirawira guard post and by the occasional forays into the Corridor by visitors and scientists. But until now it had always proved impossible to relocate the pack, because the dogs never stayed in any one part of their range for long enough.

At times the Ndoha pack ventured as far east as the edge of the central plains, loitering for a few days to the south of the Masai Kopjes and the Seronera river. This was an area also occasionally used by the Naabi pack, and it was quite possible that the two packs knew of each other's existence. With so few wild dogs living in the Serengeti they might even have been related. Despite the huge area encompassed by a pack's home range, the dogs' keen senses and great mobility would undoubtedly alert them to the presence of other dogs. People who have witnessed the meeting of two packs report that the smaller gives way, usually as a result of being chased; actual physical violence in such encounters is thought to be rare. In general packs seem to avoid one another.

Eventually the Ndoha pack was sighted while denning in a beautiful secluded spot at the edge of the Ndoha plains – hence their name. A male and a female were then radio-collared. The pack had

denned in June, just as the migration was departing from the eastern plains. By the time the puppies were large enough to eat meat, vast herds of wildebeest and zebra were among them, providing excellent hunting opportunities and ample food for all pack members. Like the Naabi pack, these dogs had denned at the time of maximum prey abundance.

When Hugo van Lawick initiated the Serengeti wild dog study in 1966–7, he used a photographic file to help identify individual dogs. At one point he had 163 individuals on file, with a card for each listing pack name, individual name or number, sex and age. In this way a comprehensive library of identification cards was built up between 1966 and 1977, yielding vital long-term records of pack composition, movements of dogs between packs, degree of related-ness, age of first reproduction and longevity. Unfortunately, this continuous photographic record lapsed between 1978 and 1985, when no scientists were monitoring the Serengeti wild dog population.

With the resumption of the wild dog monitoring project in 1985, John Fanshawe created a new photographic file. When John and Clare left in 1987, Karen Laurenson took over responsibility for collating wild dog data. Karen, who is a veterinary surgeon, had come to the Serengeti to work for her doctorate on the cheetah. Her work was part of a long-term cheetah study, with particular emphasis on trying to discover whether there was a decline in the number of cheetah cubs being raised to maturity. However, like most of the people working in Serengeti, Karen was also fascinated by the wild dogs.

The first time I saw the Ndoha pack was when Karen handed me two sets of identification cards. Pasted on each card were two or three black and white photographs showing individual dogs in a variety of poses to aid recognition. Key features such as distinctive coat markings, notches in ears or unusual tail patterns were noted. Male dogs had yellow cards, females had green ones. Of the original pack first seen in July 1987, only four males and two females remained, together with ten yearlings, seven of which were males.

As I flicked through the cards the photograph of one particular dog caught my eye. Written on the top of his card was the symbol for the alpha or dominant male. What an extraordinary dog. He was rather squat, with a broad muzzle and small, sandy-coloured eyes. He looked the part of an old warrior, scarred by events in his long life

Sunset over the Western Corridor – page 86

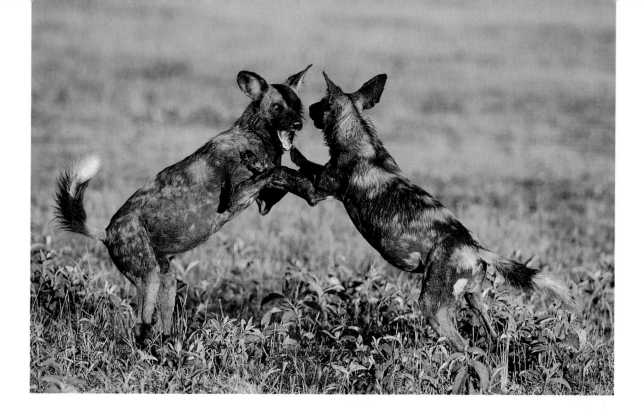

that I could only guess at. His coat was the colour of coal, his canines were worn with age. Years earlier part of his left ear had been torn away.

Half-Ear reminded me of Jock the flop-eared bull terrier, hero of Percy FitzPatrick's classic book *Jock of the Bushveld*, a beautifully illustrated story of a dog raised on a farm in what is now the Kruger National Park in South Africa. Hair-raising encounters with wounded buffalo, dog-hating baboons and leopards were everyday events for Jock. I had already seen for myself that the life of a wild dog was no less eventful. How, I wondered, had Half-Ear sustained such an injury? Perhaps it was the result of a bruising contest with a brother to establish his dominant status.

I knew from watching the Aitong dogs in the Masai Mara during the 1970s and the Naabi pack on the plains that individual wild dogs have distinctive temperaments. Some seem marked out at an early age, destined to be leaders or followers, domineering or deferring, good or indifferent hunters, blessed with that extra metre of pace or endurance which ensures a kill where another might go hungry. As I looked at Half-Ear's picture I wondered what subtle blend of characteristics had determined his dominant status. He was not a particularly big dog; in fact physically nearly everything about him was average. There was obviously no straightforward correlation here between dominance and size or strength or prowess in the hunt. So what makes a leader, causes others to yield to their will, ordains

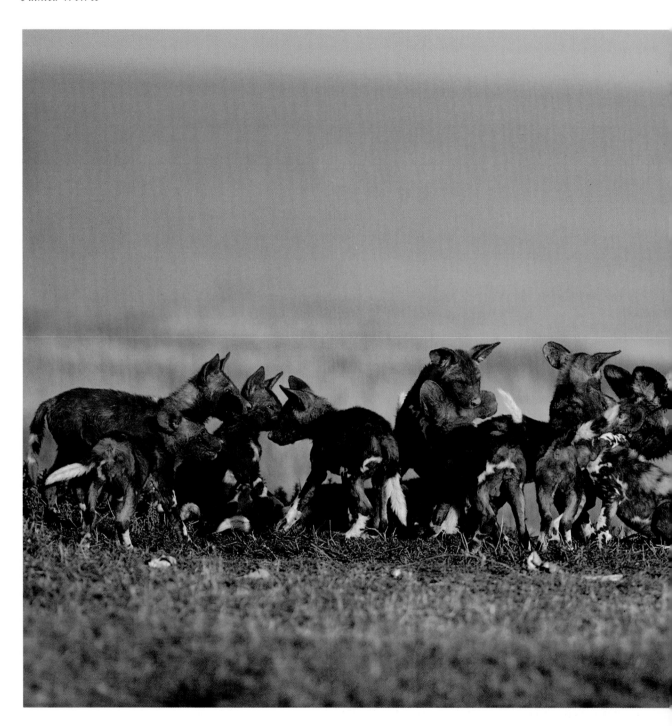

that certain individuals, such as Scruffy of the Naabi pack, will never be top dog?

Lory Frame, who studied the Serengeti's wild dogs in the 1970s, found little sign of dominance among first-year puppies, and even among yearlings I found it difficult to assess which, if any, was dominant over the others. Lory felt that it was to the advantage of all the puppies to remain as a well-integrated group while still vulnerable and dependent on the adults for food. Young wild dogs certainly seem to respond collectively rather than expressing marked individual differences. They play together, compete amicably for a share of the food regurgitated by adults, and bunch up and take to their heels together when confronted by danger. There is little in their lives that is worth fighting about, though play provides an ideal forum for puppies to hone their competitive skills. Except in circumstances where a puppy is sickly and therefore unable to compete effectively, individual strengths and weaknesses are for the most part unexploited. If there are subtle indications of dominance between young litter-mates, they have passed unnoticed.

Dominance is ultimately about breeding opportunities. Establishing a dominance hierarchy (males and females have separate hierarchies) would seem to have little relevance for puppies. Only later, when a dog is sexually mature and capable of breeding, does it become important to try and dominate a litter-mate. Young dogs constantly engage in ritualized tests of strength, rearing up on to their hind legs, like zebra stallions, mouths ajar, trying to chew each other's necks or nip at a large bat-ear. These play fights are one of the ways in which young dogs assess their strengths and weaknesses without seriously injuring one another or unduly interfering with the necessary harmony that pervades a pack of wild dogs. Perhaps this is why the dogs have such a conspicuous ruff of long hair covering their throats, helping to protect them from the effects of bites administered in more serious contests.

On arrival back at Seronera one afternoon during March 1988 I was told by a friend that the Ndoha pack had been seen close to the main road, some ten kilometres from the lodge. I had spent the last few weeks watching Mama Mzee with a new litter of eleven puppies on the southern plains. I was delighted to hear news of the Ndoha pack; I had thought it most unlikely that I would see the dogs until later in the year, when they denned, because much of the Western Corridor

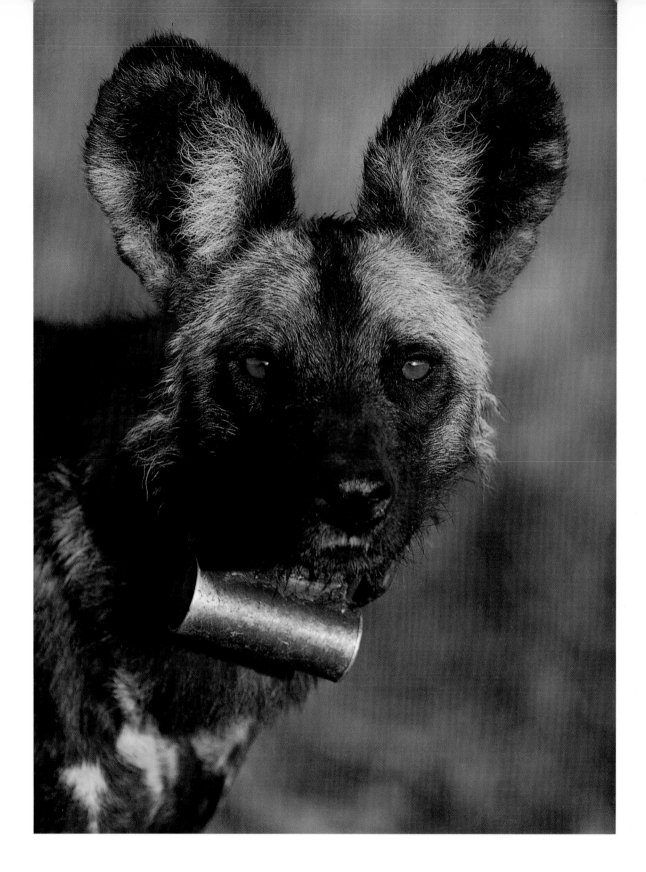

*Collar, Half-Ear's son, wearing a
350-gram radio-collar*

is impassable during the rainy season. The following day Markus
Borner flew a tracking flight to locate the pack. We found it a
few hundred metres beyond a large swamp next to the Seronera
river. That same evening I drove out to the place where the dogs
had been resting. There were four adult males, two females and ten
yearlings.

It was exciting to see new dogs after all this time. Half-Ear and his
brother were unmistakable. Both were particularly dark dogs with
similar patches of white on their flanks. The other two adult males
were much lighter-coloured animals, thought to be Half-Ear's two-
year-old sons. One was known as Collar, because he wore a radio-
collar fitted the previous year, and the other as Shyster. The
dominant female was known as Short-Tail. She had distinctive
white socks on both back legs, and a shortened white tip to her tail.
The only other adult female was a much younger animal. In addition
to the dogs lying in the grass in front of me; four females – possibly
older daughters, or sisters, of Short-Tail – had just emigrated from
the main pack.

The plains surrounding Seronera had been stripped of their cloak
of long grass by the wildebeest herds. Now they were covered with
thousands of Thomson's gazelles, which had gathered to feast on the
regrowth. The Ndoha pack moved among them, searching for
fawns lying out on the green stubble. By the end of the evening they
had flushed three of the tiny gazelles and killed them. I followed as
the dogs gathered on the rise of a low hill.

The dogs stared out across the grasslands, their sharp eyes taking
in every detail of the land. With their backs to the wind they started
to call. At first I could make out only the owl-like tone of a single dog
drifting back across the plains. But one by one the other dogs added
their voices, creating a synchronized barrage of hoots. I had never
heard wild dogs calling in unison like this before. There was a
rhythm to the sound like a chant, rising and falling, surging. Each
dog had a slightly different tone. The yearlings in particular could be
distinguished from the others by their higher notes, producing a
more pining call. As the sound faded it seemed to create a great
silence, as if every living thing was listening. The dogs stood
together transfixed, their huge ears straining for an answer that I
perhaps could not even hear.

*Young wild dogs seem to respond
collectively rather than express
marked individual differences
– page 90*

The cry of a single wild dog does not have the power of a lion's
roar, which is audible to the human ear over a range of between four

and ten kilometres, depending on how dry or moist the air is. A roar can at times cover the full extent of a pride's range – a great advantage for animals trying to defend the integrity of their territory. The '*hoo*' call of a wild dog is most commonly heard when individual dogs are trying to relocate other pack members, rather than being an aid to signalling the extent of their huge home range, which is too large to be defended. But when the whole pack calls in unison, it becomes a potent form of long-distance communication, a sound that may mean different things to different ears. For those who could hear, it served to pinpoint the position of the Ndoha pack. It said who they were, and that they were many rather than a few. A wild dog might even be able to distinguish the call of a male from that of a female – an important consideration for groups of emigrants looking for mates. Perhaps emigrants add their voices to the wind as well as their scent, helping to advertise their presence and their sex.

I wondered where the Naabi pack was at this moment; the Ndoha pack probably had a far better idea than I did. Mama Mzee had produced her latest litter in December 1988, choosing to den on the plains a few kilometres east of Gol Kopjes, in the same area where she had given birth to three puppies in 1986. But the old female had recently moved her puppies and I was uncertain of their new location. That was why I had returned to Seronera to ask if anyone else had seen the dogs.

With the help of binoculars I could just make out sixteen bat-eared silhouettes trotting away into the darkness. The Ndoha pack was headed south towards Simba Kopjes. It poured with rain the whole of that evening, the black sky illuminated by flashes of lightning. At some point during the night the dogs headed back towards the hill top where I had parked my vehicle. I found them next morning feeding on the fresh carcass of a female Thomson's gazelle. But now there were twenty of them. The four emigrant females had rejoined the pack.

There were carcasses everywhere. Looking about me I could see at least a dozen dead gazelles, with perhaps another six hobbling around on broken limbs. It looked like a battlefield. No wonder the dogs appeared so fat. A few of the gazelles had been partially eaten, but the majority provided no clue as to how they had died: there were no bite marks or signs of a struggle. Mark Jago, a veterinarian stationed at the Serengeti Wildlife Research Centre, examined the

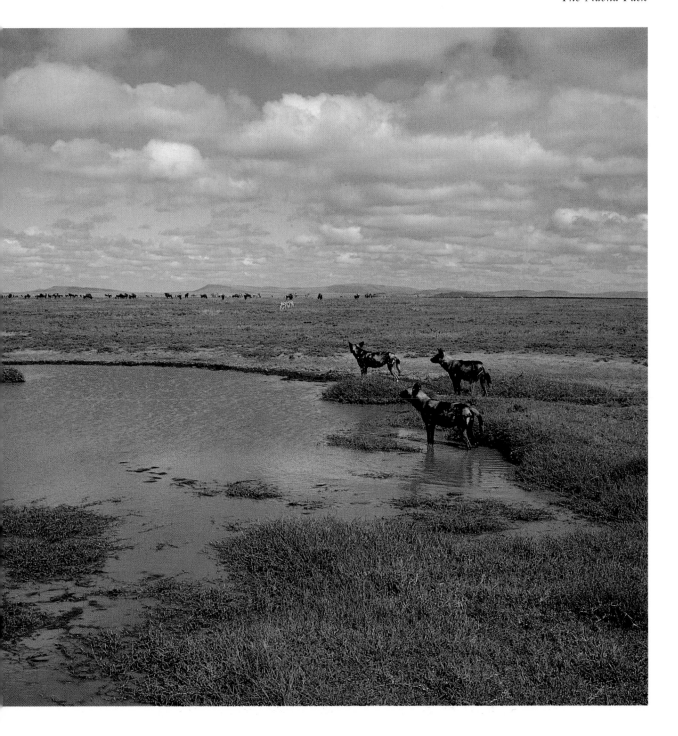

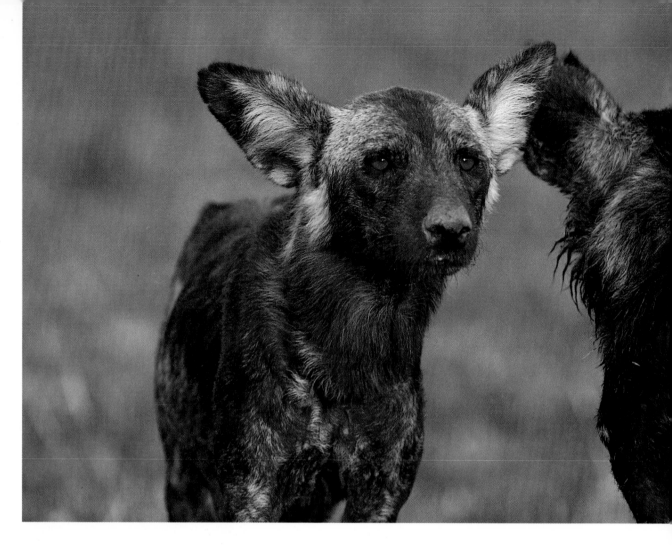

carcasses and took blood samples. He had noticed that some of the gazelles had blood around their noses, a sign associated with anthrax, but tests proved negative. Perhaps lightning was to blame. Or were the stories true?

In the past the wild dogs and hyaenas have been charged with being wanton killers, of slaughtering more than they can eat. But the fact is that in the wild, predators do not often have the opportunity to kill much in excess of their needs. If a pack of wild dogs is not hungry, it does not go out and hunt. I had seen that for myself. But if the chance of an easy kill presents itself, rarely will *any* predator ignore it. It simply cannot afford to. There are no guarantees as to where the next meal is coming from or who may be there to try and steal it.

The sight of the dead gazelles reminded me of pictures I had seen in Hans Kruuk's book *Hyaena*, documenting an incident involving the deaths of eighty-two gazelles and the injury of another twenty-seven. The gazelles had been killed by hyaenas one dark, stormy

Short-Tail and Half-Ear, the dominant pair in the Ndoha pack

From left to right, Mama Mzee, Scruffy and Shaba near the den site used in 1986 and 1988, and briefly in 1987 – page 95

night on the Mukoma plain. Kruuk provided the following explanation:

> I had seen this sort of thing before, with foxes in an English gull colony, and here again, I was struck by the apparent waste of it all. Probably such cases are natural accidents, where the normally well-adapted behaviour of the animals breaks down in the face of very unusual circumstances. Hyaenas, like other carnivores, do not always kill for food – even when they are not hungry they will seize an easy opportunity to grab an animal, then store the carcass or leave it for relatives to eat. During the very heavy storm of that particular night the gazelle had been lying down, unable to see and run, and hyaenas could quietly walk from one to the next, killing or stunning, then walk on. Their behaviour is programmed to deal with some super-abundance of food but, in the face of such fantastic food surplus, all was left to the vultures.

Hyaenas and jackals gathered to feed on the wealth of carcasses spread across the plain, warring with the deluge of vultures and migratory steppe eagles. Nothing would go to waste. In the distance I could see two of the wild dogs hurrying away to the south, leaving the rest of the pack standing atop the rise.

As the emigrant females departed their two companions started to follow, then stopped and called to them. But it was to no avail. If the others heard they took no notice, neither faltering in their stride nor bothering to answer the call. There was no turning them. Half-Ear and Short-Tail, the dominant pair, stood side by side, watching. Then they too began to call, echoed by a chorus of hoots from the yearlings, urging the females to return.

By now the first two females had vanished, swallowed up in the vastness of the rolling plains. The second two females stopped and looked back towards the hill top. They could see the unmistakable profiles of the rest of the pack silhouetted starkly against the pale sky. Ahead of them there was nothing but kilometre after kilometre of high grass. With heads bowed to the ground they called again. Who were they calling to, I wondered. Were they returning the call of the pack or still trying to keep in contact with their sisters?

The dominant pair seemed in no doubt. Half-Ear and Short-Tail

The ten yearlings of the Ndoha pack. Litter-mates spend more time resting and playing with each other than with other members of the pack – page 99

raced from the hillside, haring after the two females, and then stopped as one of them trotted back. The other soon followed.

But the urge to rejoin the missing females was stronger than any need to stay with the main pack. Despite further calls from Half-Ear and Short-Tail and the yearlings, a few minutes later the two females once more turned their backs and left.

During the next few days wildebeest poured into the Seronera area, deserting the drier regions to the south. They were everywhere, like the shadow of a huge black cloud darkening the stands of tall, red oat grass. Marabous and white storks filled the sky, spiralling overhead in response to the plethora of frogs and winged termites which had emerged with the rains. All of life celebrated. The land was alive with young animals: wildebeest calves and zebra foals; Tommy fawns and three-month-old topi; tiny grass rats and day-old plover chicks. It was a time of renewal.

Nothing can adequately convey the awe inspired by the sight and sound of so many animals seen together. At this time of year the wildebeest *were* the plains, dominating the grasslands by sheer force of numbers. Other species temporarily moved aside as the herds swept through. The early mornings were filled with the incessant, earthy grunting of the bulls; the air was raw and misty with their breath. Each day was different – a landscape of ever-changing scenarios involving the predators and their prey. Trap-door spiders waited motionless in darkened underground chambers, poised in ambush beneath a funnel of silken threads. Spitting cobras slithered cautiously through the maze of air vents that defined the inner world of the termite mounds, searching for mice and mongooses, frogs and nestlings. Birds of prey drawn from more than fifty different species patrolled the skies. The smallest, such as the kestrels, hovered above the plains in search of grasshoppers and praying mantis. Largest of all, a pair of martial eagles, hooded in black, soared overhead, yellow-eyed warriors capable of carrying off wart-hog piglets and gazelle fawns in their clawed fists.

And as always there were the hyaenas barrelling across the plains in pursuit of a wildebeest calf, congregating expectantly around the fringes of a pride of lions on a kill or walking purposefully across the wide open spaces for which the Serengeti is famous. They are the most adaptable and opportunistic of all the larger predators, forever on the lookout for food, as capable of killing for themselves as of stealing from another predator.

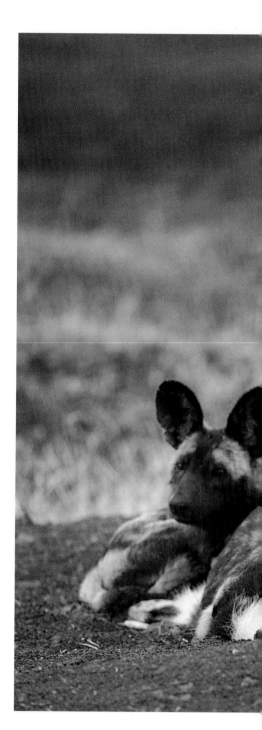

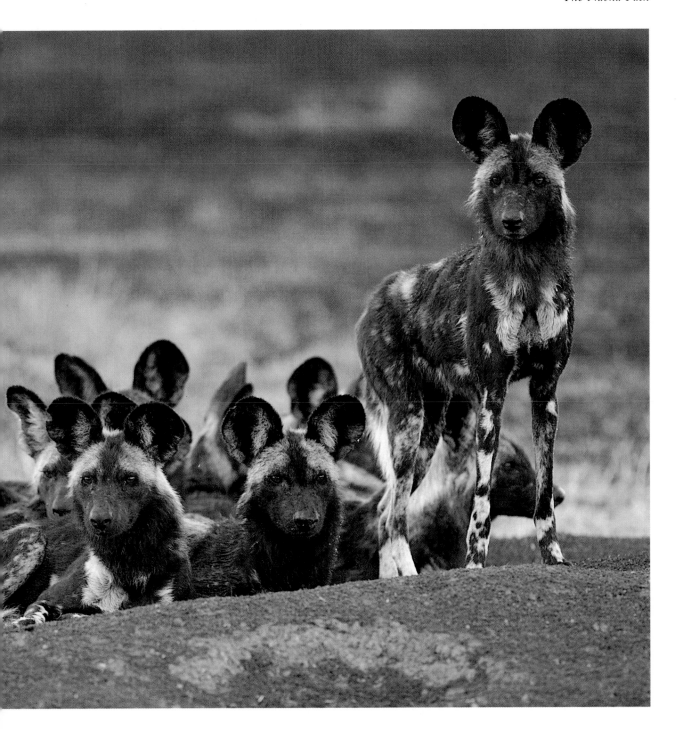

It was rather unusual to find so many wildebeest around Seronera at this time of the year. But then, there is nothing predictable about the rain, and it is the rain that determines the movements of the migration. The plains to the south, where I had been watching the Naabi pack, were dry. Here there was plenty of grass for the herds. Perhaps this was why the Ndoha pack had forsaken the acacia woodlands of the Western Corridor for these game-filled plains at the edge of their home range.

By now the majority of pregnant wildebeest had dropped their calves. This event more than any other marked the season of plenty for the predators. In the space of a few weeks 400,000 calves are born into the herds, tens of thousands of which perish within a month of birth. Some become separated from their mothers and are then doomed to die as a result of predation or starvation; no cow will suckle a calf that is not her own. These orphans stand out among the herds, desperately trying to attach themselves to other herd members or galloping alongside vehicles, even on occasion unwittingly seeking the company of predators, usually with fatal consequences. Others succumb to disease, or drown when attempting to cross a river or lake as they doggedly follow their mothers during their first migration year.

For the moment life was easy for the Ndoha pack. There were times when it hunted to perfection, stalking to within 100 metres of the motionless herd, then slicing in among the fleeing press of animals, deftly isolating a cow and calf before driving the mother away. Once caught, the calf would be dead in less than a minute.

A wildebeest calf's best form of protection out on the open plains is to avoid being seen, to submerge itself in the anonymity of such vast numbers. Usually when a cow wildebeest spots a predator she turns and quickly moves away, with her calf pressed like a limpet against the far side of her body. In this manner her long, blonde beard acts as a protective curtain, helping to shield the calf from view. Once it has been noticed, the calf's greatest chance of survival lies in speed and the stamina to outrun predators. Within a few days of birth a calf can gallop as fast as its mother and outdistance a lioness.

When the migration is massed on the southern grasslands, the plains provide ideal hunting grounds for coursing hunters such as wild dogs and hyaenas. Calves are the favoured prey, though the 4,000 hyaenas and a mere handful of wild dogs have relatively little

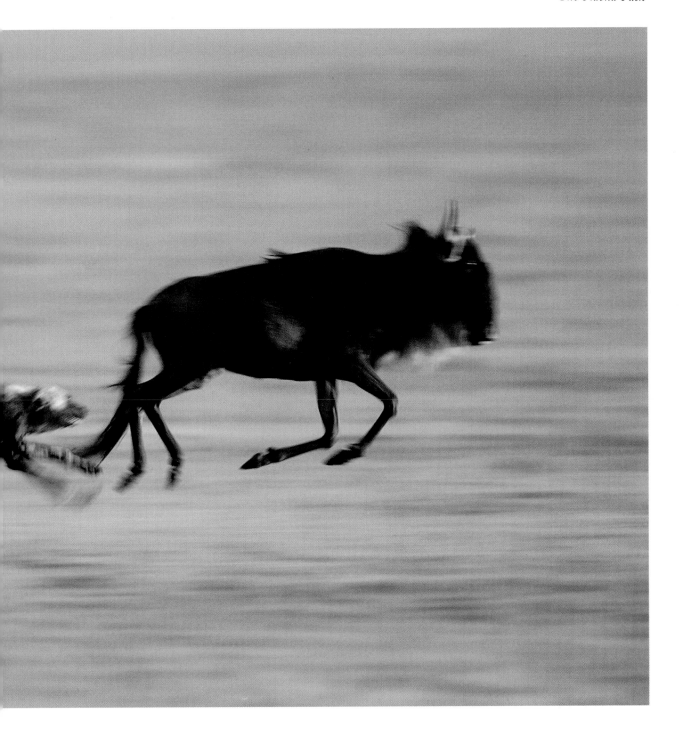

impact on such enormous numbers of migratory prey animals. It is the availability of dry-season forage, not the predators, that has, for the last twelve years, kept the wildebeest population stable at around 1·4 million.

Unlike the big cats, which must generally rely on their stalking ability to capture fleet-footed prey, wild dogs can match the pace of a wildebeest in a race across the plains. But the cows are particularly belligerent in defence of very young calves and quite often manage to stave off an attack by a single hyaena or wild dog. The calf appears almost as an extension of its mother, running flank to flank, matching her stride for stride. However, dealing with the attack of a pack of dogs, or more than one hyaena, is not so easy.

The Ndoha pack hunted later than usual on this wet and cloudy morning. It was shortly after 8.30 a.m. when the dogs singled out a calf from the herd. Within thirty seconds Shyster, the lead dog, closed in, grabbed the young animal by the flank and pulled it on to its side. The rest of the herd galloped onwards, distancing themselves from the place where the dogs had gathered to feed. But a lone hyaena had been attracted to the scene by the sight of the wildebeest scattering. It galloped flat out after the herd, intent on catching one of the new-born calves for itself. With a surprising turn of speed the hyaena closed to within a few metres of the animals in the rear of the herd, but was forced to turn off in the face of a determined charge by a particularly aggressive bull wildebeest. By the time the hyaena had recovered its momentum, the herd was a distant cloud of dust on the horizon.

An hour after the Ndoha pack had made its kill, the calf's mother reappeared. Usually a cow loses interest in trying to defend her calf once its bleats of distress have been silenced. But there are times when a cow will charge right up to the dogs as they feed, scattering them in every direction, pausing a moment to sniff at the remains of her calf before giving way to the hungry pack. She may stand at a distance before finally departing, mesmerized by the sight of the frenzied feeding of the predators, incapable of understanding that her calf is dead, forced by her instincts to wander back and forth across the plains long after the dogs have continued on their way. Such behaviour is not as futile as it might at first appear. Occasionally a calf becomes separated rather than killed during the panic surrounding an attack by predators or at a river crossing, and is later reunited with its mother thanks to her diligence.

Wild dogs are coursers rather than stalkers and are capable of sustaining a chase for five kilometres – page 101

This particular cow was not alone for long. As she hurried across the plain an orphaned calf fell into step beside her, galloping along as if it really had refound its mother. But the cow knew. Though it might look like her calf, it did not match the sensory memory imprinted within minutes of birth, enabling mother and calf to identify each other. She could smell that this spindly-legged creature at her shoulder was not her own. But the calf was less discerning, reassured for the moment by the familiar presence of a fellow wildebeest.

At first the dogs ignored the cow and calf. The pack had fed well these past few days and now they were content to rest through the hotter hours of the day in the shade of a tall clump of long grass, assured of easy pickings for as long as the wildebeest remained within reach.

The cow was nervous. Ahead she could see a hyaena emerging from a mud wallow; another lay nearby in the grass. She veered away, jinking and tossing her head, as if pursued already. The calf never faltered, following the cow's every move. Then a wild dog stood up.

The dog was one of the litter of ten puppies born on the Ndoha plains the previous year. At ten months old he was almost fully grown and though he had already proved himself capable of capturing a gazelle fawn, he was not yet experienced in killing larger prey animals. But the sight of the wildebeest calf excited the young dog, prompting him to move out a short distance from the place where the pack rested.

It was as if some unspoken command had been passed among the dogs. One by one they rose from the ground; one by one their ears went back. They moved out together, bunching up behind Collar, the two-year-old radio-collared male. The cow saw them coming, recognized the hunters for what they were and fled. She made no attempt to protect the calf, an unrelated creature that did not carry her genes. It stood alone, bewildered, unsure of the intentions of the dark shapes stalking slowly towards it. By the time the calf turned to run it was already too late; the dogs were almost on it. In a last desperate effort to defend itself the calf stopped, lowered its head and charged the dogs. As it did so Collar lunged forward and caught it by the upper lip. But most of the dogs were not really hungry. Having eaten the softer parts of the carcass they abandoned their kill to the hyaenas. Meanwhile, the cow had vanished over the horizon.

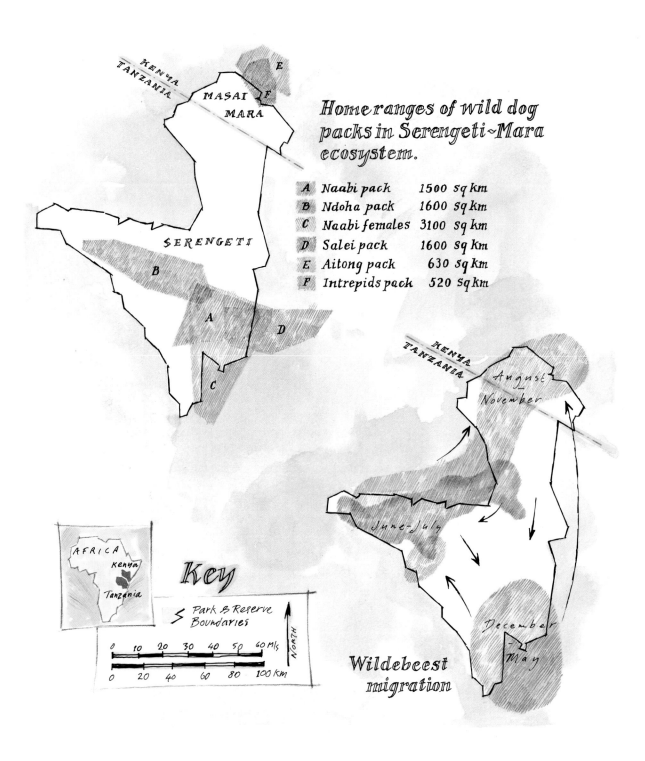

Home ranges of wild dog packs in Serengeti~Mara ecosystem.

A	Naabi pack	1500 sq km
B	Ndoha pack	1600 sq km
C	Naabi females	3100 sq km
D	Salei pack	1600 sq km
E	Aitong pack	630 sq km
F	Intrepids pack	520 sq km

KENYA
TANZANIA

MASAI MARA

E

F

SERENGETI

B

A

D

C

AFRICA
Kenya
Tanzania

Key

Park & Reserve Boundaries

0 10 20 30 40 50 60 Mls

0 20 40 60 80 100 Km

NORTH

KENYA
TANZANIA

August – November

June – July

December – May

Wildebeest migration

Kith and Kin

If we do not expect the unexpected, we will never find it.

HERACLITUS

Since the previous day the younger males in the Ndoha pack had been acting in an especially solicitous way towards their mother, Short-Tail. She excited them. Their greetings with her were even more boisterous and prolonged than usual; they repeatedly licked and nuzzled her vulva. I watched carefully to see the reaction of the older males, particularly that of Half-Ear, as I thought that Short-Tail must be coming into oestrus. But for the moment the dominant male seemed content to ignore the activities of the youngest of his sons, even though one of the older males, Shyster, was also now beginning to show interest in his mother.

It is usual for the dominant pair in a pack to rest together, curling up alongside one another, heads propped comfortably across the loin or neck of their companion, reinforcing the special bond of allegiance that marks them out from other pack members. But on this occasion Half-Ear and Short-Tail chose to lie some twenty metres apart.

Shyster – age-mate of Collar – was at least one year older than his seven younger brothers and was by now sexually mature. Any amorous intentions he harboured towards the dominant female might well be perceived as a challenge to his father's status. Shyster hovered in the vicinity of Short-Tail, following her when she moved, guarding her when she rested. Half-Ear stood watching close by. He did not immediately move to complete the pee ceremony when she urinated or try to harass Shyster in the way I expected. In fact he did none of the things that I expected.

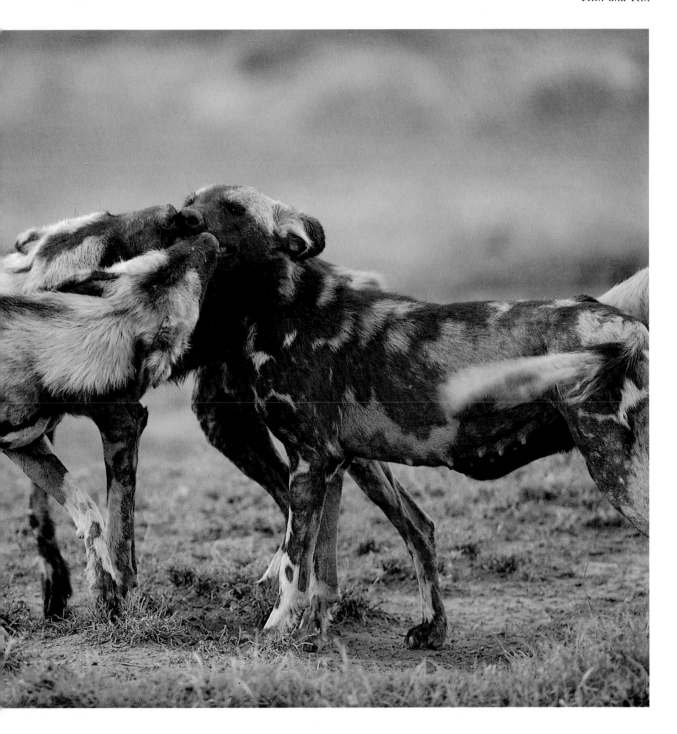

Wild dog social behaviour finds expression through a complex array of gestures and vocalizations, designed to lessen conflict and promote order within the pack. Ears, teeth and eyes are all used to communicate a dog's response, mirroring mood and intent. There are signals conveying every degree of appeasement and aggression. The benefits accruing to an individual by remaining within the pack are balanced by the eventual possibility of breeding. Beneath the harmonious veneer that characterizes the life of a pack, individual dogs promote their own best interests. Through a blend of guile and subtlety, force and strength, change is brought about.

Shyster was nervous. His urge to mate with Short-Tail was balanced by the need to appease Half-Ear; he sensed that his behaviour might cause Half-Ear to attack him. So he ran to Half-Ear and rolled, open mouthed, at his feet. But the dominant male seemed strangely indifferent, as if Shyster's actions were of no consequence to him.

Ten minutes later Shyster and Short-Tail mated. Half-Ear looked on impassively as the female sat with Shyster's front paws clasped over her hips. Then Shyster ran towards Half-Ear. He approached his father in a playful manner – head low, ears up, jerking his head from side to side – as if inviting Half-Ear to play with him. Now he fawned before the dominant male, squirming and whining, peeing in anxiety, licking at his face. Finally Half-Ear got to his feet and ended the interaction by shoving his muzzle down hard on to Shyster's throat, a blunt reminder of his status. During the next few days, he mated with Short-Tail himself, guarding her from further advances by the other males.

Half-Ear's initial indifference to Shyster's activities may not have been as inappropriate as it first seemed. Short-Tail was probably only just coming into oestrus, and as yet was not ovulating. The exclusivity of the pee ceremony conveys a major advantage on the dominant male in a wild dog pack. It allows him to monitor the sexual condition of his mate carefully and to determine the optimum time to impregnate her. This helps prevent unnecessary and possibly injurious fighting between the dominant male and his relatives which could only harm the social stability of the pack. Furthermore, by allowing other adult males to mate with her, regardless of whether they actually sire any of the puppies, the female encourages them to remain in the pack and help raise her puppies, rather than emigrate to try and find breeding opportunities elsewhere.

Members of a pack greeting each other. Ears are laid back as a sign of appeasement – page 107

Successful impregnation of a female by a number of males is not uncommon in domestic dogs, so it is possible that mixed paternity also occurs in wild dogs. Studies at present being carried out on wild dogs in the Serengeti and Masai Mara will soon ascertain if this is the case.

If Short-Tail had conceived, her puppies would be born in early June. In the meantime the best I could do was keep in close contact with the scientists monitoring the movements of the dogs. At the end of each month Markus Borner and Karen Laurenson flew a tracking flight over the Serengeti to pin-point the positions of radio-collared cheetahs and wild dogs; Markus also flew for scientists studying lions and hyaenas. Each new sighting was recorded on a map of the park, providing a more accurate picture of the home ranges of the Naabi and Ndoha packs, and of the two groups of collared females. This information will enable scientists to determine how much the dogs' movements are influenced by the seasonal availability of their prey, and to what extent the wild dogs wander beyond the safety of the park boundaries.

The use of a light aircraft to help track radio-collared animals has proved indispensable. From a plane, it is possible to detect a radio signal from up to forty kilometres away. Working from a vehicle the range is rarely even four kilometres. This is feasible once you know roughly where to begin searching for your study animal, but no better than a good pair of binoculars when trying to relocate such far-ranging species as wild dogs.

I drove south. It was time to leave the Ndoha pack to check on Mama Mzee and her puppies. But search as I may, I could find no sign of the Naabi pack. Hoping that perhaps I might be lucky enough to track them out on the eastern plains, I decided to pay a visit to Barafu. That seemed to be the general direction the wildebeest were headed and the site of Mama Mzee's den the previous year. Perhaps the dogs had followed the herds.

I had learned by now to skirt around the most southerly of the Gol Kopjes, not just drive as the vultures fly, to avoid jolting across a never-ending run of erosion terraces sculpted by wind and rain. Before long I reached the two deep furrows marking the path taken the previous year by twin-wheeled safari lorries. These had been used to ferry supplies to mobile tented camps, which had sprung up once people knew that the Naabi pack had denned at Barafu. But as

Members of the Naabi pack – Shaba, Mama Mzee and the yearling female born in 1986 who emigrated in 1987 to join her four older sisters – play-fighting – page 111

109

soon as the park authorities realized the damaging effect this might have on the fragile soils, the practice was stopped. Taking the jutting knife edge of Lemuta Hill as an easterly bearing, I continued until the largest of the Barafu Kopjes suddenly emerged from the swell of the plains.

Thousands upon thousands of wildebeest streamed south-east along the Ngare Nanyuki lugga and spilled on to the plains, encircling Barafu's seven kopjes in a black tide of animals. The misty morning air was heavy with the grunting chorus of the herds, the majority of which were bulls. The massed armies swept forward in a great arc, clipping the dew-laden grass before the sun emerged to rob it of its vital moisture. I stopped and watched, mesmerized by the sheer abundance of life.

Suddenly the herds panicked, bunching together then storming away. It was a sight that had come to mean only one thing – wild dogs. As they passed, I counted five dogs in pursuit of a yearling wildebeest. At first I could hardly believe my luck. Could it really be that the Naabi pack had once again taken up residence at Barafu? But when I drove to the spot where the dogs had made their kill I realized that it was not the Naabi pack at all; it was the four Ndoha females. Except that now there were five; they had been joined by a younger relative. This repeated the pattern of behaviour adopted by the youngest of the Naabi females in 1987, who was a year younger than the others. Some time after her older female relatives had emigrated she joined them rather than remain alone within her natal pack.

The Ndoha females were deep inside the home range of the Naabi pack. If their paths crossed, would the presence of the females prove sufficiently attractive to some of the younger Naabi males and cause a split in the pack?

The five females huddled together in the open. They made no attempt to seek shelter from the burning sun, ignoring the shade offered by a row of burrows excavated along the face of the erosion terrace. The dogs' breathing was shallow and rapid, accentuated by the sight of their long pink tongues lolled across rows of shiny white teeth. This was their only concession to the heat. By panting rapidly they kept themselves relatively cool. Later they would replace the moisture lost in evaporation from one of the rain-filled water-holes. The dogs' huge ears provide another means of controlling body temperature, by offering a large, vascular surface area to facilitate

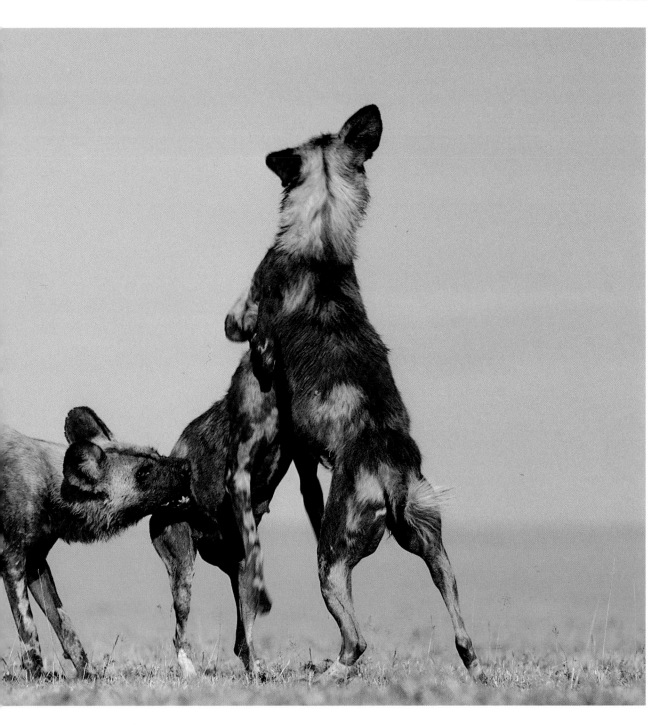

heat loss. In the Kalahari desert wild dogs must survive without drinking water for months at a time, relying on the body fluids of their prey and confining their hunting forays to the cooler hours of the day or after dark, particularly when the moon is full.

While I waited for the dogs to rouse themselves I made a series of sketches. Drawing each individual forced me to take note of the dogs' every features, making me see them anew. By the time they started to become active I could tell them apart. Three of the dogs were very black and had rather similar markings to Short-Tail. The fourth dog was more brindled and the fifth, the youngest, was a handsome combination of brown splashed with white. The females looked as if they were the offspring of three different generations or had been sired by different fathers – perhaps they were. If the litter is small and only one or two females survive to maturity, they may delay emigration until sisters from the next litter are old enough to leave with them to form a viable hunting unit. Sometimes young females emigrate in the company of their mother's sisters.

One possibility was that some of the females were Short-Tail's sisters. Once Short-Tail had established herself as the breeding female in the Ndoha pack, her sisters may have decided to emigrate again, a process termed 'secondary emigration'. Again, studies using the latest techniques of genetic fingerprinting on relatedness among individuals within a wild dog pack will help resolve this sort of speculation.

Shortly after 5.00 p.m. one of the black dogs stood up. It was the same dog that had led the group to their resting place. She moved towards one of the other black dogs, which immediately rolled on to her back in a gesture of submission. She then proceeded to walk round and round in a circle, cocking her leg and pee marking in the way that I had seen dominant females do. Her movements were quite different from those of a dog that simply needed to urinate. Was this a sign that the black dog was the dominant female in the group, free to advertise the fact now that she was beyond the rigid control imposed by Short-Tail? She visited each of the other dogs in turn, sniffing at one, removing a tick from behind the ear of another. Then she pee marked again. A little later the youngest of the females approached the place and sniffed the ground. If the females were to find new males, they would have to advertise their presence. They would need to travel widely, to call and to scent mark.

Having greeted, the dogs trotted north towards the Ngare

Nanyuki lugga, where the wildebeest were gathered in their thousands. They ignored two hyaenas which fled at the first sight of them. If they had been with puppies they would immediately have attacked the hyaenas, but these dogs were interested only in hunting for prey.

The dogs stopped and stared, scanning the herds for calves or yearlings. But try as they might, the dogs failed to make any impression on the wildebeest, except to prompt an outburst of grunts and honks which rippled through the herds, alerting each and every animal to the arrival of predators. Four or five times the females charged into the midst of the massed ranks of wildebeest, scattering them in every direction as they tried to identify young or vulnerable animals in their midst, but to no avail. Most of the wildebeest were bulls and seemed singularly unconcerned by the dogs' attempts to rout them. Eventually the dogs abandoned the wildebeest and, just before dark, killed a male Thomson's gazelle. I could not help thinking how fortunate it was that young females are often the fleetest of foot among the dogs in a pack, particularly adept at hunting smaller prey species.

The following morning I tried to radio-track the females from the roof of my vehicle but failed to pick up a signal. They and the wildebeest had vanished. The Ndoha females must endure the same bleak future as the five Naabi females, who were still without males. They seemed destined to spend their days in a futile search for mates.

On my way back to Gol Kopjes I passed the Barafu den site occupied by the Naabi pack for two and a half months in early 1987. It was bursting with life, yet somehow looked empty without Mama Mzee and the puppies. Zebra paused to slake their thirst, noisily splashing through the shallow pool. Gazelles clustered in a half-circle around the edge of the water, clipping the earth-islands of tender green shoots. Others nibbled at patches of bare soil for salt and minerals. I searched in vain for the capped wheatear, which had daily performed an eye-catching dance, hopping and bobbing, visually proclaiming his presence from atop a tuft of grass at the edge of the dogs' burrow. He would rise into the air and then drop like a feather, wings fluttering in a splendid display of controlled descent, giving voice with a piping call in his efforts to attract a mate and deter rivals. The surrounds to the den had provided him with a rich hunting ground: flies and other insects flourished on the scraps of meat and skin left by the dogs.

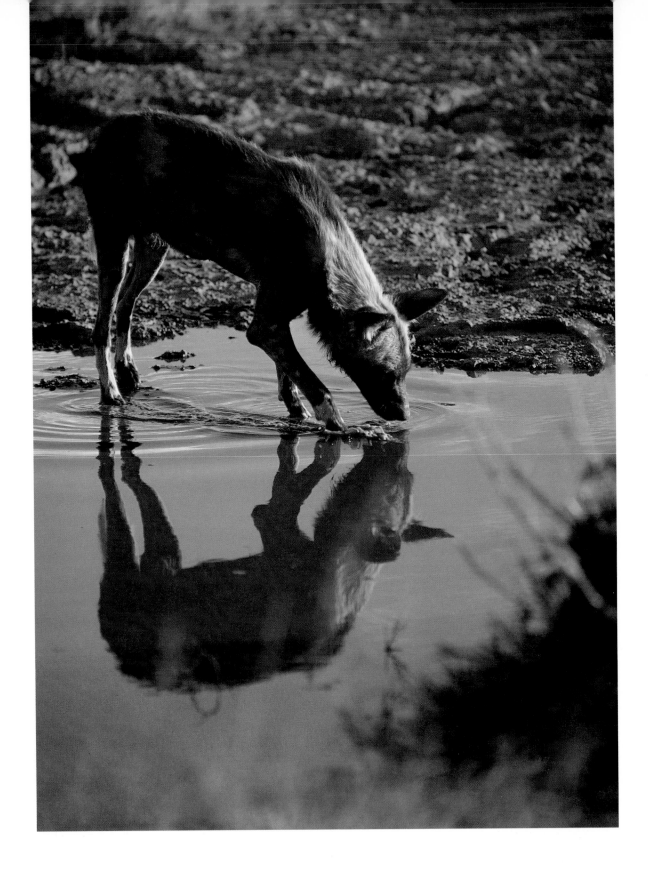

The sun struggled to blast a way through the dreary grey blanket enveloping the gaunt stone castles of Gol Kopjes. Here the surrounding plains are littered with holes and fractured erosion terraces. Metre-deep burrows jump out of the grass with a wicked earthy grin, ready at any moment to gobble up a front wheel or crack a spring. Driving across the plains encircling Barafu Kopjes had been a joy by comparison.

The air was thick and damp on this cold and misty morning. The swath of tussocky *Indigofera* and purple-flowered Sodom apple reminded me of a Scottish moorland. Parties of yellow-throated sandgrouse chuckled as they swifted overhead, briefly silhouetted against the white sky before merging in perfect camouflage with the green and brown tartan of the plains.

I stopped and checked again with my binoculars. My heart missed a beat at the sight of dark canine shapes gambolling about in the distance. They could not be hyaena cubs. Those clearly visible white-tipped tails were quite distinctive. They belonged to wild dog puppies. As I drove closer I realized that they were near the den that Mama Mzee had chosen for her puppies in 1986, the same site that the Naabi pack had occupied after first leaving Barafu in April 1987.

There was nothing to help me identify positively the place where the pack now rested. The only real landmarks on the surrounding plains are Naabi Hill to the south, Gol Kopjes to the east and the tip of Big Simba Kopje just visible to the north. I leafed through my old notebooks until I came to the page where I had drawn a profile of the countryside surrounding the den, showing the exact position of the largest of the Simba Kopjes in relation to the horizon. This had helped me relocate the den out on the featureless plains even when the dogs were away hunting. The sketch was identical to the view I now looked at. They were back at the old den. But unlike last year there was not a single wildebeest to be seen.

I reread my notes, visualizing how it had all looked to me the very first time I had visited the area in 1986. Then it had been dry and barren, ugly in its harshness. The dogs would invariably retreat to one of two nearby water-holes, where they could drink or wallow during the heat of the day. The five yearlings, Spot and his four sisters, particularly liked to play, gambolling about in the shallows until all would lie exhausted in the long, cool grass surrounding the water. Now, even though everywhere looked green, both water-holes were dry and the whole pack had taken to disappearing below

When water is available, wild dogs will drink regularly. But in dry conditions they can survive for months without water

ground to avoid the bludgeoning heat in the middle of the day.

I would never have found the exact location of the old den again without the drawing to jog my memory. But the dogs had. It was as if they possessed their own map of the area. Why should I be so surprised? I know that although wild dogs roam over a huge home range, certain key places of interest are visited time and time again – erosion terraces and old hyaena dens, water-holes and reedbeds, tree-lined valleys and clusters of bushes. A familiarity with such sites is passed on from one generation to the next: young puppies learn and remember, as adults, the location of important places. It is hardly surprising that the dogs revisit old den sites. They are invariably situated close to seasonal water-holes, where a lactating female can most often find water, the very same places that any wild dog or hyaena might choose to rest during the daytime, providing both shade and the possibility of a drink and a wallow.

It was good to see the Naabi pack again. One of the adults was busy chewing over the remains of a male Thomson's gazelle that had been brought back for the puppies to feed on. The dogs often did this once the puppies were old enough to deal with larger portions of food, such as the head and neck of a gazelle, a piece of ribcage or a leg bone. Scruffy had even carried a live Tommy fawn back to the den one morning but was confronted by Mama Mzee before he could reach the puppies. The old male twisted and turned as he attempted to keep it away from her, but she was not to be denied, forcing him into a tug of war that quickly tore the fawn in two.

The four male and seven female puppies looked fat and healthy and made no attempt to retrieve the scraps from the kill. They had obviously already eaten their fill. The dogs lay on their sides, occasionally lifting their heads and pushing their noses into the breeze. Tall grass stems, left ungrazed by the passing herds, sprouted feathery seed heads one metre tall around the main den. A pair of crowned plovers, held motionless for a moment in the face of the wind, screeched out a warning as a harrier swept low over the plains, a dark shadow menacing the camouflaged world of the grasslands. The wild dogs looked up. It could have been a lion or a hyaena approaching. Agama lizards and grass rats scurried for the safety of the nearest hole. As one, 100 heads jerked skyward: with large brown eyes reflecting pinpoints of light, parties of yellow-throated sandgrouse and Caspian plovers shuffled closer together for protec-

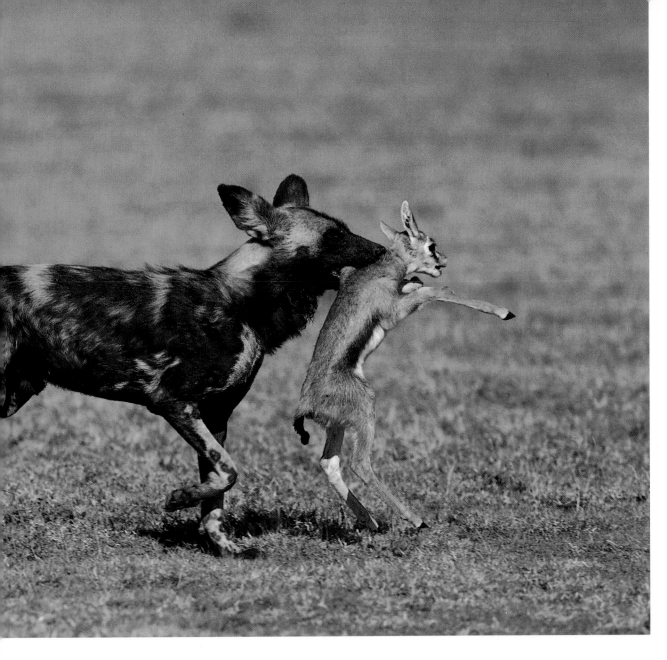

Scruffy carries a live Thomson's gazelle fawn back towards the den

tion, crouched low, ready to launch themselves from the ground. But on this particular morning the harrier swept onwards, effortlessly distancing itself on long, curved wings.

The heat haze rippled across the coarse mantle of *Indigofera*, creating a mirage of galloping animals. Black shapes stumbled through the haze. Were they ostrich, or vehicles perhaps, or could it be the first few wildebeest – a trickle of animals that would build into a flood of hundreds of thousands once the rains returned? For the moment the herds were cloistered at the edge of the woodlands beyond Lake Lagarja, waiting for the storm clouds to break. In 1986

conditions had been so dry that when the wildebeest had traipsed across the lake, the water barely covered their ankles and not one animal perished. In wetter years many hundreds of calves are drowned or become separated from their mothers as they struggle to keep up.

Not a single drop of rain had fallen on the plains during the last two weeks. The land looked desolate, battered by heat and dust. Nothing remained but the wind-weathered grass. If I were to drive ten kilometres – twenty even – from where the dogs lay, I knew I would not find a single wildebeest. And nor would the dogs. Instead, the Naabi pack scoured the plains surrounding the den, taking whatever they could find: adult Thomson's gazelles, fawns and hares. Perhaps it was time for the dogs to wander further afield now that the puppies were big enough to follow.

The clouds swelled, crowding out the sun. I moved around my car, trying to find a scrap of shade. Heat clung to the ground and filled the car with its sleep-inducing embrace. Just occasionally a cool breeze evolved to dissipate the humidity. The cloud-filled sky promised relief but each day it faded into the night. Surely it must rain? Too soon, said the rangers; it will come when it is ready; be patient.

I stared into the distance. The massive shape of Lemagrut mountain was barely visible. Gol Kopjes beckoned, dark shapes breaking through the swell of the plain. There I could find shade, perhaps even a rain-filled rock pool. But my fuel supply was too precious to indulge that luxury, and besides, it meant leaving the dogs. Something of interest might happen while I was away, something I had never seen or photographed before.

Mama Mzee stood looking out across the wind-torn plain, surrounded by yet another writhing mob of fawning pups. It was extraordinary to realize that the old female was responsible for the creation of every one of these dogs, except her mate Shaba and his brother Scruffy. Twenty-four offspring representing three generations of puppies; each year a new litter, helping to repopulate the plains. The Naabi pack had proved that, protected from persecution by man and free from serious disease, wild dogs are quite capable of surviving on the Serengeti plains, despite the competition from enormous numbers of hyaenas.

At first the dogs failed to notice the herd of wildebeest marching

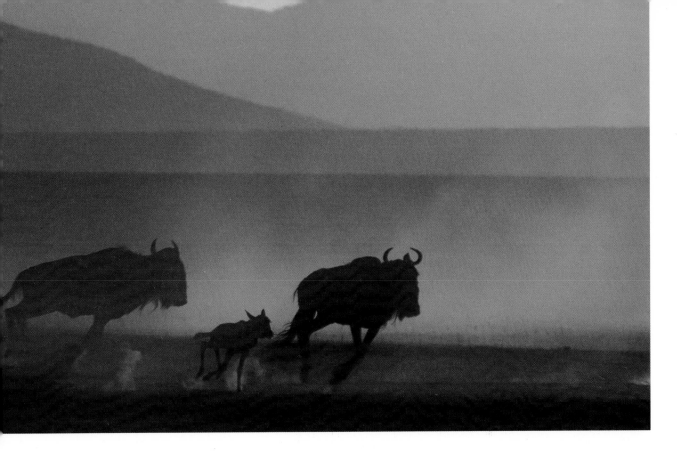

resolutely across the plains towards them. With their heads tucked tightly against their bodies, they were interested only in keeping the chill air at bay. If the wildebeest saw the dogs they made no concession to the fact, even though they were accompanied by a number of yearlings and calves. One more minute and they would be safely out of sight, shielded from view by the dip and swell of the surrounding plains.

Scruffy stood up and stretched, eyes half closed. For a moment the herd paused, rooted to the spot, responding to the unexpected movement of the predator. Suddenly there were fifteen dogs standing, watching, staring towards the herd. The presence of young calves ensured that the dogs would attack. The pack moved out, bunching together, falling into step like a well-trained squad of soldiers. Closer and closer, short, measured steps, waiting until the first wildebeest panicked and fled. It was the sight of the animals running from them that set the dogs on their heels.

There was no escape. Fifteen dogs raced towards the herd, deftly isolating the cows with calves or yearlings. The pack did not concentrate on capturing just one animal; a number of dogs took the initiative by pursuing different wildebeest. As soon as they had successfully anchored their prey, some of the dogs hunted again or joined others still involved in a chase. In this way the pack was able to

The sight of wildebeest calves guarantees the attention of a pack on the hunt

119

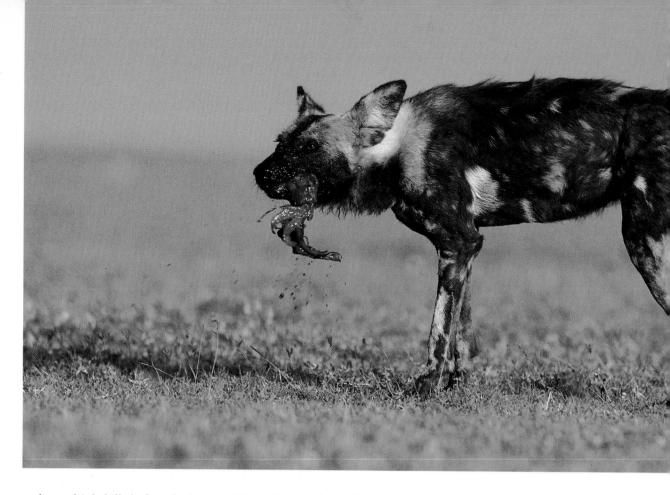

make multiple kills before the herd could outdistance them. By the time the dust had settled the dogs had killed a calf and two yearlings within a kilometre of the den.

Hyaenas watched as the wildebeest galloped into the distance. The four rough-coated predators knew better than to contest ownership of the three kills with so many dogs ready to defend them. This was not the moment. They could only stand and watch as individual pack members hurried back to the den to regurgitate for the puppies. Initially the puppies ignored their older relatives each time they turned their backs and returned to the kills. But after a while they seemed to sense that it was safe to follow in the adults' footsteps. The eleven puppies kept close together, slightly nervous, responding to each other's movements, faltering, then surging forward again. It was a momentous occasion for them. They were breaking new ground, the first tentative steps that would soon free the pack from the restrictions of the den.

Seeing the puppies approach, the adults ran back and escorted their young charges to the carcass, encouraging them, and then stood aside to let the puppies eat their fill. This was always the case once puppies arrived at a kill. Without any urging, and without

At about fourteen months of age wild dogs can kill adult Thomson's gazelles for themselves. But when hunting they benefit greatly from the support of older, more experienced pack members.

exception, the whole pack would step back while the younger dogs fed, forming a protective shield against the threat posed by hyaenas. It was a pact, a compromise for the benefit of all. The adults could always hunt again – and again – if necessary, to provide sufficient food for themselves. No other predator could compare with the hunting efficiency of a pack of wild dogs.

It was just like old times. The sense of harmony and cooperation was still to the fore. Yet things had changed. Watching the dogs hunt made me aware of the inevitable transitions that take place in every wild dog pack: the way younger dogs learn and mature as hunters by associating with older and more experienced pack members. The yearlings were swift enough to kill small prey animals such as gazelle fawns on their own, but their lack of experience betrayed itself as soon as they attempted to confront larger prey requiring expertise and cooperation among pack members. At fourteen or fifteen months old dogs can catch adult Thomson's gazelle, but their finishing is poor and needs time to develop – a luxury that being a member of a pack provides. Dogs of this age sometimes lack persistence and benefit greatly from the help of older males. They still need the experience of dogs such as Scruffy, who had learned just the right moment to separate a young wildebeest from its mother without being tossed or kicked off his feet, and when and how to grab a larger prey animal by the nose or throat. On one occasion I saw a lone yearling struggling to subdue a large wildebeest calf by hanging on to its nose. Each time the dog let go and attempted to feed, the calf struggled to its feet and broke free. In similar circumstances Scruffy would have killed the calf with a strangle hold.

The most obvious change in the Naabi pack was in the development of Spot (who was now three years old) and, to a lesser extent, his two younger brothers. It was still Mama Mzee who most often set the course when the dogs left the den, but once prey was sighted and the pack began to close on its quarry, it was Spot who took the lead, flanked by his two younger brothers. Every so often Spot would pause to look around, slightly unsure of himself, making certain the rest of the pack was following. Sometimes his initiative petered out for lack of support, but there was no denying the new sense of purpose in his stride and his bearing. He would often streak ahead of the pack to close on a calf or yearling and grab it by the leg or tail. And when he did, Scruffy or Shaba would be there

At times subordinate males will exploit the opportunity to mate with the dominant female. In this instance, Scruffy mates with Mama Mzee just after Shaba had left the kill to feed the puppies – page 122

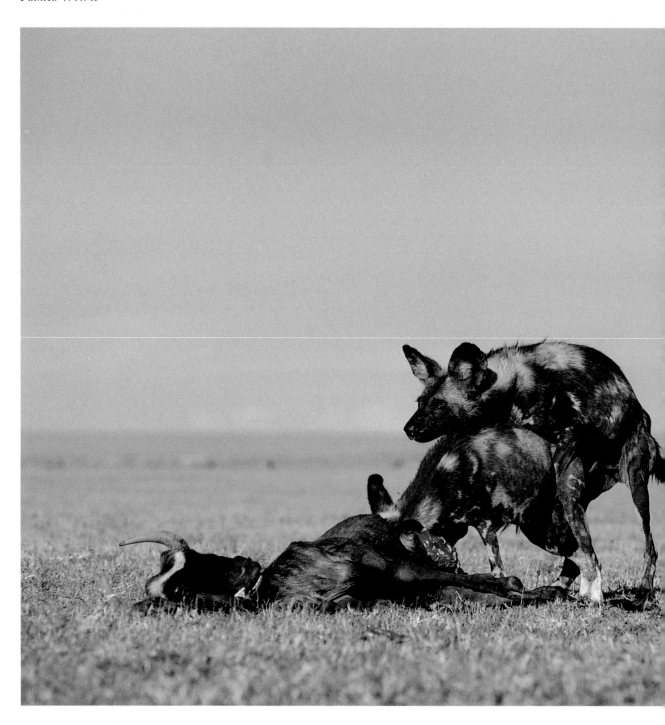

to hold it fast by the nose and throat.

A breeding female is rarely challenged; none of the females I watched lost their dominant status. But the situation is different for males. When a new pack is formed, the dominant male's brothers often remain with him rather than immediately emigrate again to find breeding opportunities for themselves. And at times they are allowed the privilege of mating with the dominant female. There was no denying the fact that the subordinate males took a great interest in the dominant female, though with the care necessary to avoid too severe a reprimand from their dominant brother. If for some reason Shaba was absent Scruffy might take his place alongside Mama Mzee or try to mate with her. But Shaba was quick to reassert himself when he arrived on the scene. I watched as he admonished Scruffy when he found him nestled next to Mama Mzee, approaching with his eyes fixed on his brother and ears cocked, forcing Scruffy to whimper submissively and move aside. Would Spot, I wondered, end up like Scruffy? Or could it be that chance and individuality had other plans for the younger male?

What a sight it was to see so many dogs together. Perhaps, given time, the plains population really would recover. Each morning and evening the puppies tried to follow the adults, expanding their horizons, gaining confidence. There were distractions aplenty. Everything was new and interesting: burrows to investigate, patches of vegetation to be chewed or peed on, lizards to chase and old skulls to be carried around. Mama Mzee and the other dogs no longer attempted to hurry the puppies back to the den. Often they lost interest after going a short distance and stopped to play with one another, absorbed in a different world from the older dogs, a world dominated by chasing and fighting, playing and dozing, eating and sleeping. As the rest of the pack disappeared over the horizon the puppies would eventually wander back to the security of the den area.

Soon the puppies were ready to trail along behind the adults, always with one or other of the dogs close at hand to control the inevitable panic that set in when the pack charged after their prey. Initially, with wildebeest and dogs running in all directions the puppies were frightened and confused by the commotion. They might also be left way behind when the pack took off after gazelles. But before long one or more adults would race back to the spot

where the puppies sat waiting and lead them to the kill. They were old enough now to follow wherever the pack chose to wander.

As the Naabi pack drifted away into the darkness I found myself thinking about the Ndoha pack. Where were they at this moment? In little more than a month Short-Tail should give birth to a new litter of puppies. Would she return to the Ndoha plains and choose the same den site as last year? The Serengeti plains and the woodlands are two different worlds, inhabited by different kinds of animals. Lions and hyaenas, wildebeest and zebra are to be found in both areas. But among the wooded grasslands there are also many more topi and Coke's hartebeest, as well as buffalo and giraffe, dik-dik and impala. Did the Ndoha pack prey on different species in the Western Corridor to those taken by the Naabi pack? And what about the poachers?

Journey to Handajega

What now remains compared with what then existed is like the skeleton of a sick man, all the fat and soft earth having been washed away, and only the bare framework of the land being left.

PLATO

At the end of June Charlie Trout agreed to fly a tracking flight to try and find the Ndoha pack and see if they had denned. Both Charlie and Markus Borner work for the Frankfürt Zoological Society, the largest donor of conservation funds to the Serengeti. Charlie is an aircraft engineer by training but is one of those gifted individuals who can turn his hand to just about anything – a valuable attribute for someone living in the bush. Whatever the requirement, be it building a house or overhauling a Land-Rover engine, Charlie is up to it.

First we decided to check on the Naabi pack. Karen had caught sight of them a few days earlier while searching for cheetahs. They had been resting near the main road, halfway between the Simba and Gol Kopjes. Now we located them just to the north of Barafu Kopjes. The yearlings and the puppies lay in two tight bundles out on the open plains, the predominantly brown and yellow coats of the puppies blending perfectly with each other. They cocked their ears as we flew overhead.

Considering the harshness of their surroundings the dogs all looked in remarkably good condition. This is the hardest time of the year for predators trying to eke out an existence on the short grass plains. With the departure of the wildebeest migration, the pack was roaming far and wide in its efforts to secure sufficient prey to satisfy its needs. The six-month-old puppies were growing rapidly but were still too young to contribute to the hunting efficiency of the pack. It would be at least another six months before they could participate effectively in helping to capture larger prey species.

Charlie pulled away and headed towards Lemuta Hill and the Gol Mountains. It was here that Markus and Karen had located the Salei pack – the newest and smallest pack of wild dogs living in the Serengeti. Shortly after I had last seen them in March, Spot had left the Naabi pack with his younger brother, Limp, and joined up with a pair of unknown females. No one was sure if the males had left their natal pack of their own volition or if they had detected the presence of the two unattached females and gone to find them.

Fortunately, John and Clare had fitted Spot with a radio-collar just before the Naabi pack left their den at Barafu in April 1987. Without it we would probably never have known where he and his brother had disappeared to. If the Salei pack denned on the eastern plains at this time of the year, they would have difficulty finding sufficient food while shackled to one place with small puppies. Karen was particularly anxious to relocate Spot as he had not looked well the last time she saw him. But search as we might, we were unable to pick up a radio signal from the Salei pack, so we turned back. It was time now to fly over the Western Corridor.

We swept through the sky, the sun glinting on the radio antennae jutting like giant silver toasting-forks from the leading edge of the plane's wings. The sky turned hazy as we entered the wooded grasslands of the Corridor. Ahead of us I could see the Ndoha plains smouldering beneath a thick pall of smoke. I listened intently, willing the receiver to spring to life as we passed the previous year's den site, but the dogs were not there. We continued west to where Karen had last seen the Ndoha pack during the tracking flight in early June. In the distance a palm-speckled arm of the Mbalageti river snaked south across the plain. Nearby a huge herd of chestnut-coloured topi stood motionless at the edge of a dry lugga, and further off wildebeest threaded black through the golden grass, plotting their daily path to water.

Beep . . . beep . . . beep . . ., almost inaudible at first, then pulsing stronger. We checked the map. Karen felt sure that the dogs were in virtually the same place as a month ago. We dropped from the sky like a vulture descending on a carcass, leaving my stomach a kilometre above me. Up popped a dog from out of the blond grass. Charlie pulled the plane around and brought us in low for a closer look. Other dogs sprawled in the shade of the long grass close to where shallow pools of water languished in the drying belly of the lugga. As we circled overhead I noticed a narrow pathway leading

directly from where the pack now rested towards a naked mound of earth. Three dark holes pierced its sides.

It was surely too much of a coincidence that such far-ranging creatures as wild dogs would be located in exactly the same place four weeks after they had last been seen. They must have established a den. The only way of knowing for sure was to drive out and see for myself.

From the air we traced the route I would need to follow from Handajega guard post to reach the place where the dogs now rested, some twelve kilometres away. They were located in the middle of a large unburned section of the plains, enclosed on three sides by tributaries of the Mbalageti river, which had halted the westerly march of the fire. Charlie pointed out a poacher's track that ran between the park boundary and a southern tributary of the river. At least there would be a clearly marked crossing-point to guide me towards the den – if there really was a den.

How beautiful it all appeared from high above the ground. It was another world, a part of the Serengeti where tourists never ventured, a land stamped with all the features of wilderness. There were mountains, the Mbalageti river and acacia woodlands interspersed with open plains country. Already I could feel a sense of excitement building up, the anticipation of exploring new country for myself. This would be a real Serengeti safari; the dogs would be a bonus.

I tried to visualize it from the ground. The bird's-eye view afforded by the plane would soon evaporate into the reality of water-filled drainage lines and rock-strewn hillsides. How many times in the past had I been directed to a place only to find that it all looked quite different from what I had imagined? From the air the grass looked short and the view unimpeded; luggas appeared easy to cross and hills smoothly contoured. The truth would be different. I searched for landmarks. One particularly distinctive pyramid-shaped hill stood out to the east. Apart from that my best bet would be to find the poachers' track and then hope to pick up a signal with the radio-tracking equipment. Fording the Mbalageti river would be the first major obstacle.

I spent the next day at Seronera, packing the vehicle with tinned food and photographic equipment. That night I feasted with friends – a wonderful meal of beef and cabbage, roast potatoes with rich onion gravy. No one hesitated to accept a second portion; tomorrow

it would be sardines or corned beef, and dreams of something better. As I lay restlessly in my car, waiting for sleep to release me from visions of the Ndoha pack, two jackals started to bark their distinctive high-pitched yelps of alarm. It was as if I could see the leopard, the white underside of its tail curled high above its back, hurrying to distance itself from the attentions of the smaller predators. And later still, I felt sure that I heard the leopard's spine-tingling, rasping cough. Fading . . . fading.

Seronera looked parched, the soil ashy grey, the grass rustling dry and lifeless in the teeth of the breeze. The mornings, though, had been wonderful these past few days, chill and invigorating, with the clarity of the air intensifying the colours. I turned off the road at the signpost pointing towards the guard posts at Kirawira and Ndabaka. Two and a half hours over rough roads and with luck I would be there before nightfall.

The heat was stifling, a sudden gust of air unbelievably refreshing. Nyaraswiga Hill stood out in sharp detail, etched clear against a brilliant Serengeti sky. To the north stood the unmistakable blue profile of Kubukubu, a strange hump-backed hill that always reminded me of the sculpted dorsal fin of a giant sea monster emerging from a green sea of grass.

I searched the skyline. The darkly silhouetted shapes of a pair of tiny klipspringers perched like lofty sentinels on the highest point of Nyaraswiga, 300 metres above the plains. By revealing themselves so clearly the antelope helped proclaim ownership of a territory encompassing a few hectares of rock and bush. Here they could browse on a variety of plants and raise a single young annually. From their rocky lookout, one or other of the lifelong partners could always be on the alert for predators such as caracals or leopards, and those other hunters that soared in the sky above them, the giant martial and Verreaux's eagles.

All life seemed to wilt in the dry afternoon heat. The only noise came from the hostile buzzing of scores of tsetse flies imprisoned inside my car. An angry black cloud of the biting insects followed in my wake. Birds fell silent, animals ceased feeding. The flick of a tail, the twitching of a large hair-filled ear betrayed a shadow within the thorn scrub. A small party of Thomson's gazelles moved in short, nervous strides through chest-high stubble. For the moment they were safe. The predators had long since sought the shadows of rock, cave or lugga.

Every year, grass fires sweep through parts of the Serengeti. Some occur naturally, some are set by poachers and cattle-rustlers, and others are deliberately started by the Parks Service to create fire-breaks – page 131

Much of the Western Corridor is whistling thorn country, infiltrating the plains like the silvery shadow of an old man's beard. The slender bushes – a type of acacia with characteristic black galls – grow in stands, as if planted by hand in neat rows across the plains. Driving through the thickets one is forced to crush the nail-sharp thorns beneath the wheels of the car. Days later the spikes of wood will have burrowed their way through the tyre casing to puncture the inner tube. Interspersing the patches of thorn bush are a series of open plains where wildebeest, zebra and Thomson's and Grant's gazelles gather to feed during the dry season. This is the kind of place where wild dogs search for prey.

In the distance I could see tall spirals of smoke crowding out the blue sky. Dust devils danced restlessly across the land, whipping the dry remnants of the grass into the air, wafting them onwards. Gazelles and wildebeest continued feeding until it seemed they must surely be engulfed, walking then trotting just a few steps ahead of the heat and the flames. One amorous male Tommy paused long enough to mate as the flames lapped around his ankles.

The series of early burns initiated by the Parks Service during the last two weeks had proved a resounding success. Burning when the grass is still relatively green is far less damaging to the woodlands and, by creating fire-breaks, helps pre-empt the potentially devastating fires started sporadically during the dry season by poachers and cattle rustlers. Setting fire to the grass makes hunting easier for the poachers, attracting the game animals to the green regrowth, and, in the old days, made it easier to recover poisoned arrows. One fire during 1967 raged uncontrolled for three weeks, consuming 3,000 square kilometres of dry-season forage.

Though huge tracts of grassland had been scorched to a stubble, the precious woodlands remained green and luxuriant. Freshly burned areas appeared blackened and desolate to the eye, smudging the clean white stripes of the zebra herds as they passed through. Within the space of a few minutes the hidden world inhabited by grasshoppers and crickets, lizards and puff-adders, was revealed for all to see. Marabous and white storks, stilt-legged secretary birds and ground hornbills traversed the naked plains in their search for food. The sky above was filled with all manner of insectivorous birds: sand martins and black rough-wing swallows, lilac-breasted rollers and drongos gathered for the feast, swooping and swifting to snap up the clouds of insects trying to escape the fire.

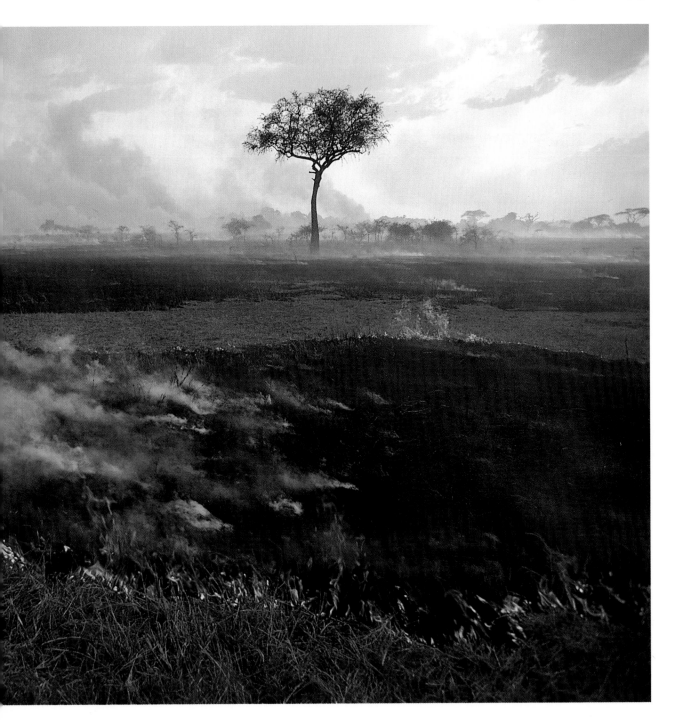

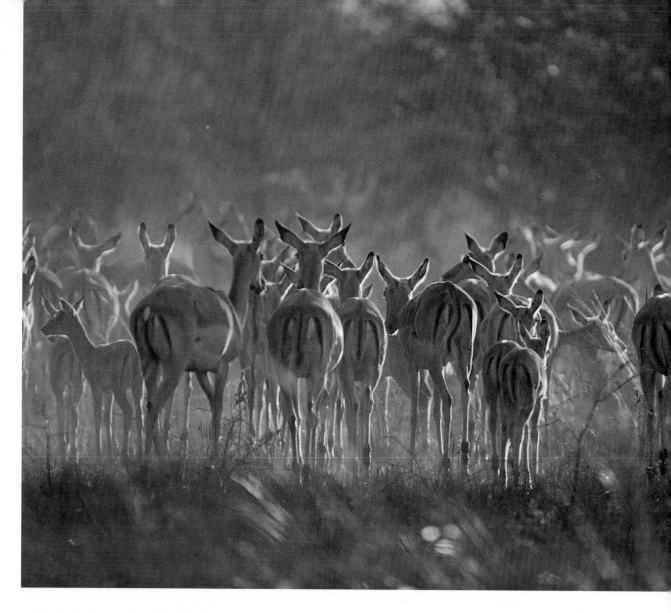

As the darkness closed in, the larger avian predators departed for their tree-top roosts. Ghostly shapes emerged from bush and burrow to take their place quartering the foot-sore stubble. A side-striped jackal, serval cats and white-tailed mongooses all arrived to search out the victims of the fires. Ahead of me flames lapped hungrily at the edges of the dry grass. I stopped the car. It was as if the whole of the Serengeti were ablaze. Tongues of fire flickered against the ink-black sky, barring my progress. The dogs would have to wait until tomorrow.

I had been forewarned by one of the scientists that it might prove difficult to find the track leading to Handajega guard post. How right he was. After a fruitless three hours spent exploring on either

A group of female and young impala

side of the main road between Kirawira and Ndabaka, at the very west of the park, I headed back towards Kirawira, stopping every so often to seek advice from fellow travellers along the road. An old safari hand in a battered Land-Rover mused that the concrete drift across the Mbalageti marked on the map had been out of action for the last ten years or more. And as for an alternative track – well, he knew nothing about that.

I was beginning to realize just how little of the Serengeti I knew. Like many people, I was familiar with its major features, the kopjes, short grass plains and Seronera valley, but only some of the kopjes, a few of the larger plains and the woodlands by name alone. The better-known vehicle tracks barely scratch the Serengeti's vast surface.

An Italian construction worker engaged in the building of a new tourist camp on the banks of the Grumeti river sounded more optimistic. Yes, there was a track leading to Handajega used by parks personnel during the dry season; the rangers would be able to show me the exact place to turn off. But when I asked at the guard post the rangers seemed strangely non-committal. There was a track, but it was still impassable in the wake of the rains; I would have to drive all the way to Ndabaka and then double back along the boundary track if I wanted to reach Handajega.

I suggested that I take a ranger to have a look; perhaps we might find an alternative crossing place. If we did manage to cross, we could proceed to Handajega and search for the dogs before returning to Kirawira. Eventually a ranger agreed to guide me. We would go, have a look and be back before nightfall. I tried to contain my excitement. The Mbalageti river was now all that stood between me and the dogs.

Ranger David directed me to leave the road and head south across the plains. No wonder I had been unable to find the track. It was only after a kilometre or two that it became visible, and then barely so. The parks patrol vehicles had only just started to use it again. We crossed a saddle of high land cutting through some of the prettiest woodland I had ever seen. Impala melted in and out of the dappled shade, blending toffee brown with the rich tones of the early dry season. Olives and African greenhearts grew side by side among a thick carpet of acacia bushes and drying oat grass; colours of green and brown blended to the shades of a Canadian autumn. Ahead of us a band of thick green vegetation marked the tortuous course of the Mbalageti river.

Three of the yearlings from the Ndoha pack. Their huge ears are important in signalling mood and intent, in locating long-distance calls from other pack members, and as a means of evaporative cooling – page 135

133

Could this really be the place? What I now looked down on hardly deserved its name as a river. It was nothing more than a shallow puddle in a sand-choked ditch. Or so I thought. The only impediment it presented appeared to be a precipitous sandy bank leading to the water's edge. Tyre tracks were clearly visible across its muddy bottom where a parks vehicle had recently crossed. Yet I hardly needed reminding of the limitations of my own vehicle: it was built like a tank and weighed almost as much. It projected a metre and a half beyond the back wheels, predisposing it to snag at the slightest opportunity. The crossing certainly looked innocuous enough, but would the old battle-wagon condescend to lift its grossly overweight rear end out of the mud? There was always the winch to pull us out if we did get stuck.

We crossed with almost embarrassing ease.

I had always thought of whistling thorn as being a rather small type of acacia. Elsewhere annual fires stunt the growth of the wispy bushes, in places keeping them to within a few metres of the ground, but here they had escaped the fires, growing as trees to six metres tall. Wild, spindly branches reached out like spiny fingers to snag and rip, impeding our way with a mesh of tightly interlocking thorns. The track stumbled blindly onwards through window-high grass, jolting us over concrete-hard ground rutted with the spoor of hippo and buffalo, giraffe and antelope. But nowhere did I see signs of elephants. They had long since fallen prey to the poachers' guns. We crested a rise, the land falling away to the south in a spectacular moonscape of desolate plains and rocky outcrops. A kilometre ahead the glint from a handful of shiny metal huts welcomed us to Handajega guard post. It was nearly 5.00 p.m.

David explained to Abnel Mwampondele, the corporal in charge of the guard post, the reason for my visit. It was decided that we should leave immediately to try and locate the dogs before nightfall. Abnel directed me to the track demarcating the boundary of the park. It was not hard to find, mirrored for kilometre after kilometre by huge fields of maize crowded hungrily along the edge of the park. Move a few metres north of the farms and you were a trespasser in the Serengeti.

Within half an hour we had found the poachers' track that Charlie had pointed out from the air. At the point where the track crossed the Balejora river – a tributary of the Mbalageti – a large fallen tree barred our way. 'It is supposed to help keep the poachers out,' said

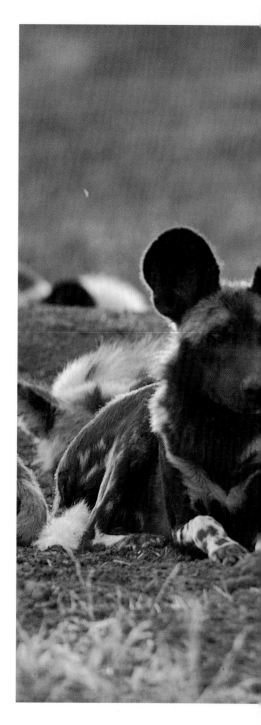

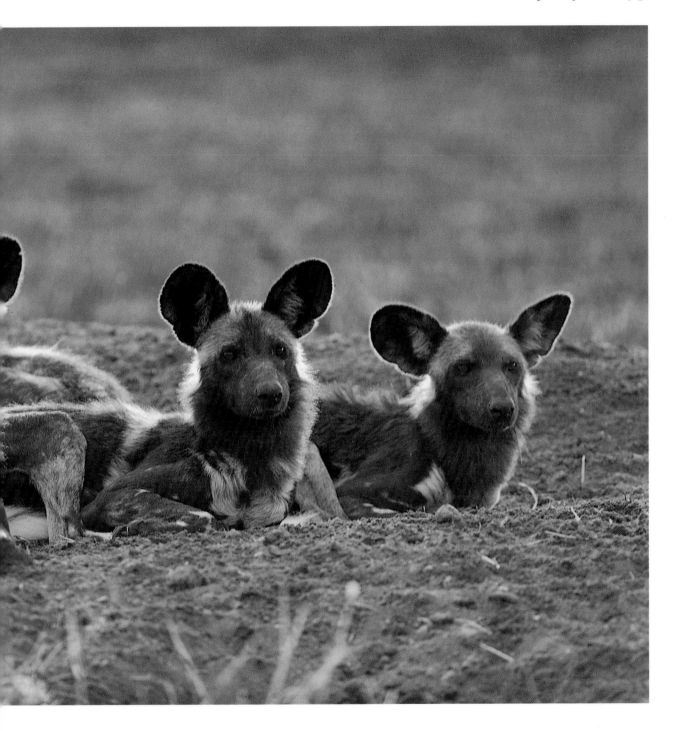

Abnel. But already a fresh track had been cut around the obstruction. It would take more than that to keep the poachers at bay.

The Western Corridor has always been known as poachers' country. The Chief Park Warden of the Serengeti, Bernard Maregesi, who was previously in charge of the anti-poaching campaign, had told me that some of the landowners living along the southern boundary of the park had guns, supposedly to protect their crops from wild animals. But he added that it was common knowledge that those same guns sometimes found their way into the hands of the poachers. During the rainy season, when the area's black cotton soils became impassable to vehicles, the poachers operated for months on end with little fear of apprehension.

I climbed on to the roof of the car and slowly rotated the antenna of the receiver. If the dogs were within a few kilometres I should be able to pick up a signal. Nothing. I tried again. Still nothing. Suddenly the surrounding country looked horribly similar. Which

Abnel Mwampondele, the corporal in charge of the Handajega guard post, on anti-poaching patrol. Wire snares are the commonest means of trapping wild animals for meat

136

of the three or four luggas was it that the dogs had chosen as their resting place? It had all looked so clear from the aeroplane. What had appeared to be a relatively flat vista of open plains dipped and rolled to the horizon, obstructing the view. The possibility that the Ndoha pack had not denned did not bear thinking about.

The rangers pointed skywards, where I could just make out a dozen tiny black specks against the blue. Vultures. My spirits soared; perhaps the dogs were on a kill. We hurried to the place, only to find the head and ribcage of a bull wildebeest buried beneath a seething mass of birds. It seemed unlikely that this was the work of wild dogs. They did not possess powerful enough jaws to butcher a carcass as completely as this. Neatly cut strips of skin could mean only one thing: the predators had been men.

My disappointment at not finding the dogs was hard to disguise, but by now it was too late to continue our search. Abnel unerringly guided me back to Handajega through a dense wall of whistling thorn. It was like driving in a maze. There were no tracks, just a rough bearing to be followed. We blundered roughshod over the bushes and stumps, and it was almost dark by the time we reached the guard post.

Before we departed for Kirawira, Abnel instructed David to send two armed rangers back with me in the morning, so that we could pursue the poachers. Already I could feel the intense commitment to his work that set Abnel apart. This was not just a job, dictated by the number of working hours in a day; this was his life. It involved his pride and said something about the way he saw himself. He left you in no doubt as to who was in charge. There was a job to be done. Abnel meant business, and all of us knew it.

The drive back to Kirawira was a disaster. Descending the northern bank of the river earlier in the day had made the crossing seem all too easy. Despite the potent magic of four-wheel drive, and a hefty winch, it took us nearly an hour to extract the vehicle from the soft sandy bottom of the Mbalageti river. The far bank was just too steep. Then, to add insult to injury, we got lost trying to follow the threadbare track through thick bush. Half an hour later we were back at the river. We got out of the car and examined the crossing place, shaking our heads in disbelief. Had I really driven in a straight line yet come full circle?

By the time we arrived at Kirawira the last thing on David's mind was returning with me next morning. My vehicle might have all the

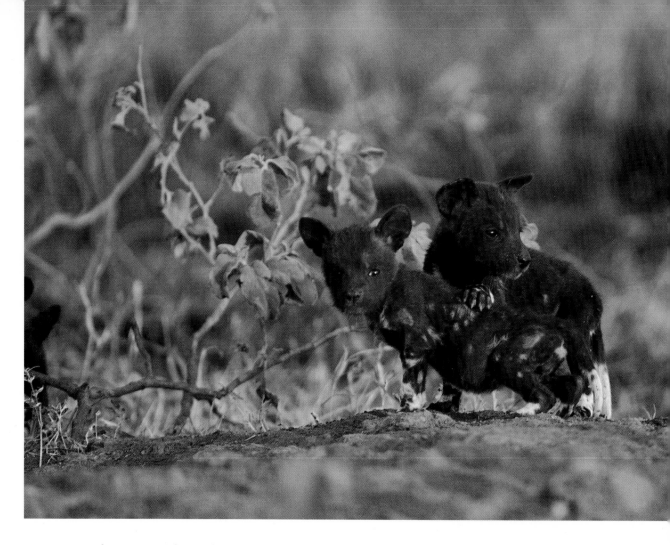

Two five-week-old puppies from the Ndoha pack. The circular patches of bare skin are probably due to ringworm or mange

requirements for surviving for weeks at a time in the bush, but it was no bloody good in mud! He would wait until the parks vehicle returned from service at Seronera. I should proceed back to Handajega alone, which suited me fine. Now that I knew the way I preferred to travel by myself. I had food and drinking water, and a comfortable bed to sleep in. If I got stuck I would get myself out of trouble. Better by far than having to fret about inconveniencing someone else.

This time I was taking no chances. I relished the opportunity to work some exercise into my car-weary body. Now I could use the motley array of implements that lay gathering dust in the back of the vehicle. Shovel, *jembe*, *panga* and axe – all were brought into service to help dig away the steep sandy bank and improve the track across the river. As I worked, a paradise flycatcher zipped back and forth to waylay the hordes of brightly coloured butterflies that gathered to drink at the shallow pools created by my tyre tracks. And, perched motionless within a curtain of thick foliage, a tiny malachite

kingfisher appeared oblivious to the shoal of tiny fish swimming so perilously close to the surface – until it launched itself with breathtaking speed and accuracy and snatched one up in its beak.

The sun had already begun its descent towards the west by the time I felt it prudent to recross. Just as I finished packing everything back into the car a parks Land-Rover arrived. Without slowing to engage four-wheel drive it sailed across. Three rangers waved in high spirits from the open back of the vehicle. 'Good work. Nice smooth road,' shouted David, his cheerful face nearly splitting with laughter. 'See you this evening.' Well, it was funny.

At Handajega we decided to leave at first light to look for the dogs. When I awoke the following morning, Abnel and another ranger called Gilbert were ready and waiting. Each carried a rifle and a flask of water; they would eat on our return. Both were delighted to be able to escape the drudgery of confinement at the guard post.

Having crossed the poachers' lugga, I drove to the top of the nearest rise and set up the radio. This time I picked up a signal. I let out a whoop of delight. The rangers were fascinated by the radio-tracking equipment; their faces lit up as they rotated the aerial for themselves and heard the signal pulsing through the headphones. Now they understood why I had felt so certain that we would find the dogs if they had denned here. We went two kilometres further on and there they were.

Both Abnel and Gilbert seemed genuinely perplexed that I should be so excited to see these strange-looking predators. They knew of the dogs' reputation, had seen them kill. How could I possibly like them? Abnel remarked that it was not unusual to see wild dogs in this area, though they never stayed for long. Once he had seen a very black dog with half of one ear missing, which made it look very fierce. The villagers believed that the dogs were capable of killing anything given half the chance – even people. But the rangers knew better.

The Ndoha pack looked surprised at the sudden arrival of a vehicle. The adults stood up and stared in our direction, and as they did so I felt sure that I glimpsed five or six tiny puppies disappearing below ground. One of the yearlings kept bobbing its head at us, gruff-barking in alarm. It was obvious that nobody else had been here. When Abnel noticed Half-Ear, he clasped his hand to his mouth in surprise, then roared with delight.

It was still early and as I knew Abnel was keen to pursue the poachers, we decided to leave the dogs. Their blood-stained necks and faces announced that they had already hunted.

We had barely crested the rise when we found the carcass of a bull wildebeest. Not a scrap had been eaten. The vultures stood around, ruffling their feathers, unable to feed. If the dogs had killed the wildebeest, why had they abandoned it without eating? There were none of the signs of disembowelment that characterize a wild dog kill. The vultures had seen to the eyes, but otherwise the carcass was intact. Now the giant birds could only squabble among themselves. There was no further food for them here, unless a hyaena happened along to help rip through the wildebeest's tough, leathery skin.

Abnel heaved the wildebeest over, and pointed to a small round hole in its side. It must have escaped into the darkness after being shot during the night, only to die a lingering death hours later.

We drove for the rest of the morning, stopping every so often to

This snared male impala has died and been eaten by scavengers before the poachers could return to butcher it

investigate game paths and water-holes, all the while keeping a watchful eye on the vultures. If animals were being slaughtered, the scavengers would lead us to them. Whenever we saw a vulture drop from the sky we hurried to the spot – just as a hungry lion or hyaena might do. If we found them on the ground or clustered in tree tops, we might be in luck.

I quickly realized that while I had learned to spot a lion crouched beneath a thorn bush from two kilometres away or pick out the dappled markings of a leopard lounging in a fig tree, I was incapable of recognizing a poacher's snare. For every ten wire nooses that Abnel and Gilbert picked out, I could manage only one or two. But that was exactly how it should have been; they were meant to be concealed. Gradually I came to see what the rangers were looking for – or perhaps more importantly, I began to see *where* they were

Tens of thousands of animals are snared each year, mostly wildebeest

looking. The loop of wire was usually well camouflaged by the bushes it was attached to. The clues to look for were the neatly cut stumps where branches had been removed or the 'fences' of thorn bush channelling the game animals towards the wire-encircled gaps. It was not the clarity of one's vision that counted; it was knowing where to look and what to look for.

Wildebeest, particularly the territorial bulls, often stand beneath the thorn bushes during the heat of the day. They are not merely seeking shade, but use the bushes as marking sites during the annual rut, tearing up the ground, horning the bushes and advertising their presence with piles of dung and urine. As the massed armies of wildebeest pass through the Western Corridor on their migration westwards, the poachers have a field day. Hundreds of snares are set among the whistling thorn – and thousands of animals are slaughtered. Day after day, week after week, the carcasses are butchered and the snares reset. For a time the area is like a huge open-air meat market. Each carcass is cut up into strips and dried, then ferried out of the park, carried away on the shoulders of men and across the backs of women and children. Trucks and bicycles, even tractors and trailers – all are at times called into use. As one warden wryly remarked, paying off the bank loan on a new tractor is far quicker when it is employed for commercial meat poaching rather than for farming maize.

As the dry season progresses the poachers increasingly concentrate their efforts along game paths leading to water, carefully monitoring the day-to-day changes in the animals' movements. When one area dries up they move on to another.

Abnel told me to stop. Virtually every bush within fifty metres of the river had a necklace of wire attached to it. Freshly pruned branches littered the ground, thorny obstacles to be avoided by a vehicle. It was obvious why the poachers had chosen this place. The surrounding vegetation had been torn and trampled; the muddy banks imprinted with the marks of hundreds of pairs of hooves. Here was a favoured watering place for the wildebeest herds. If animals tried to reach the water at this pool, some of them were going to be caught up in the snares. Drawing closer we found two wildebeest, a cow and a yearling. The younger animal stood up to its belly in the middle of a deep pool, anchored by a snare around its horns. Fortunately it was in a shaded spot and though it had jerked

the wire tight, it was uninjured. But the cow was already half dead, with a snare biting deep into her chest.

The rangers decided it was too dangerous to try and overpower the animals in the water: one swipe from those sharp horns could leave a man with a gaping wound. Shooting the animal was out of the question, since the sound of a rifle would scare away every poacher for kilometres around. The yearling still had a chance of surviving if we could set it free, but otherwise it was doomed. Cutting the snare as close as possible to its head was the best we could do in the circumstances, but even after we had released the yearling it refused to leave the cow, who may have been its mother.

The cow lay in water churned to a mud-brown soup by her frantic attempts to free herself. She was too weak to stand, but still strong enough to toss her head wildly at any attempt to reach her. The wire snare had pulled so tight that her breathing was painfully laboured. The cow's eyes bulged white with fear as we struggled to free her, hoping that she might still survive. But it was hopeless and we knew it. Abnel cut the wire and walked away; at least that would prevent her pulling the snare even tighter. A single splash stopped us in our tracks. The cow had keeled over like a sinking ship and drowned.

Meat poaching never did have much to do with sentiment. We could so easily have been the poachers returning to claim their 'kill', triumphant at finding two animals to be butchered. Our forefathers stoned, clubbed, dug pits for, speared and otherwise maimed animals in the process of capturing and killing them for food. They employed the most economic means available to them to ensure that they and their families did not go hungry. The meat poacher does not set a wire snare to brutalize his prey. He uses it because it is cheap, reasonably efficient, readily available and reusable. He does not look mean or particularly tough, like a hardened criminal, his mind filled with violence. More often than not, he is just poor, and it is poverty that needs to be destroyed if we genuinely wish to conserve nature. The poacher's crime is one of trespass, of illegal killing in a protected area, but he is no different from the countless other villagers whom I passed strolling along the boundary path. The poacher is respected for his craft, as a provider of meat for the community. Regardless of the methods, both wild dogs and hungry men kill to eat. My feelings – anger, depression, a sense of hopelessness – seemed inappropriate in such circumstances.

It was nearly 3.00 p.m. by the time we arrived back at Handajega. Abnel invited me to stay for lunch, an invitation I was only too happy to accept as by now we were all hungry. One of the rangers' wives produced a bowl of clean spring water so that we might all wash our hands. Easy access to the spring was one reason why this site had been chosen for a guard post. It was built to provide a permanent ranger presence in the area when boundary changes were approved in 1959, extending the Serengeti southwards to include land traditionally occupied by the WaSukuma. In those days the spring was considered to have great religious significance, being the home of a giant python whose tail was believed to stretch as far as Kitu Hill on the Duma, thirty-seven kilometres away.

We crowded round the wooden table chatting and laughing. Bowls piled high with boiled maize-meal and cassava, stewed chicken and goat meat, beans, onion and tomato salad, provided us with a rich banquet. There was a pleasing sense of rhythm to it all: hands reaching out, fingers kneading the *ugali* into balls of dough, each person obeying an unspoken sense of timing that made it a truly communal meal. Sharing food in this manner reminded me of the role that eating together has played in creating our societies, helping to reinforce bonds between individuals in a group.

After we had finished I watched Abnel's wife washing the bowls, a simple task performed with the dexterity of years of repetition. Her hands appeared to dance over the dishes, transforming a chore into an act of grace and elegance. I knew that if there had been other white people with me an invisible barrier would have sprung up between us. It would have felt quite different. I had not come to Handajega just to follow the wild dogs. I wanted to know more about the Serengeti and the people in whose hands its future rested: the Tanzanian people.

Life at the Den

. . . time is fast running out. National Parks and other uncultivated areas are coming, quite naturally and inevitably, under increasing pressure from local populations, who begin to realize that you can't eat the money that is brought in by safari-going tourists. What these visitors come to admire, and would like to preserve, is to hungry men on the spot above all tempting meat on the hoof.

Introduction to Pyramids of Life, NIKO TINBERGEN

145

Short-Tail with her twelve puppies. A wild dog mother produces more puppies per litter than any other species of canid, and has twelve or fourteen teats

My greatest hope when becoming involved in the lives of other animals is eventually to be completely ignored. I long to blend into the surroundings, to become as unthreatening in their world as the wind and the trees. But achieving that kind of rapport is rarely possible. With the Naabi pack I always felt completely accepted, yet here at the den of the Ndoha pack I was treated like an uninvited guest at a party. I was an intruder and would have to work hard to gain their trust.

The den was located in the middle of a gently sloping plain, providing an unimpeded view of the surrounding countryside. The dogs could easily see what was happening around them. They would have plenty of time to move out and confront any lion or hyaena that might pose a threat to the puppies. To the west a single tree marked the top of the rise, a beacon to plot my homeward path from far away as the sun dropped below the horizon. The plain was almost completely encircled by the palm-fringed arms of the Balejora and Mongobiti rivers, tributaries of the Mbalageti. Beyond the Mbalageti, the blue knife edge of the Simiti Hills rose from the plains. And there was always Handajega, a distinctive pyramidal hill towering above the tight stands of whistling thorn.

There was nothing to distinguish the den from the dozens of similar earthy termite mounds scattered across the plains. Each was covered with a mantle of Sodom apple, a fleshy-leaved plant with thorny stems and round, yellow fruits belonging to the potato family. It was hard to believe that this was the same place I had seen

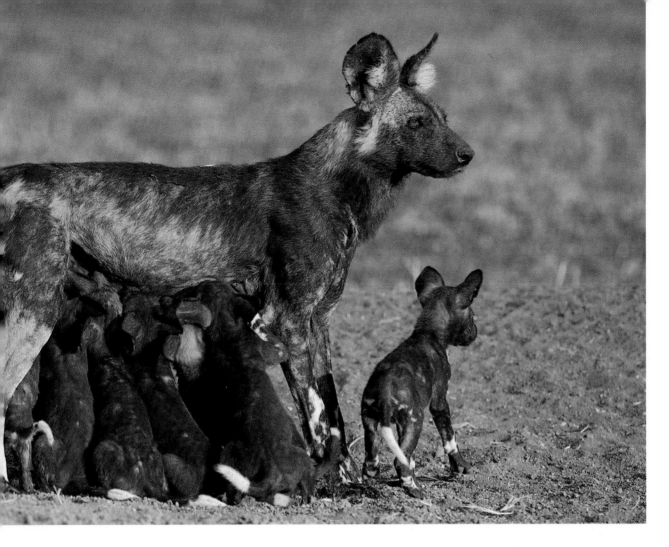

Four of the yearlings of the Ndoha pack summoning the puppies from the den – page 148

from the air a few days earlier. The golden grass was gone, blackened by poachers' fires. Somehow the den had survived the onslaught. The dogs had inadvertently created a fire break by excavating large quantities of sandy soil from the den's interior and scattering it in an arc around the entrance holes. The four-week-old puppies must surely have felt the heat of the fire sweeping towards them, smelt the acrid smoke filling the air and heard the crackle of burning grass. Perhaps Short-Tail had been curled up inside the den with the tiny puppies when the fire started. Whatever else, the blaze would have passed within seconds.

To begin with I kept well back, watching the dogs through binoculars, familiarizing myself with their daily routine. The den was little more than a shallow hole in the ground, a slight swelling on the surface of the plain, distinguished only by the bat-eared presence of the dogs themselves. But soon my vehicle created an indelible mark across the scorched plain, guiding me back to the dogs. Even when the adults were concealed below ground, or had sought shelter

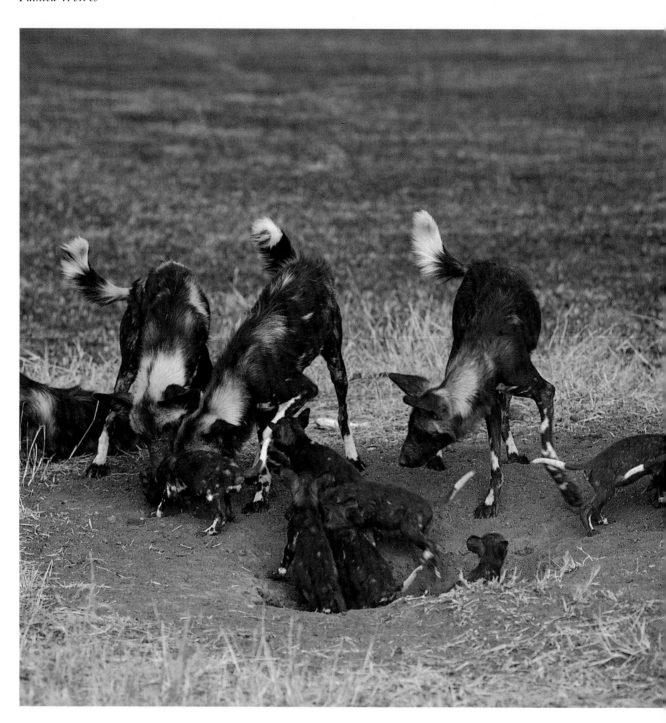

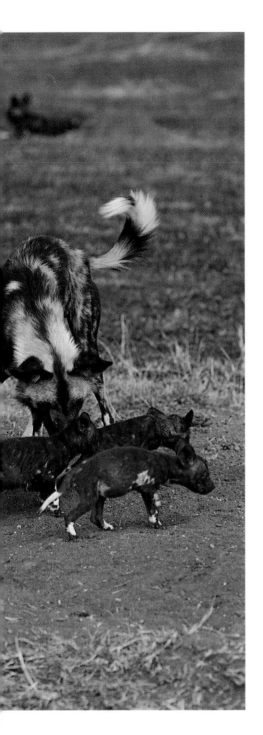

from the sun in one of the nearby luggas, I could always find their den again and wait for them to reappear.

Half-Ear and Short-Tail appeared to be rather nervous individuals. At first I thought this was simply a consequence of their status – as parents and guardians they were bound to be wary of anything they might construe as a threat to their offspring. Fortunately, the ten yearling dogs did not seem to share their parents' wariness. They were still distinguishable from the five adults, being leaner of build and thinner in the face. People and vehicles had been a part of their existence ever since they emerged from their den on the Ndoha plains in 1987, when the scientists had arrived to fit radio-collars. They were more at ease with the sight and sound of vehicles than the older dogs.

I waited for the puppies to emerge – but the process entailed so much more than that bland statement can ever suggest. I had seen Short-Tail mating in March, watched as Half-Ear eventually asserted his dominance over Shyster, counted the days until the dogs denned. I had longed for this moment, speculating endlessly on the size of Short-Tail's litter. A wild dog mother produces more puppies than any other species of canid, and has twelve or fourteen teats. In Serengeti a female has an average of ten puppies per litter. Would there be more? Hugo van Lawick once saw a mother with sixteen – the largest litter ever recorded in the wild – and one zoo reported the birth of nineteen, though three were stillborn.

I watched as the hazy yellow sun tumbled slowly across the smoke-filled sky. Fifteen pairs of ears twitched as one, picking up the sound of vultures descending with effortless ease to land astride the lone tree. For the hundredth time that day I glanced across to where Short-Tail slumped over the den entrance. The puppies were still too young to venture above ground unannounced. They must wait to be called. I willed Short-Tail to rise and put her head down the mouth of the burrow. Finally, a few minutes after 5.30 p.m., she did so.

Out they came, a mob of tiny black and white puppies, pug-faced and flop-eared, with heavily wrinkled corners to their mouths and furrowed brows. They were quite different in appearance to the adults. The sight of them unleashed a paroxysm of activity among the other dogs. The yearlings went crazy with excitement, causing the puppies to hug the ground, ears pressed flat. Each and every pack member's attention was focused on the puppies as they joined in greeting. I tried counting them but it was impossible while the

yearlings kept nudging the puppies around the den entrance, flipping them on to their backs to lick and clean them, rolling them through a thicket of long slender legs like small furry balls. For their part, the puppies seemed remarkably unperturbed by all the fuss and noise, despite at times being accidentally kicked off their feet and slapped in the face by long bushy tails in the mêlée. They craned their necks, searching for their mother's teats, reaching up and exploring the naked bellies of the other adults, nipping at the extraordinary tasselled penises of the male dogs.

Short-Tail yittered – a high-pitched bird-like sound – mouth parted, black lips pulled back in a tense grin. It looked almost as if her teeth were chattering with cold. Having forcefully cleared a space around the puppies she reclined on her side, inviting them to suckle. The puppies needed no further prompting, swarming all over their mother's swollen udders with their distinctive white-tipped tails cocked stiffly in the air. But they did not suckle for long, wobbling about, bleary-eyed, at the entrance to the den. Despite their small stature the puppies were already quite boisterous, making odd bouncy little jumps as they growled and scrapped with one another.

Half-Ear came and stood next to his mate as the yearlings once more crowded around the puppies. His posture was protective, intimidating. He lowered his head to the ground and, even before he had time to regurgitate, the puppies had formed a tight huddle about his face, scrambling to reach the small pile of meat that suddenly appeared at their feet. In a flash Short-Tail shouldered her way in among the puppies, gobbling up most of the disgorged meat and wresting whatever she could from their tiny jaws. One puppy suddenly found itself suspended half a metre above the ground as it clung, albeit briefly, to a hard-earned scrap of food. Another seemed baffled at all the attention it was receiving, unaware that it was walking around with a piece of meat perched on its head. It was eleven hours since the pack had killed, yet Half-Ear had still managed to regurgitate some food without any prompting. But generally the adults finished feeding the puppies within an hour or so of returning from a kill. It was hardly surprising that Short-Tail stole a fair portion of the regurgitated food. She was still heavy with milk, so the puppies would not go hungry. Her need for meat was far greater than theirs.

The puppies clung to their mother's teats, rising and falling with the rhythm of her breathing. Half-Ear lay nearby, with the yearlings

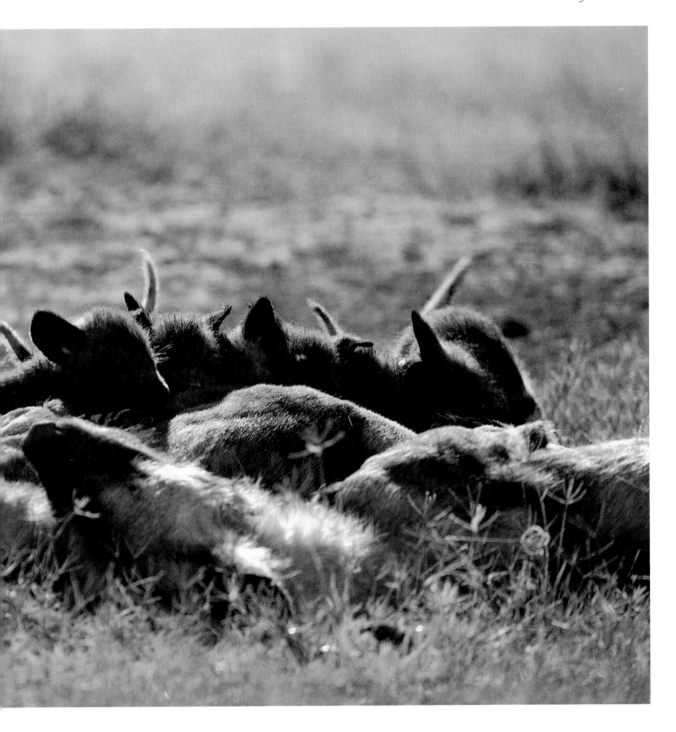

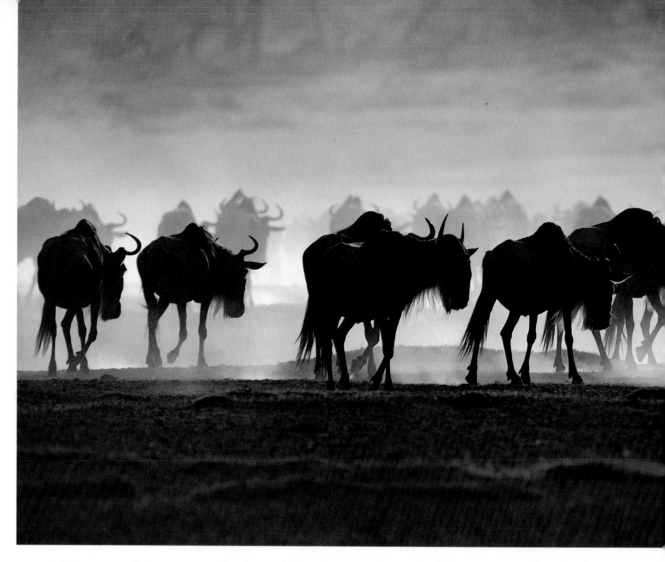

scattered in twos and threes across the dusty plains. Shyster and Collar, the two-year-old males, huddled together some fifty metres away, with Half-Ear's brother, Blacky, resting just a few metres beyond them. For a while an air of calm settled around the den, the puppies gently stirring in the half-sleep induced by their mother's warm milk and soft belly. Now I could count them. There were twelve: four males and eight females.

Half-Ear's and Short-Tail's slightly aggressive behaviour towards the other members of the pack helped to temper the exuberance of the yearlings and prevented them from running amok. This was, after all, the first litter of puppies they had seen. Their natural tendency was to mob the puppies with such a display of unrestrained interest and affection that they ran the risk of trampling them underfoot. The fact that a dominant wild dog female will sometimes try and kill small puppies that are not her own attaches a premium to guarding puppies during these early days, even if you are the

Wildebeest migrating from the short grass plains to the Western Corridor at the beginning of the dry season

When the puppies are very small, the mother lies down to allow them to feed more easily – page 151

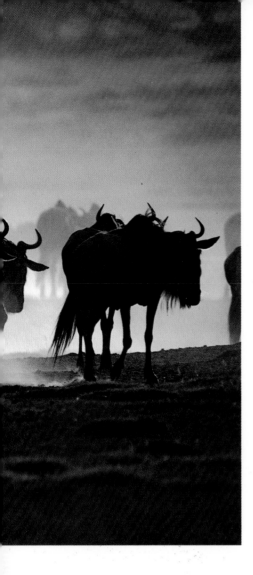

dominant female. But apart from this, it was important to focus the puppies' attention on the dominant pair. They would not be suddenly emigrating from the Ndoha pack and were, particularly the mother, the centre of the puppies' lives. At this stage they were both the main providers of food and also the most vigilant among the dogs, the first to initiate attacks on hyaenas that strayed too close to the den.

Just after 5.30 p.m. the dogs greeted prior to their evening hunt. Their sense of timing was so perfect that I hardly bothered to look at my watch. Each day the dogs began to stir between 5.30 and 5.45, unless it was cool and overcast; in that case they often set off earlier, particularly if they had failed to kill during the morning. I waited, watching through binoculars as the hunters departed. Short-Tail stayed at the den, following the same pattern she had observed since giving birth to her puppies one month earlier. She resisted the urge to follow and take her place among the other members of the pack.

Short-Tail appeared weary, as if her milk might already be drying up. She looked thin and had a number of dry, hairless patches along her spine, perhaps the result of long hours lying hunched up inside the den with her puppies. One of her eyes was gummy. The puppies' cheeks looked hollow, their legs bandy and some of them had either mange or ringworm. It was evident that the pack had yet to benefit from the wildebeest hordes. Only within the last few days had the migration swept into this area.

By now the dogs were two or three kilometres away. Short-Tail stared into the distance, where wildebeest stood out bold and black against a patch of unburned grass. They ran with their long tails streaming behind them, blurred shapes dissolving into a contiguous ripple of dark bodies. The confusion lasted less than a minute, which was as long as it took for the dogs to separate a calf from its mother. Even before the dust had settled I could just make out the scrum of bodies, pulling, rending, gulping down chunks of meat. Less than 100 metres away, two dozen wildebeest and a family of zebra stood frozen in a semi-circle, watching.

Short-Tail turned and stared again, ears cocked, her excitement mounting as she jumped forward with anticipation and impatience. It was as if she knew that Half-Ear was rushing homeward with a belly full of meat. She moved out a few paces, then stopped, looking back furtively over her shoulder towards the den. Already the first hyaena was shuffling away from its communal den at the edge of the

Wild dogs are remarkably unafraid of vehicles. On the treeless plains, vehicles provide welcome shade for them – page 154

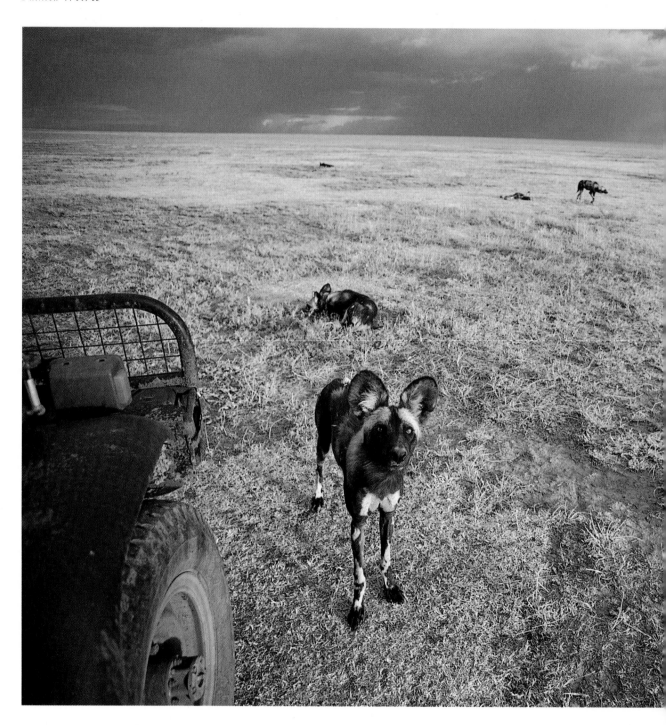

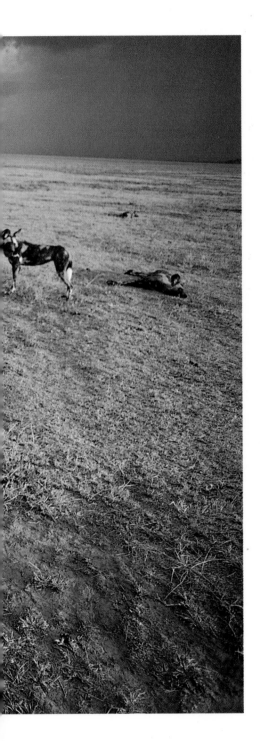

Mongobiti lugga, barely one kilometre from where the wild dog mother stood. '*Whoo-oop . . . whoo-oop.*' The hyaena's mournful long-distance contact call echoed across the plains. For as long as the pack provided her with sufficient food, nothing would induce Short-Tail to leave her puppies unprotected.

The night closed around us like a cold dark hand, squeezing the light from the sky. An hour later I sat listening to the dogs squealing and yittering with excitement as the last of the pack returned to feed Short-Tail and her puppies.

Suddenly I was awake, struggling to read the hands on my watch: 2.00 a.m. One of the dogs was barking over and over again, a yappy bark that I presumed to be a yearling's version of a gruff-bark, signalling alarm or danger. Could it be poachers? And if it was, what would they do? But a few minutes later the scary stillness was shattered by the unmistakable cacophony of a full-scale 'hyaena bash'. As the commotion died down the whole pack called in unison, '*ooow, oow-ow, ow-ow*', building into a barrage of noise, an eerie rendition that sounded rather like the collective '*hoo*' call they had used when the four females emigrated from the pack earlier in the year. But this was different: less plaintive and more aggressive, a mixture of alarm and distress.

A week later I heard the dogs use the same call after a heated battle with members of the Mongobiti hyaena clan a kilometre from the den. It reminded me of the way lions often roar aggressively after an unsettling altercation with hyaenas or strange lions, warning them off, hoping to intimidate, bolstering their own spirits.

Each morning, long before sun-up, I was roused by the less than gentle swaying of my car. Peering into the semi-darkness, I could just make out the distinctive shapes of the yearlings gambolling around the vehicle. While two of the dogs gnawed on the heavy rubber moulding on one of the front tyres, another grated its sharp canines on the metal 'cow catcher' protecting my lights and radiator. But these were minor disturbances. The most destructive of their inquisitive games involved poking their long noses deep into the belly of the car, searching for the softest parts to rip and chew, yanking and pulling with all their strength. So this was what it felt like to be caught by the dogs. When the Naabi pack had taken to doing this in 1987, they managed to remove half of the electrical wiring, leaving a spaghetti-like mass of red, white and blue leads

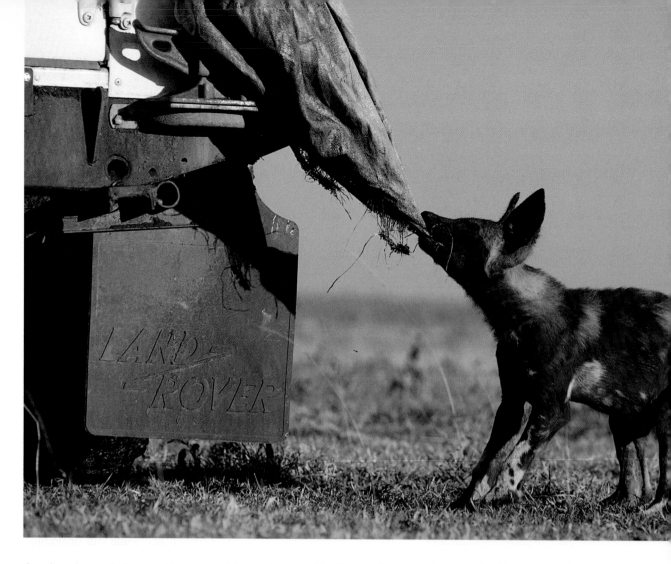

A ten-week-old puppy tugging playfully at the covering of a car-jack

dangling beneath the car. Forewarned by such antics I had securely taped all wiring safely out of reach.

The Ndoha pack generally hunted earlier in the morning than the Naabi pack had done. Most days they were gone long before first light, travelling while it was cooler, seeking the advantage of twilight to advance as close as possible to their victims when prey was scarce. I would drive to the nearest rise and scan the surrounding countryside for signs of the pack. Even if I could not see the dogs, something else might provide me with a clue as to their where-abouts: vultures circling overhead, a hyaena galloping expectantly across the plains, topi standing rigid with alarm or wildebeest streaming over the horizon. Most of the time they could find ample prey within five kilometres of the den, showing the same preferences as other packs I had watched in the Serengeti and Masai Mara. And even though they lived in an area including patches of woodland, it was evident from records kept by the monitoring unit that they

tended to favour the plains areas, where they could find the greatest concentrations of their favourite prey.

There were occasions when the Ndoha pack killed at night, as did the Naabi pack. Even if I had not witnessed a kill being made it was often possible to piece together fairly concrete evidence of what had happened. Sometimes I could see the dogs in the ghostly light of a full moon; hear the sounds of countless hooves beating a resonant tattoo on the bone-hard ground; listen to the laboured breathing of the wildebeest as they gagged on the dust stirred up in the confusion.

The sudden appearance of a wildebeest herd always drew attentive looks from the dogs. One evening after a number of abortive hunts in pursuit of Thomson's gazelles, the Ndoha pack hurried across the Balejora lugga towards a mixed group of wildebeest, topi and zebra. There were many more topi and zebra to choose from than wildebeest, and the topi had young and the zebra foals. But the dogs had eyes only for the small group of wildebeest cows with calves, even though on this occasion they failed to secure a meal. It is not simply that dogs are used to preying on wildebeest or that they are often found in large numbers. The youngest calves weigh between sixteen and eighteen kilograms which makes them ideal for the dogs to capture; yearling wildebeest weigh approximately ninety-five kilograms and are about the maximum that an average-sized pack of five or six adults can handle relatively easily while still providing adequate food for all of them. Rarely did the dogs succeed in killing adult wildebeest and when they did it was usually a female. Even when successful, they found an animal of this size difficult to feed from, unlike hyaenas, which are well equipped to open and dismember a carcass as big as this quickly. Only twice did I witness the Naabi pack launch a really determined attack on a bull wildebeest, and on one of those occasions they lost it to hyaenas. It took so long for the pack to pull the bull to a halt that the hyaenas took it from them before they had time to eat. Individual bulls made it quite apparent that they were a match for the dogs, sweeping past, stiff-legged, with an elegant, strutting gait. Usually the dogs gave up once they realized that there were no young or vulnerable members in a herd of wildebeest and switched their attention to the gazelles.

I kept a daily record of the hunting activities of each pack, logging the details in my notebook, recording the time of day that a kill was made, the type of prey, its sex and approximate age. In fifty-six days of observations in February and March 1987, I had recorded the

following kills by the Naabi pack: forty-six Thomson's gazelles, of which twelve were males, two females, three large fawns and twenty-nine small fawns; fifty-seven wildebeest, of which one was male, four were females, sixteen yearlings and thirty-six calves; and one Grant's gazelle fawn.

One morning I watched the Ndoha pack kill a female wildebeest six kilometres from the den. I timed the dogs to see how long it would take them to feed from the carcass. After twenty-five minutes they were still gnawing around the dead animal's anus, trying to chew their way in to the body cavity. The dogs were fortunate that there were only a few hyaenas in this area; in less favourable circumstances they might already have been robbed of their kill. An hour and twenty minutes later the body cavity was empty, the ends of the ribs chewed down and the protein-rich rump eaten. All of the dogs looked unbelievably fat! Two hours after the cow had died, Half-Ear arrived back at the den to feed Short-Tail and the puppies.

The wildebeest are a seasonal bonus for the dogs. Thomson's gazelles make up the majority of wild dog kills in the Serengeti ecosystem, with adult males being taken more frequently than females. One explanation given for this is that male territory holders are reluctant to leave their hard-won territories, or to trespass on that of another, or are in poorer condition through the rigours of having to defend their territories. Like wildebeest calves, Tommies are an ideal size for the dogs to hunt and have the added attraction of being available, somewhere within their home range, throughout the year. But when wildebeest were in the area the dogs willingly trotted past herds of gazelles to find them. It was quite apparent that they often knew which species of prey they were looking for when (if not before) they decided to hunt.

Some mornings I waited with Short-Tail at the den so that I could photograph the return of the hunters. They were usually back by 8.00 a.m. Meanwhile, the twelve puppies remained snuggled together for warmth below ground. As the minutes ticked by I could feel the tension rising. Every so often Short-Tail would get to her feet and stare off into the distance, keeping an eagle-eye out for the pack, ready to race out to meet the dogs as they neared the den.

Invariably Half-Ear was the first to leave a kill – something he could well afford to do, as he usually had access to the best feeding positions at a carcass. As soon as Half-Ear neared the den, Short-Tail would rush out and try to impede his headlong rush long enough for

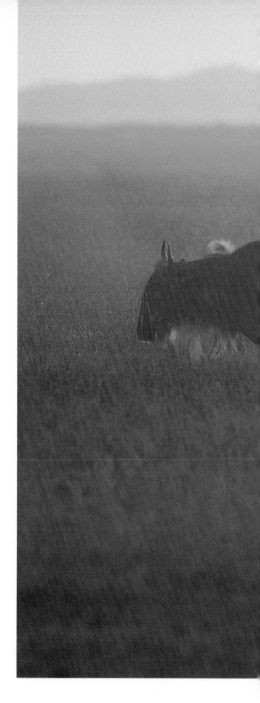

One of the rare occasions when the Ndoha pack succeeded in killing an adult wildebeest

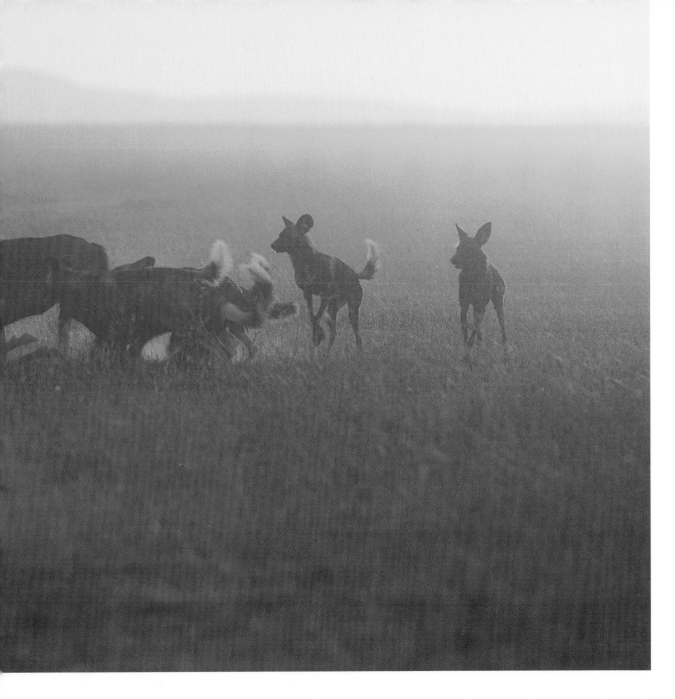

him to regurgitate for her before he reached the puppies. Then both dogs would run to the entrance of the burrow, pushing their heads and shoulders below ground, uttering a series of short whines to call the puppies forth. Half-Ear dutifully regurgitated a parcel of meat for them. Short-Tail would be there too, darting in to snatch away a proportion of the food. But later, in her own good time, she would regurgitate some of the stolen food for the puppies between short bouts of suckling.

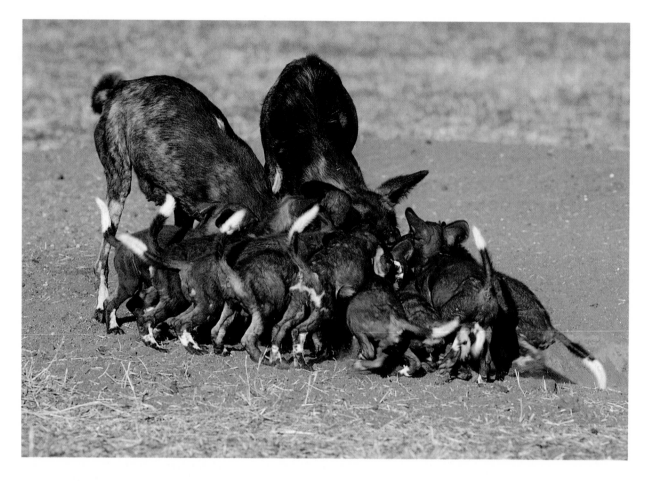

Short-Tail was less successful in persuading the yearlings to regurgitate for her. Invariably they raced straight to the den, despite their mother's noisy urging, intent on delivering their contribution directly to the puppies. But the yearlings dared not interfere when Short-Tail appropriated some of the food they regurgitated. If she was particularly hungry, Short-Tail would harass any one of the dogs until it was obliged to provide her with some meat. She used every means available: burrowing beneath their bellies, winding herself round their legs and chests, nipping at their mouths, yittering – anything to get them to regurgitate. Half-Ear was not averse to stealing food provided by the other members of the pack and at times there was a good deal of competition around the den, with a number of dogs regurgitating and stealing in quick succession.

Short-Tail, on the left, competing with her puppies for her share of meat regurgitated by one of her yearling daughters

When the puppies were seven weeks old, Short-Tail occasionally joined the pack when it hunted. At these times one of the other dogs would stay with the puppies. Sometimes they were entrusted to the watchful charge of Half-Ear's brother, Blacky. More often, one particular yearling female waited with them at the den. It was noticeable, now that Short-Tail had begun to relax her iron-like grip around the den, that all three yearling females competed with one another for access to the puppies. Accompanied by much yittering and squealing, the females attempted to hold sway at the mouth of the den, blocking the entrance with their bodies so that they could keep the puppies to themselves. Short-Tail tolerated only so much before racing to the den to admonish whichever of her daughters was being a pest.

The first time that Short-Tail left the puppies it was apparent that

A yearling regurgitating meat for his younger siblings

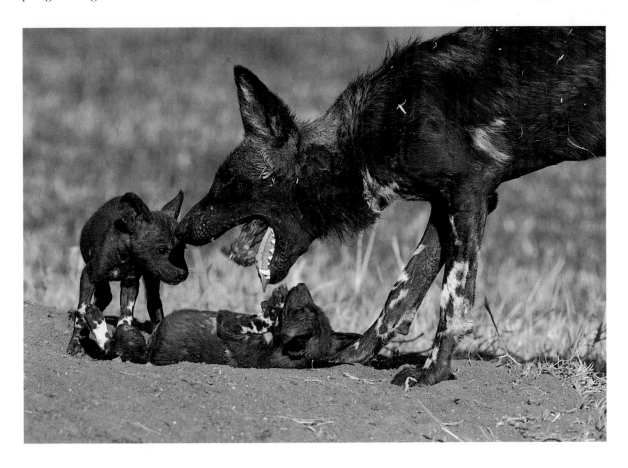

she was ravenous; for the last few days the pack had struggled to find sufficient food. However, on this evening they had located the wildebeest masses a few kilometres beyond the Mongobiti lugga. Once the pack had captured a calf, Short-Tail tore into the carcass, bolting down chunks of meat as if her life depended on it. She kept moving to the edge of the feeding mêlée and staring in the direction of the den, anxious about her puppies. Soon she was rushing homewards.

As the hunters neared the den the yearling female who had stayed with the puppies during Short-Tail's absence ran out to meet her. Short-Tail ignored her daughter's demands to be fed, snapping at her and biting down on her nose, causing the young female to roll on her side in a gesture of appeasement. Short-Tail was interested only in feeding the puppies. Four times during the next fifteen minutes she regurgitated for them, twice stealing food provided by other members of the pack. When the yearlings finally arrived at the den they responded to their sister's demands and regurgitated some food for her.

It soon became apparent, once I learned to distinguish one dog from another, that there was a feeding hierarchy at a carcass, though it was evident, as always, that there were no absolutes. Once puppies are old enough to be led to a kill, all the adults and yearlings step back as soon as the youngsters approach the carcass, allowing them to feed on their own. The puppies are quick to exert their rights, snapping and lunging at any of the older dogs that come too close. As soon as the puppies' hunger abates, the adults resume feeding or make another kill. This priority at a carcass is bestowed on the puppies as a group – there is little overt squabbling among age-mates – with each successive generation retaining priority over the previous one, since by the time the next litter is born the previous year's puppies will still be only fledgling hunters.

The exception to this feeding order is the dominant pair. While new puppies are still safely cloistered at a den, adults and yearlings give way to the dominant pair, especially if it is only a small carcass, around which it is difficult to manoeuvre for position. This seems only right, as during the first few weeks of the puppies' life, it is the dominant pair who generally regurgitate most meat for them. The older males tend to move aside of their own volition but the yearlings have to learn the rules. But sex, status, and numbers can modify the norm. In 1987 Mama Mzee and Shaba always permitted

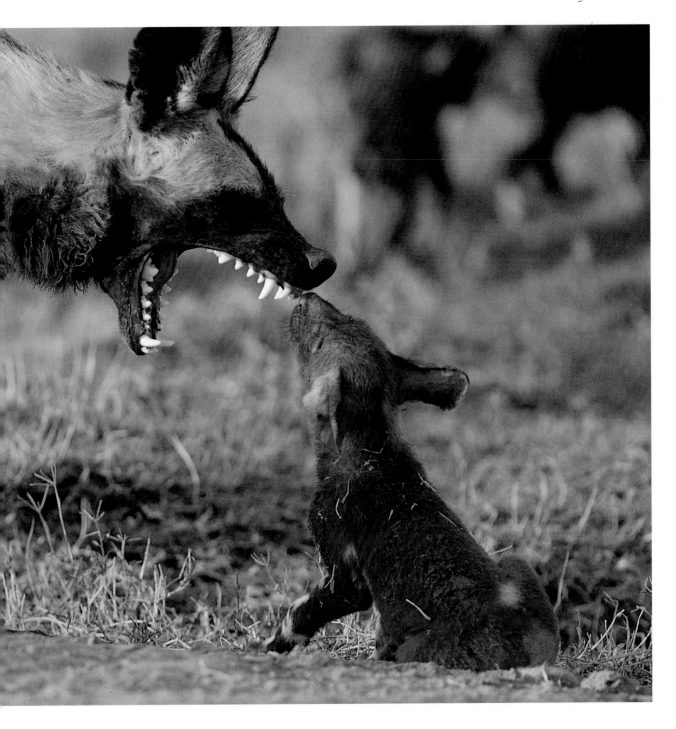

their yearling daughter to feed with them on a wildebeest calf yet would chase away her two brothers if they tried to join her. Mama Mzee enforced this rule most often, though Shaba was quick to side with his mate when necessary.

When Short-Tail abandoned a carcass and headed back to the den, Half-Ear usually followed. The moment they departed, the other dogs took over the remains of the carcass, with the younger dogs ganging up and bullying the older males into giving them priority. This often meant that the oldest members of the pack – usually the dominant male's brother or brothers – got the least to eat, though they often regurgitated as much, if not more, of their portion of the food for the puppies. When food was not a matter of contention, younger dogs invariably acted in a submissive manner towards an older dog of the same sex, though if a squabble broke out age-mates tended to side with each other. It was as if a wild dog never forgot the priority afforded to it as a puppy and could count on its age-mates to help perpetuate this privilege.

Once most of the Ndoha pack had returned to the den and the puppies had been fed, Short-Tail made her daily journey in search of water. A ready source of drinking water is an important consideration for a lactating female, and Short-Tail knew just where to look. For as long as there was still water in one of the nearby luggas she would go trotting off to find it. Both she and Mama Mzee also chewed on old bones while they were lactating, helping to boost their calcium levels.

Whenever Short-Tail departed on these journeys, Half-Ear went with her, and as soon as the puppies were old enough to be safely left alone at the den, the whole pack followed. As the dry season progressed and the water-holes dried up, Short-Tail daily led the pack directly to one of her favourite shady spots along the Balejora lugga, half a kilometre from the den. This exodus from the den invariably took place around 9.30 a.m.

Short-Tail was not necessarily the fastest of the dogs or the best hunter, although she may have been when she was younger, but like all dominant females she played a major role in determining the direction the pack took when it moved. Though one of the other dogs sometimes trotted away on a path of its own, the dominant pair could overrule it simply by refusing to follow. The dogs were like a flock of birds on the wing, responding to subtle cues that maintained their cohesion. Despite the inevitable diversions – the wanderings

On this occasion an adult makes it perfectly clear to the begging puppy that there is no food – page 163

and investigations – the dogs remained closely focused on one another as they moved across the plains. Ultimately, and without any fuss, the pack fell into line with what the dominant pair chose to do. In all the wild dog packs I have watched, the dominant female played the central role in the life of the pack, like the hub at the centre of a wheel. But this is not to imply that the other dogs were incapable of acting for themselves or on their own. They were.

On reaching the lugga the dogs would explore, sniffing around the dried-up water-holes, with the ten yearlings racing each other through the long grass, bounding and leaping, standing up on their hind legs in order to see over the vegetation and jousting one against another until all were exhausted. Gradually an air of calm would descend and the dogs would rest through the middle of the day. Lying in the dappled shade of the bushes, their coat markings merged perfectly with the browns and yellows of the vegetation, they became a part of the thick shadows and windows of light. It was only because I now knew their favourite resting places that I was able to find them. Without realizing it I fell into an unchanging routine, an order imposed by the dogs.

Spending time with the Ndoha pack involved much more than simply driving around admiring the scenery, burning up film. Days could feel interminably long. I would look round me and see nothing to lighten the mood or stimulate the eye. The constant dry wind would gust charred remains of grass through every crack and window until I could see it reflected on the glass elements of every lens. Shutters seized and buttons jammed. My teeth grated on grit and grime. My skin and clothes were clogged with dirt. For days on end the beauty of the Serengeti blurred to indifference beneath the smoke-filled sky, which sucked all colour from the land. By mid-morning I might have written off the rest of the day, once the dogs had slumped in the shade of the Balejora lugga. It was no good bridling at the vacuum. At such times I busied myself writing, reading and drawing, watching the slow passage of the sun across the sky, waiting for the dogs to break the tedium with their greeting ceremony. Come the golden hour, the last hour of the day, when the sun hung low across the horizon and bathed the palm trees in emerald light, it all seemed worthwhile.

On this particular morning the dogs had slipped away without a sound. I searched for signs of their whereabouts but could find

The scenery in the Western Corridor is quite different to that of the plains. Borassus palms are a distinctive feature along the rivers of the Handajega area – page 167

nothing to suggest where they had vanished to. It was going to be one of those days. I scanned the nearby villages. From this distance they looked sullen and brooding, without the vibrant sounds of children playing and people laughing. A white mountain of maize cobs towered in front of a large storehouse where people gathered to work. Sturdy brown arms rose and fell in effortless unison, beating the ripe kernels from the cobs. In the distance a tractor hurried across the fields with yet another trailerload of produce, sweeping past a shiny new Toyota truck trundling along the well-worn boundary track.

An air of expectancy constantly hangs over the villages clustered along the boundary of the Serengeti, yet nothing ever seems different. People stand or sit, wedged into the shade provided by cool mud walls and broad-leaved banana trees. Each day passes as a series of rituals: people exchanging greetings, striking a deal over an item of food or clothing, transporting water or firewood to their mud and wattle houses. Cigarettes are a particularly cherished commodity, a potent form of currency among travellers, a token of friendship shared even with strangers. Two people stop, an outstretched hand makes the request, then one final drag before the stub is passed on.

Life for the villagers revolves around children, livestock and water. The WaSukuma are great cattle people. Wherever you see people you see cattle, sheep and goats. Cattle promise much more than just milk and meat. A large herd is an insurance against drought and disease, a visible expression of wealth and status, the price of a bride, the down-payment on a new Toyota truck. Livestock are as much a part of daily existence for the WaSukuma as the children I saw, some happy and smiling, others crying, with fly-infected eyes, listless with the burning fever of malaria or dangerously dehydrated after devastating bouts of dysentery. Mothers queue for hours on end outside the village dispensary for pills and potions, fighting the endless cycle of reinfection.

Under these circumstances, what possible relevance can places like Serengeti have for villagers whose relationship with animals is based on usage: livestock for milk and meat, chickens for eggs, dogs to herd cattle or bark out a warning at night? The Serengeti is a slumbering giant, harbouring man's most basic requirements of land, meat and firewood – resources that have been virtually exhausted outside the park. The utilization of the Serengeti as a

recreational resource for wealthy visitors seems quite inappropriate to the villagers' situation in life. Saved for whom? Their children? Why? They receive no tangible benefits, no financial incentives for leaving the Serengeti fallow. The villagers cannot possibly afford to visit the park, even if they want to. All the Serengeti brings them is trouble: herdsmen are fined for letting their cattle graze within its boundaries and meat hunters are imprisoned for killing wild animals in areas that have sustained generations of WaSukuma since the days when the land still belonged to the people.

This contentious issue of the people settled around the borders of the Serengeti is one of the most pressing conservation questions facing Tanzania. It is mirrored in hundreds of places elsewhere in Africa and in other parts of the world. Creating national parks and reserves is not enough. Somehow we have to find a way of harnessing realistic conservation policies to the legitimate needs of the local people. Without wildlife-based tourism, the Tanzanian and Kenyan economies would falter, bringing far greater suffering as well as the destruction of their parks, but a fortress mentality will not work and never has done. Currently the authorities are attempting to let the people know why places like the Serengeti need protection and show them that some of the revenue generated by tourism is being used for their benefit as well as the animals'.

Sometimes, on mornings when there was little happening at the den or when the weather made photography impossible, I would drive to Handajega to see the rangers. I was fascinated by the local people's relationship with the Serengeti, and in particular the part played by the meat poachers. If there was no other vehicle available for anti-poaching patrols, Abnel would ask if the rangers could go out in my car. I was only too happy to agree, delighted to have the opportunity to see a facet of the Serengeti that until now I had only read about.

Thirty years earlier Myles Turner, warden of the Western Serengeti in the 1950s, had patrolled every inch of the Handajega and Ndoha region with the park rangers, cutting vehicle tracks and pursuing the WaSukuma poaching gangs. How rewarding it must have been to explore new country on foot! A few kilograms of maize flour and some strips of dried meat were sufficient to sustain you for weeks at a time. If you knew how to read the signs and where to look, you could always find a spring to provide clear water and collect edible fruits from a variety of plants. Where a vehicle might

Everywhere firewood is in short supply, and resources outside the park have been nearly exhausted

quickly founder, someone on foot could always cross the steepest of luggas, climb the rockiest hill to spy out the land or wade waist-deep across a river. In many ways a vehicle is an encumbrance. It cuts you off from the wilderness, both physically and mentally, imprisoning you for much of the day and all of the night within its steel body.

Some evenings as I drove back to the wild dog den, I would stop and watch the villagers strolling in a leisurely fashion along the narrow pathways intersecting tall stands of maize and sugar cane. People would gather in twos and threes, talk for a while, then move on to their final destination for the night. There was that 'end of the day' feeling: shadows lengthening, the gentle warmth of the dying sun, another day's work completed. Time now to relax and enjoy a smoke, sharing food and chatting in the light of a small camp fire, with a bottle of beer or some home-made brew. But not for the poacher: he is like the watchman, a denizen of the darkness. At this very moment he might be honing the blade of his skinning knife, or securing a dozen wire snares in a cloth-covered bundle containing a few ears of ripe maize.

In addition to the patrols with the rangers I often searched the luggas surrounding the wild dog den for signs of poaching. They were everywhere. I became familiar with one particular man who hunted the Balejora river. I never saw him, yet I gradually came to understand something about his way of life. By following his trail I learned to know his hunting grounds in intimate detail.

I tried to imagine what he might look like. In my ignorance I thought he must be old and wise to be so accomplished at his job, but that was until I saw for myself just how young some of the poachers were. Could that be him, the solitary figure I so often watched loitering just beyond the park boundary, warmly clad in a long trench coat? There were hundreds of men like him operating in and around the Serengeti, men skilled in the arts of setting a snare, in concealing their presence and butchering a carcass. Poaching was a trade that many of them had learned from childhood. Most work as part of a gang, sometimes operating for weeks at a time within the park, relying on porters and vehicles to transport the proceeds of their kills back to the villages. But I knew this man to be a loner, working a two to three kilometre area of riverine vegetation. Perhaps he had hunted this area before it became part of the Serengeti in 1959, killing sufficient game to feed himself and his family and making a small profit by selling whatever else he could carry with

him. He was his own wire man, butcher and porter, shielded by his own silence.

In time I learned where to look for his snares, occasionally locating the remains of a wildebeest carcass so freshly butchered that he must have departed only minutes earlier. The positioning of each wire snare was a lesson in bushcraft, painting a detailed picture of the secret places inhabited by the wild animals, places hidden from view from a passing car. To find them you had to walk, tracing a maze of almost impenetrable thickets that mirrored the tortuous course of the river. Some of the pathways were darkened tunnels punched through the heart of the dense riverine vegetation. To enter them I had to crawl, emerging again at the water's edge. On one occasion when out with the rangers we nearly stumbled over a huge python that had recently killed and eaten an antelope the size of an impala ewe. The python lay motionless, deep within a thicket next to an abandoned poacher's hide-out. The rangers joked that perhaps the python had been more successful than we in catching poachers. I had never seen a snake so large, nor so gorged. It would no doubt lie up here to digest its enormous meal, hidden from view, safe from predators.

This was a different world of heightened senses in which nothing was taken for granted. A patch of flattened grass, a broken twig – each sign told a story. I could imagine the poacher crouched deep within the bushes, as silent as a leopard. He must have recognized the alarm calls of every forest bird, known each favoured spot where animals gathered. As I crept along the lugga I found his hiding places. Footprints marked the spot where he had scooped out a bowl-like depression in the sand to filter drinking water. A chunk of firewood, only half burned, had been stored at head height among the overhanging branches of a nearby tree. He had used strips of dried palm leaf as kindling to light his fires. Three stones, one of which was held firmly in place with a spike of wood, acted as a crucible for a cooking pot. The hull-shaped base of the palm frond served as a throwaway plate for his meal of boiled maize flour. There was a necessary economy about his methods.

The scattered remains of dozens of carcasses littered the water-holes and crossing places, skulls and pelvises of countless wildebeest tucked carefully out of sight of vultures between the concealing hollows of tree roots. Every well-used game trail and water-hole bore the mark of predation, yet there were no lions lying in ambush

at these places. In fact I had yet to find signs of any of the big cats in this part of the park, not even the familiar roar of a lion at dawn or rasp of a leopard at night; perhaps the poachers had seen to that. And hyaenas and wild dogs invariably made their kills on the open plains. This was not their work. Here the only predator was man.

It might appear that the game is inexhaustible in a place like the Serengeti, where more than 2 million ungulates are still free to roam its pastures. But this is an illusion. Each day there are more people to be fed, and accordingly each year there is less land on which to produce food. It took barely 100 years to exterminate 30 million bison from the plains of North America. There are no guarantees for 1·4 million wildebeest. Despite my sympathy for the villagers, the days when poaching was just a matter of pitfalls, wire snares and poisoned arrows have long since passed. Commercial poaching for meat is big business in the Serengeti, and seems destined to escalate still further. The poachers are not to be deterred easily. When their snares continued to disappear from favourite haunts along the Balejora, they came at night with guns. Often I lay awake, watching the eerie flashing of lights tracing circles out across the plains beyond the Mongobiti lugga. Sometimes I could hear the distant crack of gunfire as yet another wildebeest, trapped in the dazzling beam of light, crashed to the ground. Next morning tyre tracks, a pile of rumen and the neatly cut horns of the wildebeest would mark the place of slaughter.

But the poachers did not have things all their own way. One night Abnel and his rangers ambushed a large gang of men along the Mongobiti lugga. The rangers had deliberately lulled the poaching gangs in the area into a false sense of security, letting them believe that the parks Land-Rover was still at Seronera being serviced. The rangers had gone out on foot and lain in wait for the gang, who had entered the park with a tractor and trailer. Some of the poachers were armed with guns and when confronted immediately opened fire on the rangers. In the ensuing fight seventeen poachers were arrested, three of whom were wounded. Some of the men were later sentenced to three years in prison. So the age-old struggle between the keepers of the game and the poachers continues.

Where Vultures Soar

SEPTEMBER 1988–JUNE 1989

The wonder of the world, the beauty and the power, the shapes of things, their colours, lights, and shades; these I saw. Look ye also while life lasts.

DENYS WATKINS-PITCHFORD, quoting words
inscribed on a Cumberland gravestone

In early September 1988 I joined Markus and Karen on the monthly tracking flight to locate the positions of the radio-collared wild dogs and cheetahs. I had been forced to leave the Ndoha pack to have some electrical repairs made to my vehicle, so I was anxious to check and see if they were still at their den. There was no guarantee that they had not already moved on with their puppies.

It was strange to see Handajega from the air again. Two months earlier it had all looked confusingly new to me, as if I was perusing a map before journeying into unknown country. Then only the dark line of the Mbalageti river and its tributaries had provided a vague sense of order to the land. Now it was all pleasingly familiar and I could easily distinguish the hills of Handajega, Nyakoromo and Kidorodom.

We were more than thirty kilometres from the den site when the first audible 'beeps' forced their way through the static on the receiver. Markus dipped the wings left, then right, trying to pin-point the exact position indicated by the signal. We hovered above the plains before beginning our descent. With engines whirring we swept in low and fast, the air rushing over the wings. Swooping east across the open plains, low over the Mongobiti lugga, where the poachers had set their camp, past the dry mud wallows where the dogs had often rested during the middle of the day – the memories came flooding back. Lower now, barely ten metres above the whistling thorn, the radio signal screaming in our ears.

There they were, adults, yearlings and puppies huddled in distinct

groups beneath the shade of the thorn bushes. I looked back as we swept past and saw two dogs lying by themselves. One of them stood up, profiled unmistakably against the dry backcloth. It was Half-Ear, with Short-Tail.

All the dogs looked in perfect health. The puppies, now three months old, were rapidly shedding their juvenile appearance and at this distance looked like real wild dogs. Their coats were thick and glossy, richly painted with the distinctive yellow, brown and white colours of their species. They no longer needed the darkened security of an underground den. They were familiar now with the world of sunlight and shadows, vultures and hyaenas, and were ready to explore fully the life of an adult.

The dogs were free once more to wander over the full extent of their home range. They often hunted at night or in the earliest hours of the morning, long before the sun had risen. It would be pointless to try to follow them. I would have to rely on the monthly radio-tracking flights as my window on their movements.

We headed south again to search for the Naabi females, compressing time and space, flying low across the woodlands of the Western Corridor. Suddenly the landscape seemed to expand before our eyes as the vast open spaces of the Serengeti plains came into view. Seen from the air, the abrupt transition between the southern plains and acacia woodlands is truly dramatic, reflecting the westward extent of the tree-defying hardpan created over millions of years by volcanic ash discharged from the Ngorongoro Highlands, 100 kilometres away.

The five Naabi females lay sleeping beneath the bare arms of a patch of acacia bush to the south of Lake Lagarja. It was more than one and a half years since I had watched them make their first tentative exodus from the Naabi pack. I was delighted to see them again after all this time, especially to catch a glimpse of Liz, the dog with the beautiful white markings. They still wandered the length and breadth of the southern plains, and not uncommonly made long and rapid journeys. Twice when they were tracked on alternate days they were found to have moved forty kilometres or more from the place where they had been seen two days earlier. Having logged the females' position on the map we decided to visit Ndutu Safari Lodge. Perhaps someone there could provide us with a clue as to the whereabouts of the newly formed Salei pack.

Aadje Geertsema, who manages the lodge, welcomed us with her

usual generous hospitality. It was not far from the lodge that Hugo van Lawick had made his base in the late 1960s. In those days twelve groups of wild dogs roamed the Serengeti plains. Now there were just three, the Naabi pack, the Naabi females and the Salei pack – a total of twenty-three adults and eleven juveniles. The only other dogs known to roam the park with any regularity were the Ndoha pack and the Ndoha females. Added together, they totalled just forty-three adults and twenty-three juveniles under one year of age – only sixty-six dogs in the whole of the Serengeti, an area the size of Wales.

Aadje had heard no reports of the new pack from the drivers, so we decided to fly east and continue our search for them. We were all anxious to see whether Spot and Limp from the Naabi pack, together with their two female companions, had established themselves at a den.

I looked out at the land below, the harshness softened only by the sense of security gained from being enclosed above it, of passing by. It was down here, somewhere amidst these desolate, dry-season plains, that the new pack had been forged. Truly it was a godforsaken place during the dry season. Yet it was breathtaking in its vastness, a moonscape of sculpted cliffs and rolling plains. Only the hardiest of creatures could survive here at this time of year: Grant's gazelles, ostriches and magnificent fringe-eared oryx. Few people ventured across its soft, sandy soils. For visitors travelling along the main road between Ngorongoro and the Serengeti, this place might just as well not have existed. Once beset by vehicle problems, your only companions on the long, thirsty walk south would be the wild animals and bands of wandering Masai tribesmen. This was their grazing land, returned to them in 1959 by the colonial government, who excised the eastern plains from the protection of the park and included them in the Ngorongoro Conservation Area. We had seen the Masai cattle bomas perched like ancient Inca settlements on top of the hills surrounding the three-kilometre-wide corridor of land known as Angata Kiti. Each village or *enkang* comprises a circle of flat-topped, dung-roofed huts surrounded by a barricade of thorn bush designed to keep the cattle in and the night-time predators out. Radiating from the hillsides, a maze of narrow pathways outlined the herdsmen's daily journey to areas affording the best grazing – which were few and far between.

There they were. Four wild dogs clung to the shadows provided

by an overhanging wall of ashy soil. Could it really be that the Salei pack would try and den out on these plains? During the peak of the rainy season the wildebeest often flood into this area, which lies in the rain shadow of the Crater Highlands. The combination of low rainfall and thin soils provides ideal grazing for the herds, who avoid waterlogged areas during the rainy season. But this was the dry season and the sight of so many wildebeest was nothing but an empty memory now. As we departed two Grant's gazelles turned and raced away beneath us. I had seen the dogs chasing after Grant's and knew what strong runners they were, possessed of exceptional stamina and far harder to capture than Tommies or young wildebeest. There was little else for the dogs to eat out here. The fringe-eared oryx were too large and dangerous for a pack of this size to attack and the occasional hare would do little to blunt their appetites. Why were they here? There had to be a reason. Perhaps it was an area with which the two females were familiar, where they could avoid competition with other dogs, or where there were fewer hyaenas to rob a small pack of its kill.

We could all feel it. That once-in-a-month, once-in-a-year feeling of revelry; a heady sense of space and freedom; a lightening of the spirit. We were transformed by the sheer beauty of this place. In the distance the blunt cone of Oldoinyo Lengai rose like a pyramid, nearly 3,000 metres high. Its flanks were washed white with the ash from countless eruptions during its ancient history, a giant memorial marking the birth of the Serengeti plains.

We soared higher, circling like a vulture riding a thermal. Every turn of the plane revealed some new facet of the mountain's character. Its sides were steeply gullied, camouflaged in places with a covering of dark-green bushes. This is the Masai's sacred mountain of smoke and fire, home of their god, Engai, guardian of the plains, whose history it has helped create. Legend recalls that Engai adopted the mountain as his home after a Dorobo hunter shot an arrow at him. Indeed, in the early days herdsmen made sacrifices of milk and goats to appease Engai when the volcano once again began to smoke and rumble.

For millions of years the volcanoes of the Ngorongoro Crater Highlands added ash to these plains, gradually moulding them into their present form, creating treeless grasslands covering some 10,000 square kilometres. During the last hundred years Lengai has erupted

explosively on about ten occasions, a fiery reminder of the past. In 1940 ash from Lengai was carried ninety-five kilometres to the west on the prevailing winds, living proof of the origins of the Serengeti plains.

Markus kept the plane angled to one side as we rose above the rim, a precaution against unpredictable updraughts. It was an unearthly scene. Pools of fresh black lava bubbled on the floor of the crater. Walls of white-crusted rock splashed with sulphurous yellow from the fumaroles and jets of scalding steam testified to the fact that the mountain was still very much alive. On we flew to where a tributary of the Sanjan river had sliced steeply through ancient cliffs, creating a spectacular gorge that released a cascade of white, angry water into Lake Natron. As we circled high above the gorge's rugged flanks I could see the whitewashed rock face where hundreds of pairs of Ruppell's griffon vultures nest each year. Soon dozens of the great birds had joined us on the wing, filling the blue sky with their enormous silhouettes.

The dark, tree-lined walls of the gorge closed around us as we dropped from the sky. Far ahead shafts of light beckoned, drawing us towards the sparkling waters of the lake. Flashes of pink glittered at the edge of the vast inland sea, where drying soda shone like the cut and polished surface of some precious stone; tens of thousands of lesser flamingoes gathered there each year.

Hurrying now as the light began to fade, we turned for home. As we passed the familiar landmark of Lemuta Hill, Markus pointed to a group of Masai with cattle and goats loitering well within the park boundary. They had gathered at the place where water seeped cool and clear from the base of one of the Gol Kopjes. Gradually the trees and bushes were disappearing from the granite kopjes, hacked away for firewood by the bands of nomadic pasturalists. Markus would report their presence to the Senior Warden, and a parks patrol vehicle would be dispatched the following morning to issue a warning.

Out of the blue came the signal. *Beep . . . beep . . . beep.* Karen checked the scanning frequency on the receiver. It was the Naabi pack. Or rather, I should say, it was *part* of the pack. The last time they were seen there had been twenty-one; as far as we could tell there were only six dogs resting in the network of burrows along the face of one of the erosion terraces. They were all yearlings. Perhaps these dogs had become separated during a hunt and were now resting together, away from the other members of the pack. It

Wildebeest calves are an ideal size of prey for a pack of wild dogs, but a calf's mother can often successfully defend it against a single wild dog or hyaena

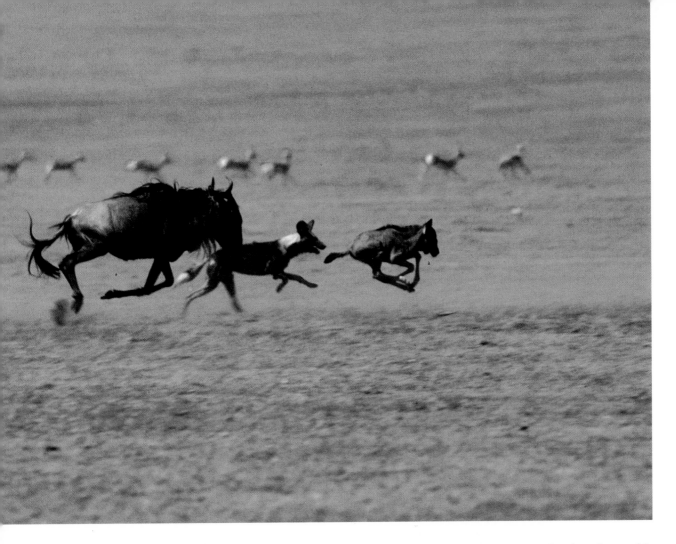

The sight of the Naabi pack with yet another litter of puppies had become an inevitable and integral part of each year – page 180

seemed unlikely that they were in the process of emigrating at this time of the year, but, if they were, we would have no way of knowing the location of Mama Mzee and the rest of the pack. None of the older dogs wore a radio-collar.

Finding so few of the dogs was troubling. During the last few weeks people had begun to voice their concern about the Naabi pack. With so many visitors and scientists moving around on the plains, it seemed strange that we had received no reports of the dogs. They had last been seen towards the end of June. All the puppies were present but only ten adults were counted. Besides Spot and Limp – the Salei males – who had left the Naabi pack in April, three other adults were also missing. I had been so involved with following the Ndoha pack that I had not given too much thought to the plains dogs. The sight of Mama Mzee with yet another litter of puppies had become an inevitable and integral part of each new year, as much a feature of the rainy season as the wildebeest. I had begun to take their wellbeing for granted.

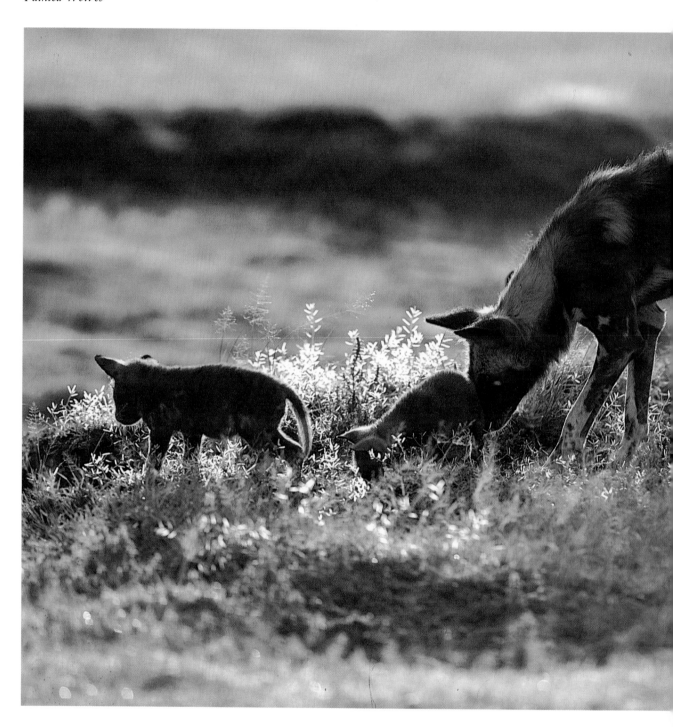

Later that month I joined Charlie and Karen on a flight to search for the Naabi pack. When radio tracking from the air it is often impossible to see the collared animal, which may be lying up in dense vegetation, or in a burrow. In 1988 members of the Naabi pack often disappeared during the heat of the day to rest below ground near their den. But regardless of where they had chosen to rest, usually at least one or two of the dogs would emerge when a plane flew low overhead. Hopefully this time we would find them all together.

We picked up a signal near the Gol Kopjes, an area much frequented by Mama Mzee and the Naabi pack in the past. We were elated, though we were unable to see any of the dogs. Charlie flew over again, pinpointing the exact position of the signal. At least we had a fix on the pack and could drive out and see how they were doing. A few kilometres further south we located the Salei pack. All four dogs were present but there was no sign of any puppies and neither female was lactating. If the pack had, as we suspected, produced a litter of puppies on the eastern plains earlier in the dry season, they had perished.

That afternoon Karen and I drove out to see the dogs. Perhaps we would have the opportunity to watch the two packs interact, something neither of us had witnessed before. The dogs seemed bound to catch sight of each other when they decided to hunt later in the evening.

It did not take long to relocate the place where we had received the signal from the Naabi pack. Our worst fears proved to be true. All that remained of the young radio-collared female was a small piece of her lower jaw and the collar.

A few months later it was discovered that Legs, another of the six yearling females from the Naabi pack, had joined up with the Salei pack. This was a surprise to everyone and rather unusual, though from Legs' point of view it may have been the obvious thing for a solitary wild dog to do to survive under difficult circumstances. Legs already knew Spot and Limp; they were her full brothers. For the moment, hunting with the Salei pack would certainly be preferable to wandering alone.

But where were the rest of the Naabi pack? Had they all really died? Or had some of the puppies that I had watched at Barafu in 1987, nearly two years ago, emigrated before the pack succumbed to yet another outbreak of disease? Our only hope of knowing was if

Mama Mzee denned again early next year. If she did, it was highly likely that we would find her at one of her old haunts on the short grass plains. All we could do now was wait.

While on a visit to England in March 1989 I received a phone call from Nairobi. At last there was news of the dogs. Markus Borner needed to contact wildlife cameraman Hugh Miles, who was making a film on the wild dogs for *National Geographic* and the BBC. Markus wanted to tell him that the Salei pack was denning not far from where Hugh had filmed Mama Mzee with puppies the previous year. There were nine puppies. But it was already too late for Hugh's purposes. He was anxious to capture the moment when young puppies first emerged from the den. In fact Hugh had driven to the Serengeti a month or so earlier, with John Fanshawe as his guide, in the hope that together they might manage to locate the Naabi pack and find them denning. Gol Kopjes, Barafu, Lemuta – they searched all the likely places. Two new groups of dogs were found wandering to the east, but there was no sign of the Naabi pack, and nothing further has ever been seen or heard of them.

Despite the demise of the Naabi pack, Mama Mzee's success as a breeding female was still in evidence on the Serengeti plains. Spot and Limp in the Salei pack were both her sons; the nine puppies that Spot had sired were her grandpups. After two years of searching, the Naabi females, who were Mama Mzee's daughters, had found a male with whom to mate. Or perhaps he had found them.

Towards the end of April, three of the original Naabi females and one younger, unknown female, were tracked to a den fifteen kilometres south of Ndutu, near the Makow road. They were accompanied by Shyster (age-mate of Collar), son of Half-Ear from the Ndoha pack.

Eleven weeks earlier a previously unknown male called Henry had been found with the Naabi females. On that occasion he had been fitted with a radio-collar and when next seen he had already left the Naabi females but was in the company of one other dog. Shyster must have arrived shortly after Henry joined the females and himself mated with them.

We knew that three of the four females had come into oestrus at approximately the same time, and that Shyster had mated with each of them – perhaps Henry had mated with them too before leaving. When the females were found denning, Stephen Lelo, a young

An underground den is vital to the survival of a wild dog litter, providing warmth and security from predators. For the first few weeks young puppies remain safely below ground and wait to be called up by the adults

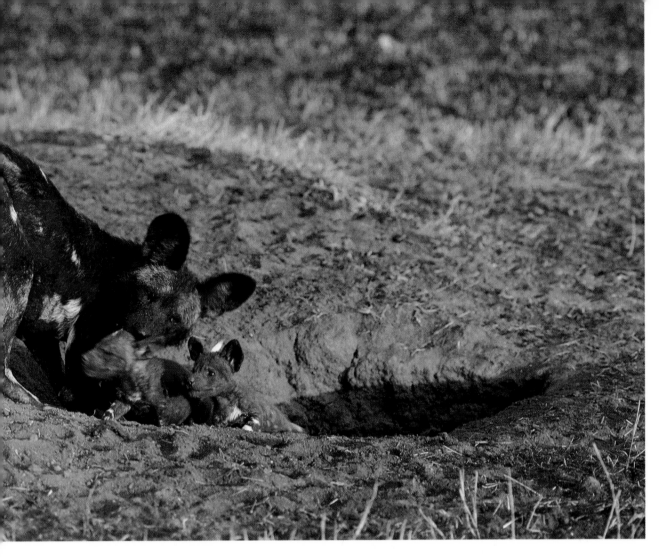

Tanzanian who had recently joined the wild dog monitoring programme, went out to watch them.

Competition among sisters for the right to breed is often intense, and particularly so, it seems, on the Serengeti plains, where seasonally prey may become scarce. Although a dominant female can suppress breeding activity in her daughters, initially the daughters seem to find it difficult to establish a stable hierarchy among themselves and ensure that only one of them breeds. Stephen's description of events provided a fascinating insight into the chaos that may erupt when more than one female gives birth at the same time.

When I had watched the Naabi females in 1986 and 1987 I had seen scant evidence of a well-defined dominance hierarchy. At that stage in their lives there was very little need for one female to assume dominance over another. They were all still firmly under the control of their mother, Mama Mzee, and her position as the dominant

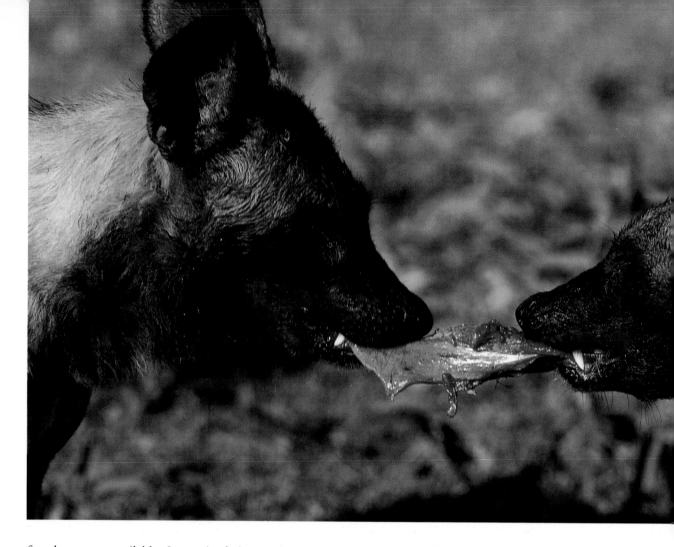

female was unassailable. It was in their own interest to conserve, rather than weaken, the special bonds forged between female litter-mates which ensure that they emigrate as a group. Apart from competition over the right to mate, the only other resource that members of a pack competed for was their share of a kill, but, as I had seen, there was little bickering between age-mates at a carcass. However, on rereading my notes from 1986 I found some interesting entries concerning the yearling females: 'Liz jousted with Mama Mzee . . . Liz led attack on wildebeest calf and anchored it by tail . . . Liz mounted Mama Mzee at kill and when approached in a threatening manner by Shaba, jousted with him . . . Liz nipped at Mama Mzee's flanks and jousted.' There was no doubt that Liz featured more often in my notes than her sisters. I felt sure it was not just because she was so conspicuously marked with white. Were there perhaps signs that Liz had the makings of a dominant female?

The fact that the Naabi females had been alone for so long may have made it even more difficult when their chance finally arrived.

Despite appearances, wild dogs rarely squabble at a kill. They compete with one another by bolting down as much food as possible

For the last two years their destinies had followed a common path. They had hunted together, shared food, defended their kills from hyaenas and searched for one another whenever they became separated. Suddenly everything was different.

There were two dens. Initially most of the pack's attention seemed to be focused around the two females who had given birth in the same den. But it was not long before one of the females, Moja, started to try to prevent the other mother from visiting her puppies, even if it meant spending the whole day guarding them. The third female was Liz. She had given birth nearly two and a half kilometres away and whenever necessary she hunted alone, leaving her pups below ground. Sometimes the male, Shyster, and one of the other females would come and visit Liz and when they had greeted, they would hunt together, with Shyster leading the way. Once the dogs had killed, Liz would return alone to her den and the rest of the dogs would regurgitate food for the other two females. All the females were wary of leaving their puppies unattended, growling and threatening any other female that tried to come too close. Moja spent nearly all her time below ground, emerging briefly to advertise her presence at the den with urine. Liz did likewise.

In circumstances such as this, when more than one litter of puppies is born, it is in each mother's interest to ensure that her puppies alone receive food and protection from the rest of the pack. With a single female capable of producing such a large number of puppies each year, it might well overtax the resources of a pack to try and raise more than one litter to maturity at any given time, particularly if there are only a few helpers. No pack can afford to endure the rigours of being constantly tied to a den site and having to find sufficient prey to provision a number of females breeding at different times of the year.

One day, when the puppies were approximately two and a half weeks old, Shyster and two of the other females came to Liz's den and started to carry her puppies to a new den barely ten metres from where Moja remained guarding the other puppies. It did not take long for trouble to start. Despite much growling and attempted intimidation on the part of Moja, Liz forced her way into her sisters' den, emerged with a puppy in her mouth and carried it to her own den. Then she killed and ate it. Within a few days Liz had taken over Moja's den. It is possible that she may have adopted some of her sister's puppies, though it is more likely that she killed them all.

There was now no question as to which dog was the dominant female in the group, now known as the Ndutu pack.

But there was a final twist to this tale. Nearly two months after the other females gave birth, Stephen realized that the fourth, unknown, female was pregnant. He had been puzzled by the hostility directed to this particular dog. She showed a keen interest in Liz's puppies but was constantly chased and bitten whenever she tried to approach them – not so much by Liz but by another female that spent a lot of time with the puppies. A few days later the pregnant female aborted. By now she looked thin and exhausted, and had deep bite marks on her face and back. She spent most of the time sleeping, staying at the den when the pack hunted. Gradually she recovered her strength. Each time the pack returned from hunting they regurgitated food for her as well as for the puppies. Her rehabilitation as a full member of the pack was assured once she had lost her own puppies.

Further north, in the Masai Mara in Kenya, another story had been unfolding, bringing new hope for the wild dog population throughout the region.

Mara: Land of Predators

1977–89

We should not have to place a value on creatures to whom values are unknown, but should treat them with compassion and their world with restraint . . . Some form of management may ultimately be necessary in all parks to keep the animal and plant communities reasonably well balanced and fit. Through aeons of evolution predators have become excellent wildlife managers, far more discerning than man, and it behooves us for our sake and theirs to comprehend as well as we can their interrelationships with the prey.

Serengeti: A Kingdom of Predators, GEORGE SCHALLER

187

Mara Buffalo Camp

To Narok
Lemek

Mara River

Mara River Camp

Mara Bridge

Aitong Hill

Mara Buffalo Rocks

Kichwa Tembo camp

1886 mts

Leopard Gorge

Oloololo Gate

Musiara Gate

2034 mts

BARDAMAT HILLS

Little Governor's Camp

Governor's Camp

Olare Orok

Musiara Marsh

ISURIA ESCARPMENT

PARADISE PLAIN

Ngiro-Are

MARA TRIANGLE

Mara Serena Lodge

Mara Intrepids

Anti Poaching Unit

Talek River

Fig Tree Camp
Talek Gate

Mara River

Sekenani Gate

Mara New Bridge

KENYA
TANZANIA

Masai Mara

Serengeti

To Narok

Keckorok Lodge

Ololaimutia Gate

Key

Sand River

Sand River Gate

NORTH

KUKA HILLS

KENYA
TANZANIA

▲ Camp

⫽ Regular Wildebeest Crossing places

🏠 Lodge

▦ Gate

░ Home Range of Aitong Pack

━ Reserve Boundary

0 5 10 Mls

0 5 10 15 20 Km

188

I was bewitched by the Mara country from the very first time I visited the area in 1975. I was travelling the length of Africa overland and could stay only for a day before continuing my journey south, but I knew then that this was the place to live for anyone interested in wild animals. I returned the following year and shortly afterwards took up residence at Mara River Camp, just beyond the northern boundary of the reserve. It was here in the Mara that I first saw wild dogs running free.

It is not only the great migration of wildebeest and zebra that draws visitors from all over the world to the wooded grasslands of the Masai's spotted land. The Mara is one of the finest wildlife habitats in Africa, a land resplendent with all the larger predators: lions and hyaenas, leopards and cheetahs, wild dogs and jackals. Yet I soon discovered that although the Mara provided ideal hunting grounds for leopards and wild dogs, they were rarely seen. And more than anything else it was these two animals that I wanted to study.

My first contact with wild dogs in the Mara occurred when a pack of eleven dogs established their den a few kilometres to the north-east of the reserve near Aitong Hill. Joseph Rotich, a driver-guide at Mara River Camp, told me that the open plains and scattered thickets surrounding Aitong had been a favourite denning area for wild dogs for as long as he could remember. Here Masai pastoralists still roam freely across the land with their cattle, sheep and goats. Despite the fact that wild dogs show little fear of man, they do not have a reputation as stock raiders in Masailand – nor do cheetahs.

189

The natural prey of both these species still survives in sufficient numbers to make it unnecessary for them to take domestic animals. And just as importantly, the Masai are always in evidence to protect their livestock and do not allow their herds to become scattered.

Traditionally the Masai have been tolerant of the wild animals who share their land, but both lions and hyaenas are considered a menace, having on occasion killed livestock and even people. Under such circumstances the Masai respond with spears and poison. Male lions are enshrined in the myth and folklore of the Masai as potent symbols of manhood and courage, worthy adversaries to be challenged on foot with nothing but a long-bladed spear and a buffalo-hide shield to boost a warrior's morale. Though lions and hyaenas are still relatively common in these areas, they are found in lower densities than within the reserve. Perhaps this is one reason why wild dogs and cheetahs do well in the northern rangelands. Both species are compromised in their ability to defend their kills and raise young when forced to compete with large numbers of lions and hyaenas. Fortunately, cheetahs are surprisingly adept at avoiding contact with man. When threatened, they can conceal themselves in the barest of cover, and the chances of a cheetah taking poisoned bait are minimal. They rarely scavenge, preferring to feed on their own kills.

Each day during the early part of September 1977 I journeyed from Mara River Camp to the place where the Aitong pack had denned. When Joseph first found the pack he counted eleven adults and fifteen puppies. He felt sure that the dogs were sick; they looked thin and mangy and had lost parts of their coats. By the time I saw them there were only eight adults and twelve puppies. The northern Mara had been experiencing unseasonably heavy rains and the pack had twice moved to better-drained areas on higher ground. I watched one grey afternoon as the female ran back and forth in the middle of a torrential downpour, grasping each puppy around its waist in typical wild dog fashion and carrying it to a new den at the top of the rise, where the rest of the pack sheltered beneath a tree. The remaining puppies sat huddled together for warmth at the entrance to their flooded burrow, tiny bundles of sodden fur waiting to be transported to safety. Finding itself suddenly abandoned, the last of the puppies tried to follow in its mother's footsteps, protesting loudly at being left alone. The female paused to let it catch up, hesitated for a moment and then dropped the puppy she was

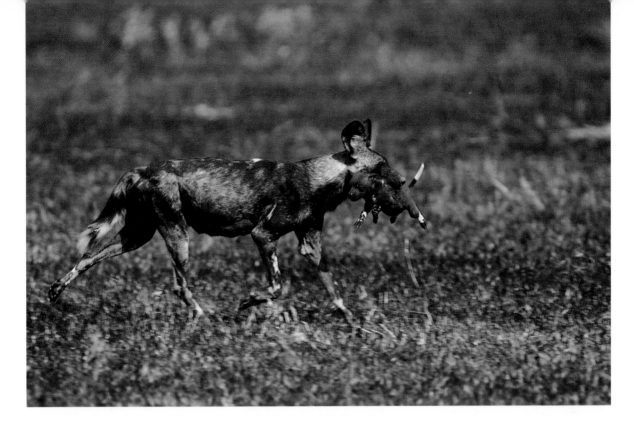

Unlike members of the cat family, who always carry their young by the neck, a wild dog mother generally grips her puppies by the waist

carrying and picked up the straggler. Eventually she and the last two puppies arrived at the new den. The puppies clambered over each other in their efforts to get closer to their mother, desperate for milk and warmth.

Within two weeks all the puppies were dead and only five of the adults were still seen in the area. Though exposure undoubtedly hastened the death of the puppies, some of the adults had died of disease.

During the next few years I endeavoured to keep track of wild dogs in the Mara area. Drivers and guides occasionally reported seeing dogs, though typically they never stayed long in any one part of their range; they are restless souls, always trying to keep one step ahead of the lions and hyaenas as they search for food. Throughout the Mara and the Serengeti the wild dogs were enduring hard times.

The Aitong pack failed to raise puppies in 1978, but in July 1979 I found the female with five small puppies one kilometre south of the 1977 den site. She was accompanied by the dominant male, Black Dog, and another male – his brother, according to Joseph. Early each morning and evening the two males would leave the shade of their favourite tree and run to greet the female and the puppies before departing to hunt. Fortunately, the surrounding plains were awash with animals: mainly wildebeest and gazelles, but also zebra and impala. But it was as if the other prey species did not even exist. It was only the wildebeest that the two males were interested in

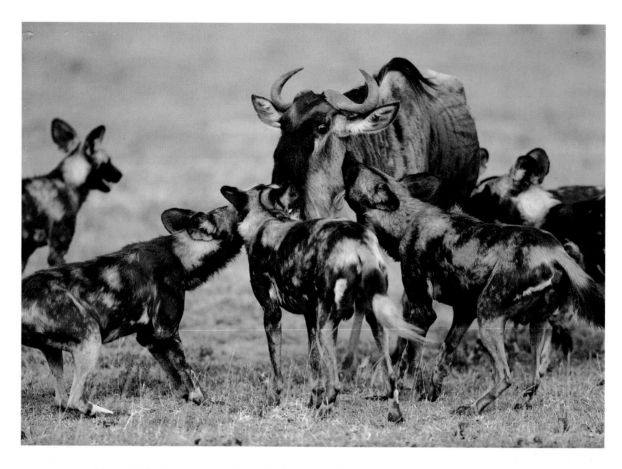

pursuing, and invariably they managed to pull down a calf within a kilometre of the den.

The two brothers worked as a team. Usually the subordinate male reached the calf first and grabbed it by the leg or tail. As the calf slowed, Black Dog lunged forward and caught it by the nose. His brother would then join him in subduing their victim, biting the calf in the throat and strangling it. The wildebeest was usually dead within a minute or two. Only then could the dogs begin to feed, using each other as a counterweight to tear the carcass apart. It was interesting to see how the dogs could adapt their hunting and killing techniques now they were so few in number. They were forced to apply a killing bite – in this case a stranglehold – in order to overpower a large prey animal such as a six-month-old wildebeest calf quickly. Adult males in larger packs often use a stranglehold in

Adults, usually the males, often use a stranglehold in conjunction with the lip-hold when trying to subdue large prey

It is noticeable that females seem to be particularly adept at the fast, long-distance chases after gazelles – page 195

When food is short, the whole pack may be forced to leave the den unguarded, thereby exposing the puppies to the risk of predation

conjunction with the lip-hold when trying to subdue adult or yearling wildebeest. But in these circumstances the dogs can usually tear their prey apart without first needing to kill it.

Numerically the Aitong pack was operating at the very lowest limits of a viable breeding unit. It is most unlikely that a pair of wild dogs could raise many puppies to maturity without helpers, though a single female in the Serengeti is known to have survived for more than six months on her own. The abundance of food represented by the arrival of the migratory wildebeest enabled the Aitong puppies' mother to stay with them while the males went off to hunt. Under less favourable circumstances she may have been forced to leave the den unguarded, exposing her litter to the risk of predation; left alone there was always the chance that hyaenas might find and kill them.

By the time the puppies were two months old the female felt

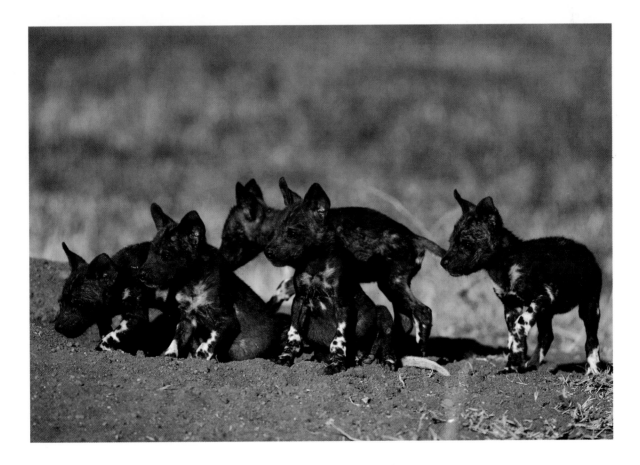

confident enough to leave them at the den and join the males when they went hunting. This was to everyone's benefit once the migration had deserted the Aitong plains, as the female was a superb huntress, particularly adept at the fast, long-distance chases after Thomson's gazelles. I never failed to marvel at the beauty of these life and death encounters, two creatures locked for a brief moment in a primordial struggle for survival that both desperately needed to win. I was transported back in time to the moment when man first strode across these plains, a club of bone in one hand, a stone in the other, competing as a social hunter and scavenger with the other predators.

In 1980 I saw the pack hunting an impala in the bush country near Leopard Gorge, which bounded through the tall vegetation until, confused and cornered, it was trapped and killed. By now one of the puppies, a male, had long since disappeared, presumed dead. The adults seemed preoccupied with excavating aardvark burrows and old hyaena dens, raising clouds of dust as they scraped and dug. The female's abdomen looked suspiciously swollen, as if she were preganant. I wondered if she would produce a new litter of puppies during the next few weeks.

But all was not well with the Aitong pack. To my dismay I could see that one of the yearling females was sick and another was missing. The third sister was visibly distressed at the absence of her litter-mate, calling repeatedly and then pausing to listen. I followed as she retraced the scent trail left by the pack earlier in the day. She veered this way and that, stopping and starting, guided by her nose. Every few hundred metres she paused to call, though I heard no reply. Eventually the female located her sister lying hunched in the grass. She looked half dead, a gaunt bundle of skin and bones. The sisters greeted each other and then moved off in the direction of their relatives. After barely half a kilometre the ailing dog lay down and refused to go any further.

That evening the pack killed a wildebeest calf within view of their stricken companion. They ran and greeted her, trying to rouse her from her resting place under a tree. By now she could barely stand, staggering about on quivering hind quarters, retching and salivating profusely. Her faeces were covered in fresh blood. She did not beg for food, nor did she try to eat from the carcass.

When next I saw the dogs all three yearling females were missing. Though it was possible that the females had simply emigrated from

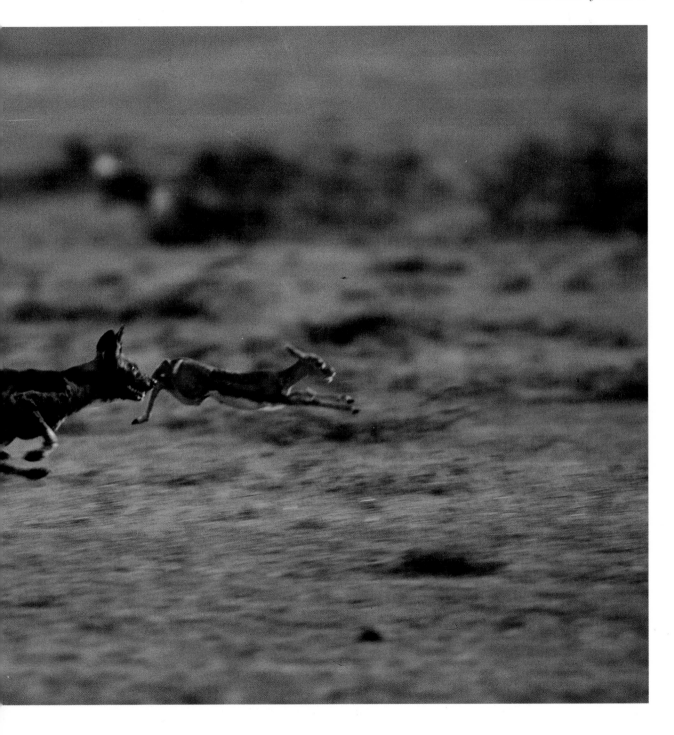

Painted Wolves

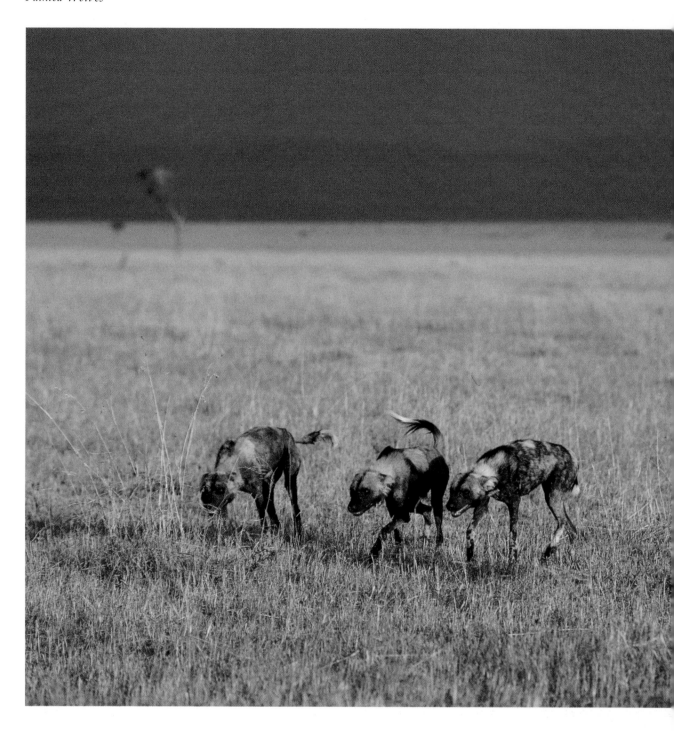

the pack I felt sure that they had died. Only the three adults and one young male were seen together after that. My hopes for the renaissance of the Aitong pack were fading.

I had often wondered what became of wild dogs that suddenly disappeared. What happened to Black Dog late one afternoon gave a graphic example of the threat posed by larger predators. The four dogs of the Aitong pack had just captured a wildebeest calf when a lioness emerged from the bushes. She had known from the calf's bleats of distress that there was the possibility of a free meal. Black Dog was the first to see the lioness trotting towards them. He announced her appearance with a gruff-bark of alarm. The other dogs immediately leapt aside, releasing their hold on the young wildebeest, which was still on its feet. As the lioness dragged the calf away, Black Dog rushed in and bit her hard on the backside.

I had watched lions chasing prey a thousand times, seen them challenging hyaenas and defending their kills from vultures, yet still I could not believe the speed with which the lioness now moved. She dropped the calf and spun round, her face a mask of unbridled menace. This was not the impassive stare of a predator chasing prey; this was a look reserved for a rival. Abandoning the wildebeest, she charged after the frightened dog. I can still see the look of surprise and terror on Black Dog's face as the lioness bore down on him. With two or three enormous bounds she had closed the gap between them. A single swipe from her outstretched paw sent him spinning across the ground. Before Black Dog could scramble to his feet she grabbed him by the neck – just as she had grabbed the wildebeest calf. Black Dog let out a yelp of alarm.

It was all so quick and appeared so final. There was no time to interfere – huge rocks barred my way – and my attitude had always been to let nature take its course. However, the rest of the pack had no such compunctions. They responded instantly to Black Dog's yelps with a rousing assortment of frenzied barks and yips. They rushed in behind the lioness, snapping at her exposed backside, forcing her to release Black Dog so that she could defend herself against their furious onslaught. With a harsh grunt of warning she charged the dogs, scattering them in all directions before trotting back to where the calf still lay thrashing on the ground. To my astonishment, Black Dog jumped to his feet, apparently unscathed by his narrow escape. I shouted a silent cheer of delight.

Not long afterwards the same thing happened again. In the company of other vehicles, I watched three of the dogs feeding on a wildebeest calf near Governor's Camp airstrip. Two lionesses had seen the wildebeest herd suddenly scatter as the Aitong pack moved in to make their kill and trotted over to investigate. Black Dog and the female looked up as the lionesses approached and, after gulping down a few more mouthfuls, abandoned the kill. But the subordinate male was still hungry. He had stayed back while the dominant pair fed and now was his chance to grab some food.

Whether the male was unsighted by the vehicles or gravely miscalculated the situation I do not know, but the next moment he was hanging limply from the jaws of one of the lionesses. Without hesitating, a photographer friend of mine drove straight at the lioness, forcing her to drop the dog. He was sure that the male had been caught only because our vehicles were present. Under the circumstances, he felt it only right to intervene. Again, the dog jumped to its feet without any sign of injury.

Confrontations between the various predators are commonplace, a part of their everyday existence. They appear exceptional to the human observer only because of their visual intensity and excitement; most of the time we see predators at rest. Rarely, if ever, does anyone observe them day and night, even for as little as a week and never from one year to the next. Our impressions are riddled with distortions and prejudiced by our presence. Despite the apparent thoroughness of field studies, the time spent observing individual wild animals is only a tiny fraction of their lives. Nevertheless, it became increasingly apparent as I watched the Aitong pack struggling to survive that a small group of wild dogs is at a distinct disadvantage in comparison with the larger packs. They are less able to watch out for the approach of other predators and defend their hard-earned kills. Ultimately, a small group is forced to take greater risks simply to obtain sufficient food, let alone breed.

I saw the last remnants of the Aitong pack in November 1982, by which time the subordinate male had long since disappeared. I found him one day, wandering alone, his face strangely swollen, and thought that perhaps he had been kicked by a wildebeest or bitten by a snake. Only Black Dog and the female remained. As I watched them lying side by side under a solitary tree, I realized just how little I knew about them: where they had come from, where each had been born, how old they were, how many brothers and sisters each had

The four Aitong dogs in 1981 – from left to right, the subordinate male, the yearling male, the female and Black Dog – approaching wildebeest – page 196

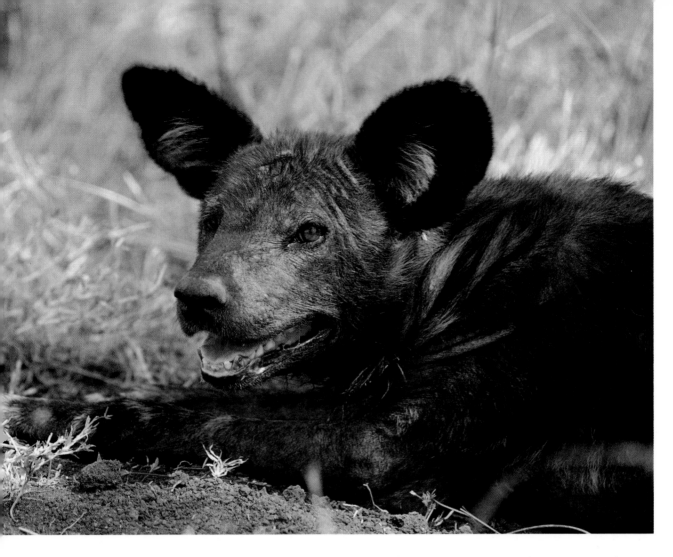

The last occasion on which I saw Black Dog

known. But even though there were so many unanswered questions, I felt a sense of familiarity in their presence.

The dogs looked weary and seemed even leaner than usual, their sharp teeth reduced to brown stumps. Except for a thick ruff around his neck, Black Dog was almost hairless, his skin a slate grey. Life was tough for the two old dogs, who, perhaps ten years old, were nearing the end of their lives. With the remorseless passage of time the female had lost that vital metre of pace which had made her such a devastating huntress of gazelles. Now, without the support of greater numbers, it was almost impossible for the two dogs to subdue animals the size of wildebeest – even the calves – as quickly as they needed to. By the time they had pulled their prey to a halt, half a dozen hyaenas or a watchful lion were likely to be charging towards them across the Mara plains. The dogs' only defence was to bolt down whatever food they could tear from the carcass. Then, with a few gruff-barks of alarm, heads bobbing, white tail-tips cocked,

199

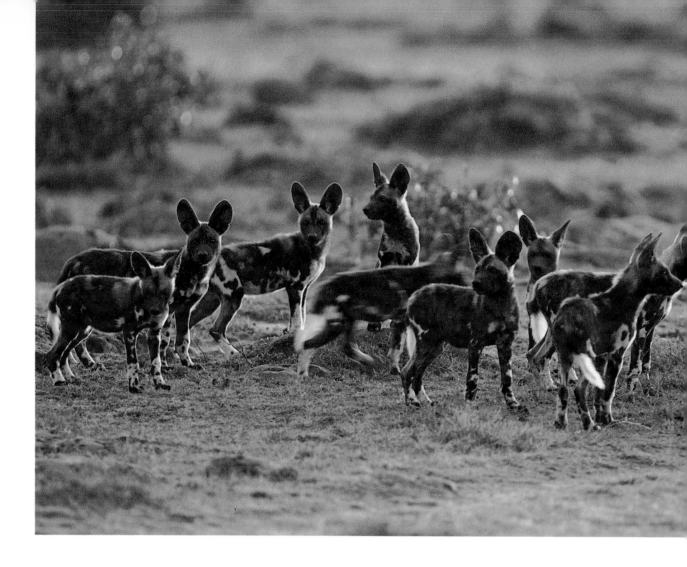

they were forced to watch as the larger predators moved in to steal their kill. Impotent in the face of greater strength or superior numbers, they could only turn and trot away.

Over the next few years I became conditioned to life without the Aitong dogs. Eventually I gave up hope of seeing them again. They faded to a distant memory, until I no longer asked about them. If anybody happened to see wild dogs, they would definitely tell me; it was always a talking point of any safari. There were occasional reports of dogs in the Loita Hills, to the east of the Reserve, and once I saw a small pack of adults and yearlings twenty kilometres beyond the Isuria escarpment, in wooded country near Lolgorien town. But for whatever reasons, and there were many, no wild dogs were seen gracing the Mara landscape.

Towards the end of 1985, at the same time that wild dogs were once

Ten three-month-old puppies of the two 1986 Aitong litters

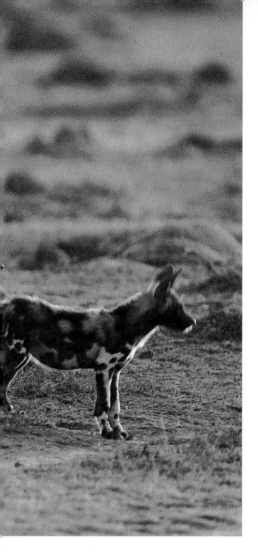

again being recorded on the Serengeti's short grass plains, a pack of nine was seen near Aitong Hill. This was the first report of dogs in the northern Mara for three years. Though sighted on a number of occasions by Masai pastoralists in the Aitong area, the pack failed to raise a litter of puppies that year and I thought it unlikely that I would hear more of them. Wild dogs wander very widely, particularly when dispersing to form new packs, and it is not uncommon for them to turn up in an area where they have not been known for many years, only to vanish again within days.

How wrong I proved to be. The new Aitong pack prospered, their success measured by three generations of puppies that helped inject fresh life into the depleted wild dog population of the Serengeti–Mara. As the number of dogs in the pack swelled, separate groups of male and female litter-mates emigrated, dispersing into the vastness of the wooded grasslands.

Between visits to the Serengeti I was able to spend time during 1986 and 1987 in the Mara, watching the new pack grow from strength to strength. Just as they had in the past, these northern rangelands beyond the reserve boundary beckoned to the dogs, establishing a rhythm to their lives almost identical to that followed by the original pack. Aitong had everything they needed: an abundance of resident game, the glut of food represented by the migration, ideal denning sites and a lower density of lions and hyaenas than other such areas replete with prey could offer. The dogs spent 90 per cent of their time outside the reserve, avoiding the long grass areas further south. It was wonderful to watch a completely different pack of wild dogs in full cry across the Aitong plains in pursuit of the wildebeest during the dry season, and I was relieved to see them looking fit and healthy, raising large numbers of puppies in similar localities and at the same time of year as Black Dog and his mate had done.

By now it was apparent that wild dogs in Serengeti–Mara synchronized their breeding cycle to coincide with the superabundance of food provided by the passage of the wildebeest migration through their home range. The Naabi pack established its den during the rainy months of November to May, when the migratory wildebeest were massed on the southern plains. The Ndoha pack denned in the early dry-season months of June and July as the migration was moving into the Western Corridor, and the Aitong pack denned slightly later in the dry season, in July or August, as the

wildebeest moved north into the Mara. This was to each pack's advantage, providing ample food for puppies and yearlings.

Quite how this synchronization is achieved is not yet known. Breeding at other times of year, when suitable prey is less abundant and difficult to locate without travelling far from the den, would certainly seem to yield smaller numbers of surviving puppies. With a relatively short gestation period, realizing this synchronization may be merely a matter of trial and error. But there may also be other more specific factors, such as nutrition, that trigger the onset of oestrus in females, increase fertility, or otherwise help to create a seasonal peak in breeding.

In August 1988 the dominant female in the Aitong pack and her sister secluded themselves among the bush-spotted slopes of Aitong Hill, out of reach of the tour vehicles. As they had done in both 1986 and 1987, the two females gave birth within a week or so of each other, suckling their puppies side by side. There was little evidence of the kind of hostility that Mama Mzee had shown when she and her sister had given birth at the same time in 1985 or that Liz had shown when the other Naabi females produced litters. The fact that on each occasion the Aitong females gave birth when the migration was in attendance undoubtedly helped make it possible for two litters to survive, but it was not only this. The northern rangelands provide ideal feeding conditions for herbivores year round. The plains and acacia thickets support high densities of the wild dogs' staple diet during the wet season, when the majority of the wildebeest have departed. Thomson's and Grant's gazelles, impala and topi all flourish among the lush Masai pastures. With a steady supply of food throughout the year, and plenty of helpers to provision and defend the puppies, the Aitong pack proliferated with relatively little conflict.

Each morning and evening throughout September the drivers of the tour vehicles awaited the emergence of the Aitong pack. You could feel the buzz of excitement as the dogs trotted from the hillside. There were no preliminaries. As the sun rose above the hills the hoarse, grunting alarm calls of the wildebeest echoed across the stillness. The herds swept this way and that, bunching and jostling, the calves clinging to their mothers' sides, all desperately trying to outmanoeuvre the pack. But the dogs were too many and too fast. There would be no escape for some of this year's crop of calves. Despite having survived the most vulnerable early days of their lives on the short grass plains of the Serengeti, the six-month-old calves

were no match for the collective power of the Aitong pack.

The dogs hunted as individuals *and* as a group. Each pack member looked for calves to chase while at the same time keeping an eye on what the rest of the pack was doing. With so many hunters the pack had little trouble finding ample food for all. As soon as a calf was hobbled, other members of the pack – particularly the older males, who might otherwise be forced to give way to the dominant pair and the yearlings at a single kill – sped onwards, pursuing other calves before the herds could disappear from view. Two, three or sometimes more calves would fall prey to the Aitong dogs. Soon the surrounding plains became known as the 'killing fields'.

This was the kind of pack I had always dreamed of watching, a pack at the height of its fortunes, breeding to the capacity of the land, with the majority of its puppies surviving to maturity and young males as well as females emigrating to make room for successive litters of puppies. I remembered stories told many years before of numerous packs of wild dogs forty or fifty strong. It was almost too good to be true.

Not until the first week of September 1989 could I return once more to watch the Aitong pack in the Mara. Friends had kept me informed as to the dogs' movements while I was enjoying life with the Naabi and Ndoha packs in the Serengeti. By this time all of the original adults in the Aitong pack had died or disappeared, except for the dominant female, who was heavily pregnant. She was accompanied by the nineteen yearlings that survived from the combined litter of twenty-two puppies born to her and her sister in 1988. Anxiously I awaited news of the birth of the latest litter of puppies. The time was near.

Each morning and evening when the pack set off to hunt the female lagged behind, heavy with pup. But it did not matter. As the dominant female she was accorded a measure of priority when the pack was feeding on a carcass. No matter how late she arrived at a kill, she was always assured of a meal. Even if the dogs had devoured all the flesh from the carcass the female needed only to beg and her relatives would regurgitate some meat for her. That was no less than any member of a pack of wild dogs could expect.

The drivers from the tented camps carefully monitored the condition of the pregnant female, knowing that before long there would be yet another litter of puppies to enthral visitors. The dogs were such good value. Though lions were by far the easiest of the

Mara's predators to find, they spent most of the day slumped in the shade of a tree. And if you were lucky enough to catch a glimpse of a leopard, it was invariably shrouded in dense cover by the time the sun was up, making it the most difficult of all to photograph. No wonder, then, that cheetahs and wild dogs were the favourites with the drivers. Being far more diurnal than the other large predators, they provided visitors with ample opportunity to watch them hunt or socialize with their young.

After a number of days searching and investigating numerous burrows, the female chose the den where she would give birth. It was a secret place just a few kilometres from the spot she had chosen the previous year. Only if someone followed the route taken by the rest of the pack when it returned to where the female waited at the den, or if they tracked the two radio-collared yearlings from the air, would they find a clue to its whereabouts. The other alternative would be to ask the local Masai landowners. They knew better than anyone what was happening in their area, particularly where predators were concerned. For the Masai, watching wild animals was not just a pastime; it was part of their way of life.

On hearing that the female had denned I drove to the Mara. It was more than two years since I had made the journey by road from Nairobi. Wooden buildings with shiny new roofs dotted the spectacular landscape of the great Rift Valley, beyond the bright lights of Kenya's capital city. In places the land had been broken up into small plots and here the drying leaves of maize cobs now rustled in the breeze, awaiting harvest. Donkey carts, skilfully piloted by young boys, hauled 200-litre drums of water along the battered tarmac road. Masai men and women cloaked in blood-red robes chatted in small groups outside clusters of wooden shops. The women held up handfuls of colourful beaded ornaments identical to those that adorned their arms, legs and necks. Bright, cheery children waved at the procession of passing safari buses filled with eager tourists. '*Peremende, peremende,*' they cried. 'Sweets, sweets.'

150 kilometres later I reached Narok town, the last major outpost east of the Mara Reserve. Here you could break your journey and refuel. Trucks lined the narrow road alongside the shiny new grain stores, waiting their turn to offload cargoes of wheat. Nearby tourists milled about the curio shops, bargaining for Masai trinkets and souvenirs.

I stopped and bought some food from the Indian trader who owned a tiny kiosk at one of the petrol stations. His shop was no larger than the inside of my car, providing a telescopic view of street life in the town. The old man knew everything and everybody. Travellers clustered around the front of the kiosk, sipping cups of sweet tea or gulping down a Coke or Fanta. His samosas were the best in town – triangles of crispy pastry filled with meat or vegetables. The old man's sight was failing now and he was hard of hearing. We talked for a while of the rains and the tourists, of the competition he faced from newer shops further up the road and of the inevitable change that was transforming this corner of Masai-land.

Just as I was about to leave, a young Kenyan joined us in conversation, inquiring as to the nature of my work. When I told him I was writing a book on wild dogs he smiled knowingly. 'That should be a strange book,' he said. 'Wild dogs are different from the other animals. They can be a menace to sheep and goats if you do not look after them properly. I used to have a pack of domestic dogs and I encouraged them to attack the wild dogs, but after a while I stopped. It was useless. My dogs just used to fool around with the wild dogs. They never actually touched one another but just used to mill around, playful but slightly wary. It was as if they knew they were brothers. They would not attack each other. I once found a wild dog den and tried to raise three of the puppies. They were very small when I took them. We gave them plenty of milk mixed with maize flour but they did not like it. Perhaps they needed meat. But meat is far too expensive to give to dogs. Within a month they were all dead.'

Our conversation reminded me of a description in one of Bernhard Grzimek's books of the legendary Margarete Trappe, the only woman ever to hold a professional hunter's licence. She recounted a meeting with a large group of wild dogs while out hunting with her own pack of gun dogs in Tanzania. 'Showing no signs of mutual timidity or hostility, the tame and wild dogs mingled and sniffed each other inquisitively without exchanging a single bite. Each party must gradually have lost interest in the other, because they quietly separated and trotted off.'

Eighteen kilometres beyond Narok the tarmac road swings south towards Keekorok Lodge. I continued west, hurrying along the rough dirt road to the northern Mara. Another 100 kilometres

and I would reach Mara River Camp. Fields of ripening wheat stretched to the horizon, obliterating memories of a land speckled with wildebeest, topi, zebra and gazelles. Narok District now provides more than a quarter of Kenya's wheat and has been identified as the most underutilized agricultural area in the country. In places large stands of maize already flourished on the rich soils next to the muddy track, reminding me of the ones I had seen clustered along the southern edge of the Western Corridor. On the horizon a small clump of wildebeest stood in a tight knot next to freshly creosoted fence posts surrounding a tin-roofed hut. The Masai were changing. Some were already farming for themselves; others were leasing their land to commercial crop growers. There was no longer any room here for the wild animals.

Life and Death on the Plains

SEPTEMBER–NOVEMBER 1989

Man always kills the things he loves, and so we the pioneers have killed our wilderness. Some say we had to. Be that as it may, I am glad I shall never be young without wild country to be young in. Of what avail are forty freedoms without a blank spot on the map?

A Sand County Almanac, ALDO LEOPOLD

Somewhere out on the plains near Aitong a Masai herdboy stared into the distance where wildebeest trudged across the grasslands. It was a sight he had seen for as long as he could remember; wildebeest were part of his life. For four months each year the wild herds seeped like a black stain across the green of the plain, swarming over the lush pastures and devouring the precious grass. The Masai pastoralists would rejoice when the rains arrived in October or November. Then most of the wildebeest would depart for their traditional wet-season pastures in Loita and the Serengeti. But in recent years much of the Loita plains to the east of the game reserve had been ploughed up to grow wheat. Leased by the Masai to farmers, the wheat ranches squeezed more people, cattle and wild animals into the ever-shrinking wilderness.

The race for Masailand was on. It was time for nomadic pastoralists throughout Kenya to play a greater role in the country's development and join the market economy. Wheat farmers, cattle ranchers, people from Lake Victoria and conservationists alike all coveted the wide open spaces surrounding the Mara. The farmers wanted to cultivate the area. For them the wild animals were a problem. The conservationists, meanwhile, wanted to protect the habitat from the encroachment of agriculture and protect the wildlife by using the area for tourism. Most of the Masai simply wanted to be left in peace to control their own destiny and graze their cattle, as they had done since they first arrived in the area 200 or 300 years before. But everywhere the population was increasing, both more people and more cattle. The Masai were left trapped between

participation in modern-day Kenya and retention of an ancient culture that until recently had safeguarded the land for themselves and the wild animals.

Ole Ndutu was twelve years old, the third son of a respected elder of the Purko Masai. He was not yet of an age to undergo circumcision, a ceremony which would signal the end of his childhood and establish him as a man in the eyes of his people. Ole Ndutu longed for that day to arrive so that he could bring honour to his family and fulfil his lifelong ambition of being a *moran* – a warrior – a lion hunter, a protector of his tribe.

The land on which the young herdboy's cattle now grazed was part of a group ranch belonging to the Koyaki group, under a system of land tenure that cedes a portion of rangeland to the male representatives of a number of Masai families. This was a recent and somewhat alien concept for the Masai. Individuals had always owned cattle, not land. Land was for grazing, administered through the elders of the various Masai clans or subtribes. It was not individually owned.

The northern rangelands surrounding Aitong consist of gently rolling plains and scattered acacia thickets, broken in places by isolated patches of forest and tree-lined luggas. To the west lie the brown waters of the Mara river. This area is considered by many to be one of the best game-viewing areas in the whole Mara region, even though it lies outside the protection of the reserve. The drivers from all the tented camps in the northern Mara patrol these lush pastures in search of lions and leopards, cheetahs and hyaenas. Thirteen years ago the Koyaki group ranch leased a portion of this land to a local safari company, granting them permission to set up a tented camp on the banks of the Mara river, guaranteeing them a degree of exclusivity in the area. Since that time a number of other companies have been granted similar leases for permanent tented camps outside the reserve to accommodate the growing number of visitors.

Today tourism in the Masai Mara is big business. Everyone wants a share in the development of Kenya's finest game area, which annually attracts more than 300,000 visitors. But until recently the Masai who actually live there have benefited little from the revenue generated by their land. In an effort to compensate for this, and to create financial incentives for maintaining the northern rangelands for non-agricultural purposes, it was agreed in 1989 that the various

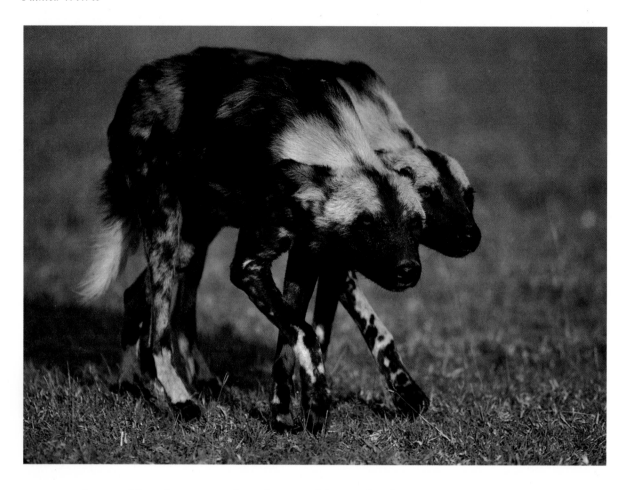

group ranches would receive revenue from the tens of thousands of tourists who visit their land in search of wild animals. Visitors now pay the equivalent of US$10 per person and US$10 per car for each day spent in the Mara, a quarter of which goes to the local Masai. Despite complaints about the lack of maintenance of the roads in and around the Mara, this seems cheap for the privilege of visiting a unique part of Africa whose value cannot be measured in money.

The wildebeest moved closer, ignoring Ole Ndutu and the cattle. To the wildebeest, cows were just another kind of animal with which they shared these pastures. But as far as Ole Ndutu was concerned, the wildebeest were a menace. He ran towards the grunting herds, shouting and waving his wooden sticks, stampeding the wildebeest

Two yearling wild dogs bunched together as they try to get closer to their prey

Traditionally, Masai pastoralists have co-existed in harmony with wild animals – page 213

to clear a path for his father's cattle. It was not just a question of competition for dry-season grazing. The wildebeest might carry diseases which could kill cattle or cause them to abort. During the wet season, when some wildebeest gave birth on these pastures, the cattle would be moved to prevent them eating grass contaminated by the nasal secretions and birth fluids of the wild herds, which sometimes carry malignant catarrhal fever or brucellosis.

The primary prey of wild dogs in the Serengeti–Mara is Thomson's gazelles. Territorial males, rather than females, are more frequently the victims

Out of the corner of his eye one of the bull wildebeest glimpsed a movement that spelt danger. He stopped and stared out across the rise, his gaze fixed not on the herdboy but on a far greater danger. Trotting towards him, almost casually, were fourteen wild dogs. The bull froze, snorting in alarm, causing the whole herd to falter. Ole Ndutu saw the herd pause, recognized the dark canine shapes

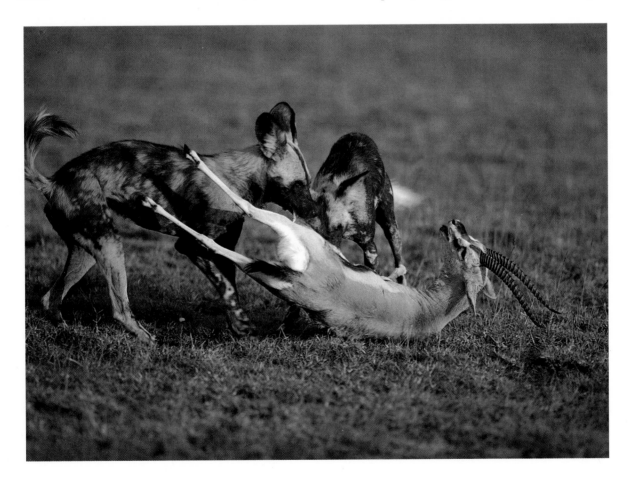

moving single file towards the wildebeest. The boy stood on one leg like a stork, bracing himself on his spear, red toga flapping in the chill morning air. He and his friends among the herdboys enjoyed watching the wild dogs hunt; he had seen them do so on more occasions than he could remember. Since the arrival of the new Aitong pack in 1985, Ole Ndutu had noticed even more vehicles hurrying across the plains near Aitong. Sometimes the drivers stopped to ask if he had seen lions or cheetahs, but their most earnest questions concerned the whereabouts of *isuyan*, the wild dogs. Everyone, it seemed, was eager to see them.

Ole Ndutu often wished that he had the speed of a wild dog, so that he too could cause panic among the great herds of game and drive them from his father's land. The wild dogs were his friends; killers of the wildebeest. They held no fear for Ole Ndutu. Only town folk despised the dogs, believing that they would tear people limb from limb as if they were a gazelle or a wildebeest calf. The boy knew such things to be untrue because he had been born and raised among animals, schooled by his father as to the ways of the wild. He knew for himself which animals were truly dangerous. A chance meeting with an old and cantankerous buffalo or a bull hippo lying up away from the sanctity of the river – these were the ones to be wary of. When the majority of the wildebeest departed in October the dogs would hunt Thomson's gazelles and impala, at times even pursuing the big toffee-coloured topi, selecting not only new-born calves, heavily pregnant females or males exhausted from the rut but even healthy animals. Why should dogs bother with people or cattle when they had an abundance of natural prey to feast on? No Masai had ever been attacked by a pack of wild dogs. To the son of a man who had killed a lion, a pack of wild dogs was nothing to fear, and such thoughts were an insult to a boy longing to become a warrior.

The wildebeest broke rank and fled. The dogs accelerated, struggling to keep sight of their quarry in the churning dust. It was the calves they were after, and in less than a minute the dogs had isolated a small group of cows and pulled two of the calves to the ground. Ole Ndutu's own dogs watched as the dust cleared. The Masai dogs were used to fending for themselves and took every opportunity to scavenge a meal out on the plains. Sometimes the boys encouraged their dogs to chase the wild animals, as young boys anywhere would do. Wart-hogs were a particular favourite. It was great sport baying the heavily tusked boars, listening to the ferocious

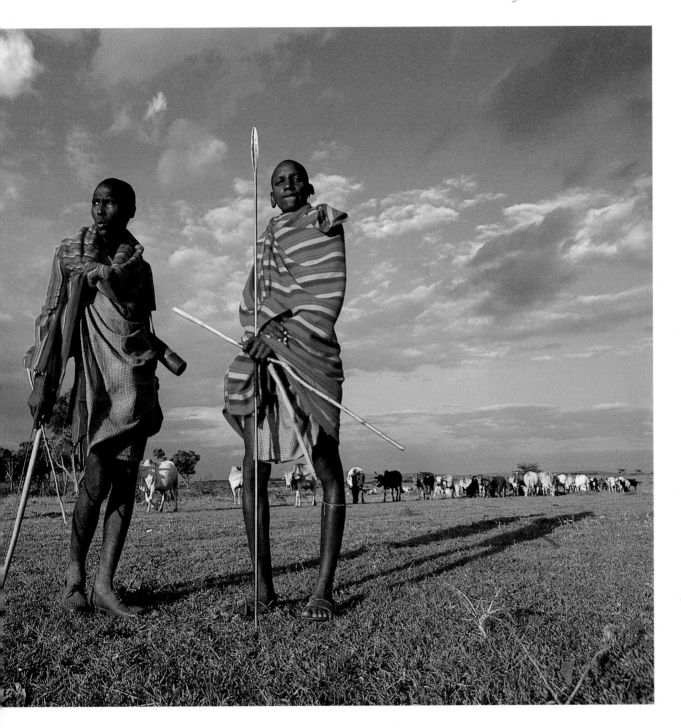

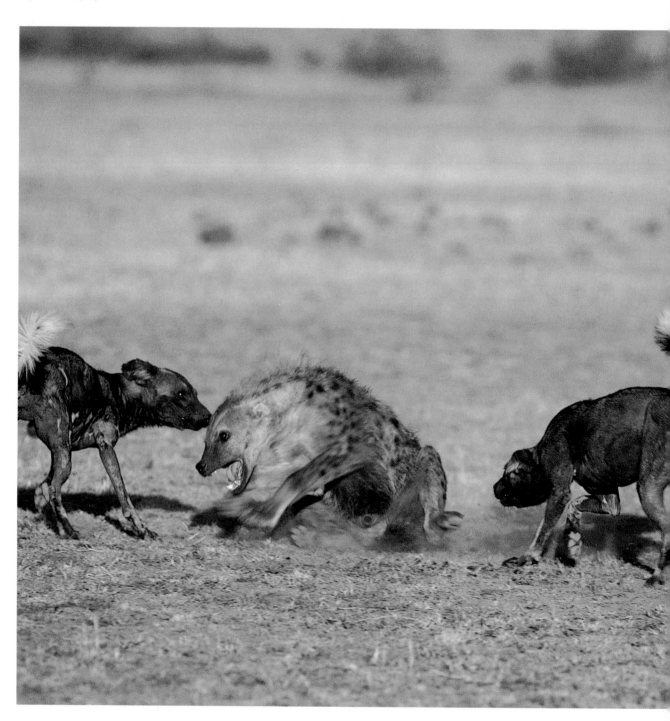

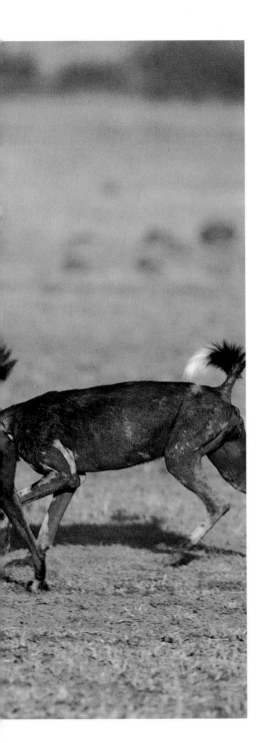

grunts and roars of a pig that had sought the shelter of a burrow. Once the animal had gone to ground, the boys would attempt to finish it with spears or *simis*, the short Masai swords, rewarding their dogs with an ample supply of fresh meat.

The Masai dogs moved closer. Ole Ndutu did not mind; he was interested to see what the dogs would do. Invariably wild dogs defend their kills vigorously against other predators, though very occasionally young hyaenas manage to share a meal with the dogs by acting as submissively as possible. Two years earlier Ole Ndutu had watched as some of the yearlings from the Aitong pack allowed his dogs to join them at the carcass of a wildebeest. It was as if the two groups of dogs recognized their similarities. On that occasion the yearlings had continued feeding as the Masai dogs trotted towards them. Others – the older dogs – stood back, as they would when puppies arrived to feed, somewhat perplexed by the boldness of their domesticated relatives. Then a single hyaena came charging on to the scene and stole the remains of the carcass, ending an unusual encounter.

But on this particular day Ole Ndutu's dogs lost interest in their wild cousins, and he whistled to them to return. Later that evening as the boy herded his cattle back to their thorn-bush enclosure, he found the half-eaten carcass of one of the Aitong pack. There was nothing to show how the dog had died, though it was obvious that the vultures had been at work. The boy knew that the wild dogs sometimes became sick, just like his own dogs. When this happened the Masai often gave their dogs a bowl of milk dosed with medicine used to treat their cattle against sleeping sickness.

When I arrived that evening at Mara River Camp, Hugh Miles told me that he had just returned from the place where the old female from the Aitong pack had denned. His description of events brought back memories of the fate of the original Aitong pack and the Pedallers in Serengeti. Hugh felt certain that the female had indeed given birth: her belly was now thin, though she showed little sign that she was still lactating. Either her puppies had been few in number or they had already died.

There was something horribly wrong with the female wild dog. Hugh filmed her as she staggered around the den site. She looked gaunt and was drooling from the mouth, with gums raw and bleeding. Her face was grossly swollen and she appeared unable to

see: her eyes remained tightly shut and she kept bumping into things. Back at camp Hugh's assistant, Samantha Purdy, managed to radio a message through to John Richardson, the veterinarian working on the Loita wild dog project, who agreed to fly to the Mara next morning. But as Hugh had feared, by the time they returned the den area was deserted. Last year's puppies – the yearlings – would now have to fend for themselves. Hugh was despondent. He had failed earlier in the year in his quest to film wild dogs with newly emerged puppies in the Serengeti, due to the disappearance of Mama Mzee and the Naabi pack. Yet again disease was claiming the wild dogs of Serengeti–Mara.

Why do the wild dogs so often fall prey to outbreaks of disease when they are denning? One reason is that faeces and pieces of old meat abound, providing an ideal environment for a variety of parasites: both hookworm and coccidia are transmitted through faeces. Some adults look very mangy and so do some puppies. A variety of fungal diseases can infect dogs and it is not uncommon to see young puppies emerge from the den with circular patches of bare skin due to ringworm, or to mange caused by mites. Normally, the protein-rich diet of a pack of wild dogs helps keep them in good condition and protects them from debilitating disease. But the burden of regurgitating food for a large litter of puppies and the need to stay for ten or twelve weeks within the limited confines of a den can be a considerable stress on the pack. And as John Richardson said to me, 'From the point of view of disease, a pack of wild dogs is one animal.' Their highly social ways virtually ensure that each member of a pack is equally exposed to any outbreak of infectious disease among their number.

It was not until the 1960s that people began studying the life histories and behaviour of wild dogs. At that time the byword for disease among wild dogs was distemper. Before long any wild dog in East Africa that was seen to be sick was said to be dying of distemper, even though there are a number of diseases that superficially resemble it in the field. Only later, when research workers began to scrutinize the disease profile of wild and domestic canids, did it become apparent that wild dogs are susceptible to a variety of epidemic diseases, one of which is 'distemper'. Now, at last, biologists, geneticists and veterinary surgeons are pooling their expertise in the Mara and Serengeti to try and unravel the history of the various epidemic diseases that have stricken the wild dog

Injuries inflicted on hyaenas by a pack of wild dogs are usually superficial. But on one occasion a visitor witnessed the death of a hyaena which had been savaged by the large Aitong pack – page 214

population in the recent past. Distemper, anthrax, parvovirus and tick-borne diseases are all potentials killers of wild dogs.

In 1987 Dr Pieter Kat, a geneticist at the Nairobi Museum, initiated a study on the wild dogs in Kenya, focusing his attention on the Aitong pack. John Richardson was acting as veterinary consultant for the project. Perhaps at last they would provide some answers.

During the next few days we searched for the remains of the Aitong pack, and each day we found them dying on the plains. I watched, sickened by the reality of yet another pack of ailing dogs. Visitors, many of whom had made a special journey to view the wild dogs, were appalled by what they saw. It is not unusual for adult wild dogs to appear rather scruffy and mangy to human eyes, even when they are in relatively good health. Indeed, some of the dogs still looked healthy, though most of them showed some degree of hair loss. But others were grossly transformed, their throats swollen to double the normal size, rendering them unable to shake their heads properly or to eat. One visitor was heard to remark to his driver, 'Let's get out of here, Charles, this is depressing.' And so it was. A yearling female stood as if in a trance, gently swaying backwards and forwards. Her eyes looked dull and lifeless, giving the impression that she was no longer in contact with what was happening around her. She seemed trapped in an inner world, confined by some sort of madness. Other dogs sought the scant shade offered by tussocks of tall grass. But as the sun climbed ever higher into the cloudless sky the female lay flat on her side, oblivious to the raw midday heat. One of the males came to his sister and licked at her mouth, gently greeting her. She hardly stirred, drooling, her gums flecked with blood. Would he too be dying by tomorrow? Perhaps he was infected already? Even now another of the pack was unsteady on its feet, staggering around like a prize fighter after one too many fights.

By evening the young female could do little more than lurch to her feet, head bowed forwards, then flop back on to the ground. Her breathing had slowed. She was painfully thin and unable to eat. I felt guilty watching her dying like this, unable to do anything to ease her misery.

The healthier dogs were thoroughly disturbed by the behaviour of their sick relatives. When one of the ill dogs came to where a healthy dog lay resting, the healthy dog would hurriedly get up and move

away, shunning it for acting in an unusual and unsettling way. Worse still, there were occasions when the whole pack started to bully and pick fights with one of the sick dogs, biting at its throat and tearing at its lips, at times ignoring its twittering yelps of submission. It seemed so brutal, a mockery of the wild dogs' normally sociable lifestyle. I did not want visitors to remember the dogs like this, almost mirroring the way people so often portray them, as cruel, vicious killers, a species like the wolf, which is known on occasion to attack and even devour sick or wounded relatives. Yet in such circumstances, their behaviour was justified. A pack of wild dogs depends for its existence on the ability of individual members to respond in a predictable manner towards one another, obeying the covenant that enables them to hunt as a group, feed peacefully together and provision young puppies, submerging their individuality within the pack's identity. Each dog provides appropriate answers to social signals. But a seriously sick or injured dog may be unable to function normally as part of the group. Instead, it becomes a liability, unable to join in the greeting ceremony or to hunt.

I felt certain that we would find the sick female dead next morning, but she was not. She was transformed. Where yesterday she seemed unable to see clearly, now she was alert, eyes blazing with an unnatural brightness, pupils contracted to black pinpoints. But this was no miraculous recovery. The female was surely dying. Round and round she went, pausing only to rip at the ground, tearing up clumps of dry grass until her mouth could hold no more. Every so often she keeled over and lay motionless. Each time she did so I could only hope she had died.

From out of the heat haze a single dark shape emerged, a solitary cheetah drawn by curiosity towards the wild dog as it played out this ghastly ritual. Normally cheetahs and leopards wisely stay well clear of wild dogs, fearful of being chased in open country with hardly a tree or bush to save them from being mobbed and possibly injured.

The moment the tour drivers spotted the cheetah they raced across the plains towards her. This particular cheetah, as it turned out, was well known to the drivers. The tourists could hardly believe their good fortune on finding such a prize. But joy soon turned to consternation as the cheetah sprang on to the bonnet of one of the vehicles. The driver smiled, assuring the visitors that they should

not be alarmed as this particular female invariably climbed on to cars. She was one of a group of five cheetah cubs who had been orphaned the previous year. They had survived their mother's death due to the help of rangers, who had provided the cubs with 'kills' until they were old enough to fend for themselves. In the past, vehicles had meant food to this cheetah. Now that she was a fully independent adult, a vehicle was not much different from a mobile termite mound, providing an elevated view of the plains and its animals. She seemed to enjoy the vehicles and felt secure in their presence. Tourists had become a part of her life and the daily movement of vehicles trekking across the plains was as familiar to her as the Thomson's gazelles which she hunted.

Abandoning her perch, the cheetah proceeded cautiously, measuring each step as she stalked towards the wild dog. Slowly the spotted cat drew closer, pausing every so often to sit and stare. The dog was oblivious to the approaching predator; it could as easily have been a lion or a hyaena. She was beyond knowing, shut off from the finely tuned senses that would normally help protect her from danger. But then the cheetah suddenly veered away, intent now on the unsuspecting male Thomson's gazelle that lay resting on the rise. The wild dog had been only a brief distraction. The cheetah was heavily pregnant with her first litter of cubs and finding sufficient food was her overriding priority.

A group of female gazelles had already spotted the stalking cheetah and hurried towards her, uttering nasal snorts of alarm, but the predator ignored them. Her eyes were fixed remorselessly on the unwary male. Another few metres and she would be certain of a meal.

The gazelle suddenly stood up, forcing the cheetah to freeze in mid-stride. He looked around, sensing the danger crouched barely twenty metres away. Then predator and prey exploded across the plain. Giant, supple strides powered the cheetah's lithe form over the ground. It seemed that the cat must prevail, but just as she seemed assured of success, the gazelle cornered sharply. Left and then right he jinked in zigzags of dazzling precision, gaining time, creating space, forcing the cheetah to the edge of her endurance. Once more the gazelle cut away, tilting at such a precarious angle that I felt sure he would come crashing to the ground. But he did not. The race was over and the gazelle had triumphed. The cheetah faltered then abruptly stopped, staring after the gazelle as he made good his

escape. A few hundred metres away the wild dog female paused, staring blindly into space, then for the hundredth time that morning she tore at the ground, trying to stuff even more grass into her mouth.

The cheetah lay panting in the shade of the tree-spotted rise. I waited on the hillside with Hugh and Samantha. Half a kilometre further north the remains of the Aitong pack huddled beneath a clump of bushes, awaiting the cooler hours of the late afternoon when they would hunt again. But the dogs were ill at ease. They lacked some of the cohesion that had always been their greatest strength. Suddenly they were no longer functioning as a group, for by now only seven or eight of them were still strong enough to hunt. Sick animals lagged behind and, becoming steadily weaker, they were unable to keep in contact with the pack when they moved on each morning and evening. Slowly but surely the life of the Aitong pack was wasting away.

As we waited with the cheetah, Samantha noticed one of the male wild dogs lying in a patch of tall grass in a dried-up mud wallow. The cheetah had seen it too. The dog had looked ill the previous evening. He kept rising from the ground and then went crashing on to his side again, as if he had been shot. Suddenly a second dog, this one a female, came trotting over the horizon from the direction where we had seen the rest of the pack. It was obvious from the way she moved that she was searching for her missing relatives. She trotted easily across the plain, then suddenly stopped and lifted her face into the breeze. She could smell the familiar scent and unerringly traced it to its source. When she reached the place where her sick relative lay motionless she circled warily. She sniffed at the dying dog but did not try to greet him before continuing over the rise. A few minutes later she was back and licked the sick dog in the mouth. She stood for a moment, looking puzzled at the lack of response from her brother. As she departed again the male stood up and staggered a few paces before keeling over. Back she came and this time the male managed to wag his white-tipped tail. It was enough. She went wild with excitement and wanted to play, jostling and sniffing, twice grabbing hold of her brother by the nose and trying to drag him out of the wallow, but he was too weak to move. As she trotted away her brother died.

Two hours later we found that the other female had finally died, her mouth still filled with grass. She looked so small, lying out on the plain.

220

Dr Pieter Kat, a ranger from the reserve and Dr John Richardson take samples from a dead member of the Aitong pack

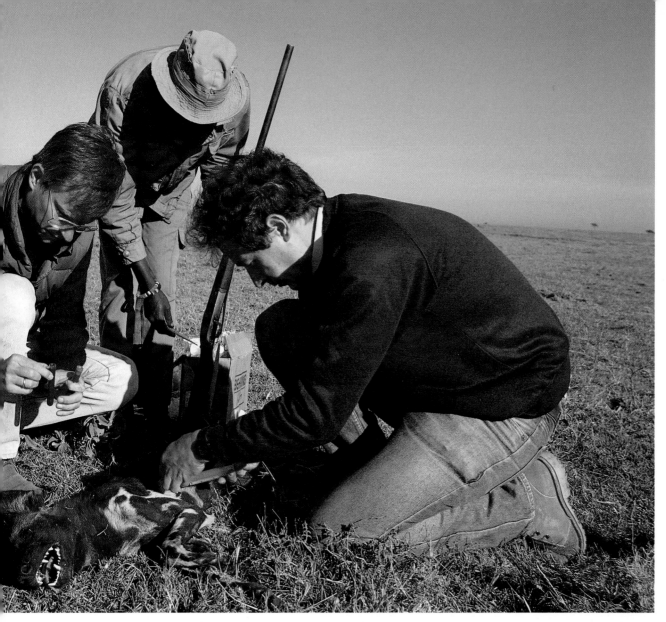

Knowing that we were likely to find some of the dogs dead, Hugh
and Samantha had brought along surgical gloves and a sack. Having
loaded the animals into their car they drove back to camp to await the
arrival of Pieter Kat and John Richardson from Nairobi, who were
flying to the Mara to try and find out what was killing the dogs.
They drove out to Aitong later that same evening. Perhaps there was
still time to save some of the dogs.

Pieter and John arrived with a ranger shortly after the dogs had
begun feeding on a wildebeest calf. They decided to immobilize the
sickest of the dogs for a closer look and to treat it if possible. The
vehicle carefully manoeuvred into position alongside the pack,
allowing Pieter a clear view of the ailing dog. The moment the dart
slapped into her rump she spun round and pulled it out with her

teeth, but the drug had already begun to work. Within a minute she began to stumble, then lay down. Working from the blind side of the car Pieter and John gently lifted the comatose dog into the vehicle. Once they were far enough away not to disturb the rest of the pack they stopped. Quickly the team set to work. The ranger held the saline drip, John administered long-lasting antibiotics and checked the dog's physical condition, Pieter took measurements and blood samples for antibody analysis, and Samantha recorded the details on a fact sheet.

When Hugh had first seen the dominant female of the Aitong pack at the den, there was little to suggest that her sickness was not an isolated case. The rest of the dogs appeared to be in good health. One possibility was that she had been bitten by a snake, for visitors had seen the dogs taunting a snake on a previous occasion. Venom from a puff-adder might explain her swollen face. But when other members of the pack began to develop similar signs of distress we knew it must be something else. Might it be poison? It seemed most unlikely that the Masai would deliberately try to eradicate the dogs. The original Aitong pack had once denned within a few metres of a path used by the tribesmen and come to no harm. The Masai had no quarrel with the wild dogs. However, many people familiar with the Mara had reported a decline in the number of lions and hyaenas in the areas bordering the reserve. In recent years the Masai population had increased in the region, and so had the number of cattle. Rumour had it that the Masai had been taking things into their own hands. When, and if, lions and hyaenas killed cattle, the response was usually immediate. Drivers told me that one of the old male lions from the Kichwa pride had been speared when it wandered beyond the reserve boundary. Others spoke of the disappearance of virtually the whole of the Ololorok pride to the east of the reserve. And hyaena numbers certainly seemed a lot lower than a few years ago. Yet the resident prey species, which sustain the hyaenas and lions during most of the year, were thriving.

If the Masai were putting out poisoned baits – in the past cattle-dip was the favoured potion – then there was always a chance that the dying wild dogs were innocent victims of an indiscriminate campaign to control predators. Or were the inexperienced yearling dogs scavenging from the carcasses of animals that had died of disease and themselves becoming infected? The female that had torn up grass had acted in a similar fashion to a domestic dog I had seen

dying of rabies. John Richardson was not prepared to commit himself but felt that at this stage rabies was the most likely cause. Periodic outbreaks are not uncommon in the carnivore population and bat-eared foxes and jackals had been known to have died of the disease in the Serengeti–Mara during the last couple of years. And there was always the risk of infection from the domestic dogs which ran wild over the plains with the Masai herdsmen.

But when we returned to Aitong the following day we found the female that had been anaesthetized and treated with fluids and antibiotics eating with one of the other dogs on an impala carcass. She still looked a mess but such a dramatic recovery for a dog that had seemed close to death did not fit with the rabies theory. However, when the brain samples had been analysed in Nairobi and America they turned out to be positive for rabies, and she was never seen again.

Pieter Kat estimates that there may be between 300 and 350 wild dogs left in Kenya, representing between sixteen and eighteen packs. There could be as few as 200 to 250. John Richardson's words echoed in my ears: 'When you talk of disease in wild dogs it becomes necessary to think in terms of "the pack". One pack, one dog; sixteen packs, sixteen dogs.' Viewed in that light, 300 wild dogs sounds horribly few. In future a more interventive stand may be necessary to safeguard the wild dogs in areas such as the Masai Mara, where domestic dogs roam freely among the wild animals. A vaccination programme is now being implemented to try and halt the transmission of lethal diseases between wild and domestic dogs. A similar campaign by the veterinary services to create a ring of immunity around the Serengeti–Mara in the 1950s helped to eradicate cattle plague, or rinderpest, from wild and domestic stock, so it has to be worth trying. Dogs could be protected from distemper, hepatitis, parvovirus and leptosporosis with a single shot of vaccine given annually to cope with recruitment of yearlings into a pack.

And rabies? Acquired immunity to this most dreaded of diseases is unheard of, unlike distemper or parvovirus. Rabies has been killing animals and humans for thousands of years; it is known from Greek history. However, Kenya had been virtually free of the disease since the late 1950s. Then, towards the end of the 1970s, it reappeared. One theory is that there was an upsurge in the incidence of a variety of animal diseases due to the return of the Tanzanian army after

liberating Uganda from the scourge imposed by Idi Amin. Victorious troops took domestic stock with them, leaving at a time when northern Tanzania was veterinarally ill-equipped. Reports soon started to reach Nairobi of outbreaks of foot and mouth disease, rinderpest and rabies. The main carriers of rabies in Keyna are medium-sized carnivores, such as domestic dogs and jackals, and also mongooses. At some point rabies was reintroduced into the Mara. The only hope is to be vigilant on behalf of the wild dogs, and to vaccinate where appropriate.

The Aitong plains were once again eerily quiet now that only two of the pack remained. Had we really been an audience to the quickening road to extinction of Africa's wild dogs? Was there still room for cautious optimism? Even now age-old prejudices linger on in and outside protected areas. Intolerance still rivals disease as a threat to their survival. In 1987 a safari driver told me that park rangers in Samburu National Park in northern Kenya threatened to shoot a pack of wild dogs seen chasing a cheetah; the rangers were worried that there was insufficient game to tolerate wild dogs. And despite the fact that the Kruger National Park in South Africa supports one of the largest and most important wild dog populations on the continent – between 350 and 400 dogs – farmers with land bordering the park still tend to view the dogs as vermin.

But there is room for hope: during the last two years some twenty-five dogs from the Aitong pack have dispersed throughout the area. There are also other dogs doing well in the Mara. When the Ndoha females in Serengeti left their natal pack in March 1988 they spent the next two months wandering extensively to the south and the east, traversing the home ranges of both the Naabi pack and the Naabi females. In June, at the same time as the wildebeest moved into the Western Corridor, four of the females were located to the north-east of Kirawira guard post. At some time during July or August the Ndoha females pushed north into Kenya. When they were radio tracked in early August they were near to Mara River Camp airstrip, beyond the boundary of the Masai Mara, over 200 kilometres north of their position in early April. At one point the females were seen to make contact with members of the Aitong pack. By this time two of the original five females had disappeared, and the remaining three were in poor condition. In January 1989 they were seen near Mara River Camp airstrip with a male dog who was thought to be one of the Aitong pack. And later

still rangers saw them swimming across the Mara river and entering the Triangle. For the last year and a half they had roamed the length and breadth of the Serengeti-Mara in their quest to breed. Finally the Ndoha females joined up with a group of seven males and denned in the western corner of the Masai Mara, barely one kilometre north of the Serengeti boundary. When a friend went out to see the pack there were twenty puppies visible at the den, so more than one of the females had produced a litter.

On the other side of the reserve, at a den near Mara Intrepids a pack of three dogs was rearing eight puppies, all of which were doing well. One of the males was Collar from the Ndoha pack, brother of Shyster, the latter being the male who had sired the litters born to the Naabi females. Between them Mama Mzee, Short-Tail and the Aitong females had, with support from the unique social provisioning of the pack, helped sustain the Serengeti–Mara wild dog population. The dogs can bounce back if given the chance. Disease has always played a part in regulating wild populations, but increased contact between wild and domestic animals has accelerated their demise. Recently, an outbreak of distemper among domestic dogs caused heavy losses to the carnivore population in Nairobi National Park, particularly among jackals and mongooses.

There are now wild dog projects under way in South Africa, Botswana, Zimbabwe and Namibia, as well as in Kenya and Tanzania. People are cooperating in their endeavours. In the Kruger National Park visitors are encouraged to photograph any wild dogs they see on their game drives to help scientists studying the dogs. 5,000 photographs have been received. Some of the dogs have been fitted with satellite radio-collars, providing a fix on the position of the dogs three times a day through a computer link in France. Technology such as this means that research workers can track the movements of packs even if they cross national boundaries. It is to be hoped that new information will focus attention on these fascinating animals in a more positive way in the future. And while it is comparatively easy to raise support for the more popular symbols of our wild places, such as elephants and lions, it is imperative that we also help the wild dog to survive.

Two of Mama Mzee's three offspring born in 1986 stare out across the vastness of the Serengeti plains – page 227

The story had come full circle: dogs dying and others surviving; from the spotted land of the Mara to where the plains run on for ever, and now back again. Serengeti–Mara is one place to the wandering

wildebeest and the wild dogs: their lives are inextricably bound. We now know that the dogs in this vast area form a single breeding population and are capable of covering the length and breadth of the land in search of mates. They need space to survive. Without the freedom to roam there is no future for the wild dogs, nor for the wildebeest or the traditional ways of the Masai.

I drove far out into the plain and thought back to that first time I had heard the haunting, hooting cry of the female wild dog. A dry wind blew from the Gol Kopjes and I wondered for how much longer it would continue to carry the call of the painted wolves across this incomparable land.

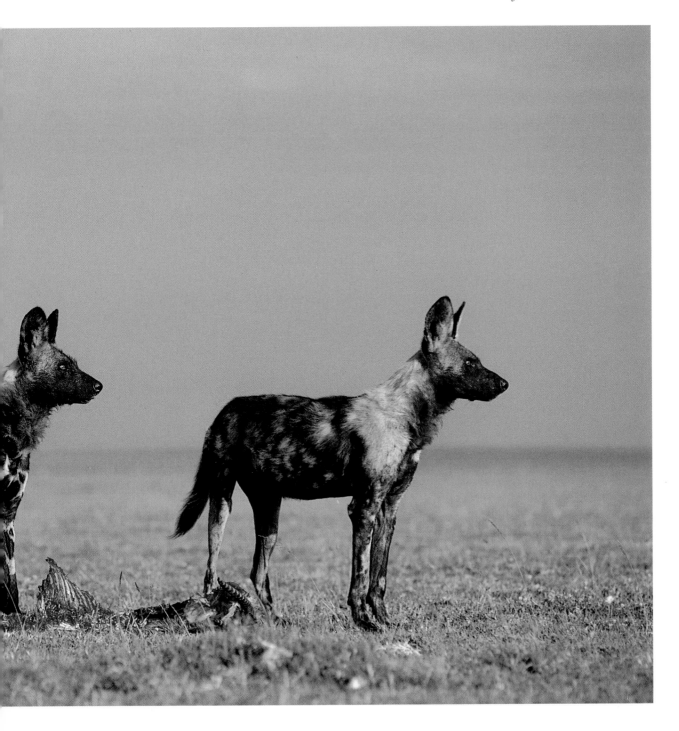

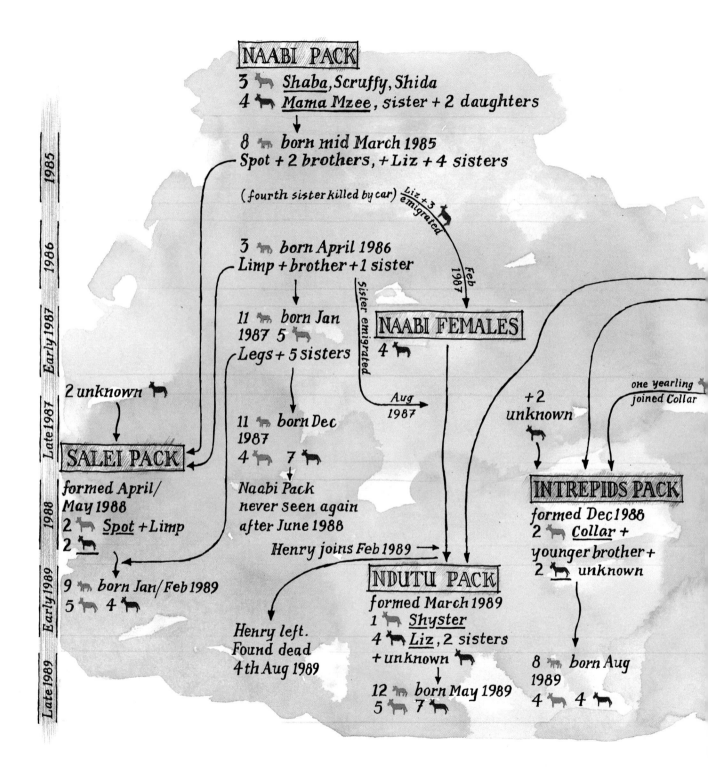

NAABI PACK

3 🐕 *Shaba*, Scruffy, Shida
4 🐕 *Mama Mzee*, sister + 2 daughters

8 🐕 born mid March 1985
Spot + 2 brothers, + Liz + 4 sisters

(*fourth sister killed by car*) Liz + 3 emigrated

3 🐕 born April 1986
Limp + brother + 1 sister

Sister emigrated

11 🐕 born Jan 1987 5 🐕
Legs + 5 sisters

NAABI FEMALES

4 🐕

11 🐕 born Dec 1987
4 🐕 7 🐕

Naabi Pack never seen again after June 1988

Feb 1987

Aug 1987

2 unknown 🐕

one yearling joined Collar

+ 2 unknown 🐕

SALEI PACK

formed April/ May 1988
2 🐕 *Spot* + Limp
2 🐕

9 🐕 born Jan/Feb 1989
5 🐕 4 🐕

Henry joins Feb 1989 →

Henry left. Found dead 4th Aug 1989

NDUTU PACK

formed March 1989
1 🐕 *Shyster*
4 🐕 *Liz*, 2 sisters + unknown 🐕

12 🐕 born May 1989
5 🐕 7 🐕

INTREPIDS PACK

formed Dec 1988
2 🐕 *Collar* + younger brother + 2 🐕 unknown

8 🐕 born Aug 1989
4 🐕 4 🐕

228

FAMILY TREE OF WILD DOG PACKS IN SERENGETI~MARA (1985~1989)

Based on data provided by Serengeti Ecological Monitoring Programme, Tanzania; Loita Wild Dog Project, Kenya.

KEY: 🐕 Males 🐕 Females 🐕 Puppies —— Mated

AITONG PACK

2 🐕 + 5 🐕
2 breeding 🐕

17 🐕 born July/Aug 1986
2 litters of 8 & 9

18 🐕 born late July/Aug 1987
10 🐕 8 🐕
from 2 litters

22 🐕 born July/Aug 1988
10 🐕 11 🐕 + (?)
from 2 litters

All the original adults had died or disappeared by Sept 1989, some due to outbreak of rabies

Only 2 yearling 🐕 survived

NDOHA PACK

5 🐕 Half-Ear + his sons
Shyster and
Collar + Blacky + 1 other
8 🐕 Short-Tail + her daughters/sisters ?

10 🐕 born June 1987
7 🐕 3 🐕

1 🐕 emigrated March 1988

4 🐕 emigrated March 1988

12 🐕 born end May/June 1988
4 🐕 8 🐕

12 🐕 born April/May 1989
5 🐕 7 🐕

NDOHA FEMALES

5 🐕

7 (?) unknown 🐕

TRIANGLE PACK

7 🐕 3 🐕

20 🐕 seen Aug 1989

4 🐕 had died, or emigrated individually by 1987

5 🐕 + 6 🐕 emigrated May/June 1988

5 🐕 emigrated Seen in Lamai Wedge, May 1989.
7 🐕 + 1 🐕 emigrated Aug 1989

17 of 1988 litters died in outbreak of rabies →

229

Bibliography

It was not appropriate in a book of this kind to cite individual references throughout the text. Instead, this bibliography contains popular and scientific accounts of wild dog behaviour that helped illuminate time spent with the dogs. Some works mention the dogs in passing; others deal with them exclusively. In particular I would draw the attention of readers to the PhD theses of Frame (L), Malcolm and Reich, and the recent paper by Frame and Fanshawe on the current status and distribution of the wild dog. Fergus Keeling (*The Natural History Programme*, 2 November 1989, Radio 4) kindly provided me with a tape of his conversation with Dr Gus Mills, who heads the wild dog project in the Kruger National Park.

Ammann, K. 'Wild dogs in the Masai Mara', *Swara*, Vol. 10, No. 5, 1987, 8–9.

Blixen, K. *Out of Africa*, Penguin Books, Harmondsworth, 1954.

Borner, M. and Fanshawe, J. 'Long-term monitoring of the African wild dog. Serengeti Ecological Monitoring Programme: proposal for project continuation', Serengeti National Park, 1987.

Bright, M. 'The Big, Bad Scapegoat', book review in *BBC Wildlife*, Vol. 2, No. 1, January 1984.

Bueler, L. E. *Wild Dogs of the World*, Constable and Co. Ltd, London, 1974.

Campbell, K. L. I. 'Serengeti Ecological Monitoring Programme: Conservation Monitoring in Tanzania', Programme Report September 1989, Serengeti Wildlife Research Centre, P.O. Box 3134, Arusha, Tanzania.

Capstick, P. *Death in the Long Grass*, St Martin's Press, New York, 1977.

Childes, S. L. 'Wild dogs: victims of ignorance', *Zimbabwe Wildlife*, No. 41, 1985, 13–15.

Estes, R. D. and Goddard, J. 'Prey selection and hunting behaviour of the African Hunting Dog', *Journal of Wildlife Management*, 31, 1967, 52–70.

Fanshawe, J. H. 'Serengeti hunting dog project', *SRI Annual Report 1986–7*, Serengeti Wildlife Research Centre, PO Seronera, via Arusha, Tanzania, 1988, 37–40.

—'Serengeti's painted wolves', *Natural History*, March 1989, 56–67.

Fanshawe, J. H., FitzGibbon, C. D., Laurenson, K., Borner, M., and Scott, J. P. (in preparation). 'The African wild dog *Lycaon pictus* on the Serengeti plains 1985–88'.

Ferry, G. (ed.). *The Understanding of Animals*, Basil Blackwell, Oxford, and *New Scientist*, 1984.

FitzGibbon, C. D. and Fanshawe, J. H. 'Stotting in Thomson's gazelles: an honest signal of condition', *Behav. Ecol. Sociobiol.*, 23, 1988, 69–74.

—'The condition and age of Thomson's gazelles killed by cheetahs and wild dogs', *J. Zool., Lond.*, 218, 1989, 99–107.

FitzPatrick, P. *Jock of the Bushveld*, Longmans, Green and Co., London, 1907.

Frame, G. W. 'Carnivore competition and resource use in the Serengeti ecosystem of Tanzania', PhD thesis, Utah State University, Logan, Utah, 1986.

Frame, L. H. and Fanshawe, J. H. (forthcoming). 'African wild dog *Lycaon pictus*: a survey of status and distribution 1985–88', SSC: Canid Specialist Group Report.

Frame, L. H. and Frame, G. W. 'Female African wild dogs emigrate', *Nature* (London), 263, 1976, 227–9.

—'Wild dogs of the Serengeti', *African Wildlife Leadership Foundation: News*, No. 32, Vol. 11, No. 3, 1976.

—*Swift and Enduring*, Elsevier-Dutton, New York, 1981.

Frame, L. H., Malcolm, J. R., Frame, G. W. and van Lawick, L. H. 'The social organization of African wild dogs (*Lycaon pictus*) on the Serengeti plains, Tanzania, 1967–78', *Z. Tierpsychol*, 50, 1979, 225–49.

Fuller, T. K. and Kat, P. W. (in preparation). 'Movements, activity and prey relationships of African wild dogs near Aitong, southwestern Kenya'.

Ginsberg, J. and Macdonald, D. 'Watchdogs', *BBC Wildlife*, Vol. 7, No. 8, 1989.

Goddard, J. 'The African Hunting Dog'. *Africana*, Vol. 3, No. 2, 1967.

Grzimek, B. *Among Animals of Africa*, Collins, London, 1971.

Grzimek, B. and M. *Serengeti Shall Not Die*, Hamish Hamilton, London, 1960.

Harney, D. and Cubitt, G. 'The last of the East African volcanoes', *Africana*, Vol. 2, No. 7, 1966.

Harrington, F. H. and Paquet, P. C. *Wolves of the World: Perspectives of Behaviour, Ecology and Conservation*. Noyes Publications, 1984.

Hunter, J. A. 'The rapacious wild dog', *Wild Life*, Vol. 2, No. 1, 1960.

Jackman, B. J. and Scott, J. P. *The Marsh Lions*, Elm Tree Books, London, 1982.

Khume, W. D. 'Communal food distribution and division of labour in African hunting dogs (*Lycaon pictus lupinus*), *Nature*, 205, 1965, 443–4.

Kingdon, J. *East African Mammals: An Atlas of Evolution in Africa*, Vols. 1–7, Academic Press, New York, 1971–82.

Kruuk, H. 1972. *The Spotted Hyaena*, University of Chicago Press, Chicago, 1972.

—*Hyaena*, Oxford University Press, Oxford, 1975.

Leopold, A. *A Sand County Almanac: And Sketches Here and There*, Oxford University Press, Oxford, 1987.

Malcolm, J. R. 'Social organization and communal rearing in African wild dogs', PhD thesis, Harvard University, Cambridge, Mass., 1979.

Malcolm, J. R. and Marten, K. 'Natural selection and the communal rearing of pups in African wild dogs (*Lycaon pictus*)', *Behav. Ecol. Sociobiol*, 10, 1982, 1–13.

Malcolm, J. R. and van Lawick, H. 'Notes on wild dogs hunting zebras', *Mammalia*, 39, 1975, 231–40.

Malpas, R. and Perkins, S. 'Toward a regional conservation strategy for the Serengeti', International Union for Conservation of Nature and Natural Resources, 1986.

McFarland, D. (ed.). *The Oxford Companion to Animal Behaviour*, Oxford University Press, Oxford, 1987.

Mech, L. D. *The Arctic Wolf: Living with the Pack*, Voyageur Press, Stillwater, 1988.

Moehlman, P. D. 'Social organization in jackals', *American Scientist*, Vol. 75, 1987, 366–75.

Owens, D. D. and M. J. *Cry of the Kalahari*, Collins, London, 1985.

Pearson, J. *Hunters of the Plains*, W. H. Allen, London, 1979.

Pye-Smith, C. *Only One Earth*, North South Productions and International Institute for Environment and Development, 1987.

Reader, J. and Croze, H. *Pyramids of Life*, Collins, London, 1977.

Reich, A. 'The behaviour and ecology of the African wild dog (*Lycaon pictus lupinus* Thomas 1902) in the Kruger National Park', PhD thesis, Yale University, New Haven, Conn., 1981.

Ruggiero, R. '*Le Lycaon est menace*', WWF-France/Panda, No. 18, September 1984.

Schaller, G. B. 'The role of scavengers and predators', *Wild Life*, Vol. 2, No. 2, 1960.

—*The Serengeti Lion: A Study of Predator–Prey Relations*, University of Chicago Press, Chicago, 1972.

—*Serengeti: A Kingdom of Predators*, Collins, London, 1973.

—*Golden Shadows, Flying Hooves*, Collins, London, 1974.

Scott, J. P. 'Wild dogs: the sociable predators', *Swara*, Vol 3, No. 1, 1980, 8–11.

—*The Leopard's Tale*, Elm Tree Books, London, 1985.

—*The Great Migration*, Elm Tree Books, London, 1988.

Serpell, J. *In the Company of Animals*, Basil Blackwell, Oxford, 1986.

Sinclair, A. R. E. and Norton-Griffiths, M. (eds.). *Serengeti: Dynamics of an Ecosystem*, University of Chicago Press, Chicago, 1979.

Smithers, R. H. N. *The Mammals of the Southern African Subregion*, 1983, 409–13.

Stevenson-Hamilton, J. 1947. *Wildlife in South Africa*, Cassell and Co., London, 1947.

Turner, M. and Jackman, B. J. (ed.). *My Serengeti Years*, Elm Tree Books, London, 1987.

van Heerden, J. and Kuhn, F. 'Reproduction in captive hunting dogs *Lycaon pictus*', *S. Afr. J. Wildl. Res.*, 15, 1985, 80–84.

van Lawick, H. *Solo*, Collins, London, 1973.

van Lawick, H. and van Lawick-Goodall, J. *Innocent Killers*, Collins, London, 1970.

Acknowledgements

I wish to express my gratitude to the governments of Kenya and Tanzania in granting me permission to live and work in their countries.

In Tanzania David Babu, Director of Tanzania National Parks, Bernard Maregesi, Chief Park Warden of Serengeti National Park, and Professor Karim Hirji, Director of Serengeti Research Institute were all instrumental in shaping this project.

Spending time at Handajega guard post was something to be cherished, sharing days with the rangers and their families, relaxing in their company, working with them, experiencing their joy and sadness, and benefiting from their generosity. Thank you, Abnel Mwampondele, David Rimbe, Gilbert Mabumo, Adison Wilson and Joseph Magombi, Warden of the Western Serengeti.

Friends living at Seronera and the Serengeti Wildlife Research Centre helped in a multitude of ways, serving up delicious alternatives to tinned food, providing the latest remedies for malaria, an introduction to computers, expert help with my vehicle, storing food, prompting stimulating discussions. Thank you, Monica and Markus Borner, Ken Campbell, Mark Deeble, Marion East, John Fanshawe, Clare FitzGibbon, John Grinnell, Heribert Hofer, Sally Huish, Mark Jago, Nancy and Scott Creel, Karen Laurenson, Richard Mathews, Samantha Purdy, Alan and Joan Root, Vicky Stone and Charlie and Lynn Trout.

I wish to say a special thank-you to the scientists who worked on the Serengeti wild dog project. Markus Borner, John Fanshawe, Clare FitzGibbon, Stephen Lelo and Karen Laurenson generously shared data, patiently listened to my many questions and still found time to provide the support of good friends. John, Clare and Karen kindly commented on various drafts of the text. Whatever merits the book may possess is in no small way due to them, even though they might not always agree with my interpretation of events.

Neil and Joyce Silverman have been of invaluable support to the Serengeti. Many of the scientists, wardens and rangers have been touched by their generosity. Earlier this year Neil and Joyce made me welcome at their beautiful home in Florida, providing that inimitable brand of American hospitality that I have been fortunate to share on many occasions.

Sandie Evans and his staff at Abercrombie & Kent in Arusha made things seem simple when they had previously appeared impossible. Sandie was always ready to help, despite his whirlwind schedule as head of a thriving safari company.

Danny McCallum rescued my safari with Neil Silverman in 1986 by generously transporting a supply of diesel from Arusha when there was a fuel shortage. Livia Duncan offered wonderful respite and hospitality for many a traveller, including me, at her farm near the Ngorongoro Crater. Aadje Geertsema and Margaret Kullander treated Neil and me wonderfully at Ndutu Safari Lodge. And friends from Ker and Downey Safaris in Tanzania were always helpful and hospitable.

In Kenya I should like to thank the Narok County Council for allowing me to live and work in the Masai Mara National Reserve, a land where animals are still to be found in numbers approaching their former glory. If it were not for the Masai people, much less would have survived thus far.

Pieter Kat and John Richardson provided original and stimulating answers to my questions about the wild dogs, animal diseases and genetics. They kindly commented on the Mara chapters, though any errors of interpretation are mine alone. Hopefully their work on wild dogs in the Mara will receive the support it deserves. David and Kim Penrose, Micheu Gitonga, Herbert Schaible and many others among the camp managers, drivers and guides provided valuable information on the wild dogs in the Mara.

It is impossible for me to think of the Mara without memories of unforgettable days at Mara River Camp. It was here that I first met Joseph Rotich, head driver-guide for Jock Anderson's East African Wildlife Safaris. Joseph showed me where to look for animals and taught me how to see and where *not* to drive if I was to avoid getting stuck. He remains a man of great dignity. Jock Anderson has been of unfailing help these past fourteen years, regularly salvaging my vehicle and offering advice. At Jock's office in Nairobi Jacky Keith, Gail Shaw, Sharon Fox and Stephen Masika were constant sources of help.

I have received invaluable support from the travel and safari specialists Abercrombie & Kent. Their staff in Kenya, Tanzania, America and England have provided assistance wherever and whenever I have needed it. For many years I have lived at Kichwa Tembo, their luxury safari camp in the Mara. Thank you, Geoff and Jorie Kent, Sammy Mwaura, David and Richard Markham, Martin Thompson, Maurice and Monica Anami, Alistair Ballantine.

Colonel T. S. Conner, DSO, KPM, still allows me the freedom of his house in Nairobi and has extended his hospitality to my whole family over the years. He is a loyal friend to a multitude of people throughout the world, who look forward to celebrating his one-hundredth birthday in 1995.

Boris Tisminieszky finally prevailed on me to buy a computer, little realizing that he would have to teach me how to use it, print a first draft of this book and patiently explain over the telephone between Nairobi and London what I was doing wrong. And that was only half of what he did.

All those fortunate enough to live in the Serengeti benefited from Barbie Allen's kindness. From her home and from the office at Queens Dry Cleaners in Nairobi, Barbie forwarded mail, helped organize spare parts for vehicles and radios, and entertained us sumptuously.

232

Gregory and Mary Beth Dimijian continued to supply me with all manner of fascinating articles on wildlife-related subjects, and David Goodnow provided good company and a vital supply of Kodachrome 64 in the Mara. And in England Pippa Millard, Gillian Lythgoe and Jennifer Jeffrey were helpful and hospitable in equal measure.

Brian Jackman of the *Sunday Times* cast a scholarly eye over an early version of the manuscript. He was, as always, constructive and encouraging.

Caroline Taggart has coordinated and edited all my previous books with her special brand of friendly professionalism. Her support and enthusiasm have been indispensable, never more so than since she went freelance as an editor. In addition, I should like to give my thanks to Kate Judd and Fiona Carpenter, the designers, who made this such a beautiful-looking book; to Keith Taylor for his help with the text and the proofs; and to Andrew Franklin for his overall assistance. Mike Shaw, my agent at Curtis Brown, was everything that a good agent should be.

Chris Elworthy of Canon UK was generous and patient with assistance and advice. The accurate metering of my Canon T90 cameras and a range of fast telephoto lenses (300, 500 and 800 mm) proved indispensable for photographing the wild dogs. All the pictures were taken on Kodachrome 64 slide film.

How can one adequately thank one's family, except to say that their enthusiasm and support make the low points of each book tolerable and the 'highs' memorable? The tranquillity of my mother's house in England is a wonderful source of relaxation.

Anybody interested in supporting the Serengeti–Mara wild dog projects should write to the following people:

Dr Markus Borner
Serengeti Ecological Monitoring Programme
P.O. Box 3134
Arusha
Tanzania

Dr Pieter Kat
National Museums of Kenya
P.O. Box 40658
Nairobi
Kenya